D0422190

Global encounters in the world of art

Global encounters in the world of art

Collisions of tradition
and modernity

edited by
Ria Lavrijsen

Royal Tropical Institute – The Netherlands

Global encounters in the world of art: collisions of tradition and modernity is published with the financial support of the Dutch Ministry of Education, Culture and Science (OCW), the NCDO (National Committee for International Cooperation and Sustainable Development), the Amsterdam Fund for the Arts, HIVOS, the British Council, Unesco and the Prins Bernhard Fund, which also supported the lecture series «Meeting Worlds» at the theatre of the Royal Tropical Institute, December 1997.

Royal Tropical Institute
PO Box 95001
1090 HA Amsterdam
The Netherlands
Tel: (31) 20 - 56 88 272
Fax: (31) 20 - 56 88 286
Email: kitpress@kit.nl
Website: www.kit.nl

Cover and graphic design: Nel Punt, Amsterdam
Editing: Sam Herman, Amsterdam
Translation 'The paradox of freedom in modern art': Nicoline Gatehouse, Richmond upon Thames
Photography: Maria-Pia Kille, Amsterdam
Printing: Veenman Drukkers, Ede

ISBN: 90 6832 281 8
NUGI: 661/911

This book is the fifth in a series about museums and cultural policies in art and culture. Previously published:
Art, anthropology and the modes of re-presentation: museums and contemporary non-western art / Harrie Leyten, Bibi Damen (eds.)
Cultural diversity in the arts: art, art policy and the facelift of Europe / Ria Lavrijsen (ed.), sold out
Illicit traffic in cultural property: museums against pillage / Harrie Leyten (ed.)
Intercultural arts education and municipal policy: new connections in European cities / Ria Lavrijsen (ed).

Cover illustration: A diptych by Clifford A. Charles entitled «All Packed». Two figures, a male and a female, are drawn on the wooden surface of fruit crates. The figures are strong and at the same time depersonalised. The focus of the two figures is on the eyes, which reveal a sense of sadness and loss. Clifford Charles comments that 'these two figures are ready to go on a journey. I wanted to comment on departure and migration. People are migrating to start a better life but the consequence is that they lose parts of their "identity" and personality. They inevitably become depersonalised. For me the eyes are crucial, being the window to understand the inside and the emotions of the personality.' [Photo: Henny van Beek, with thanks to the Franeker museum]

Contents

Preface 7

Introduction 9
Ria Lavrijsen

Between localism and worldliness 31
Okwui Enwezor

The paradox of freedom in modern art 43
Maarten Bertheux

East meets West in Arab theatre 51
Lamice El-Amari

The art of conflict 67
Catherine Ugwu

On diversity and meeting worlds 79
Valentin Yves Mudimbe

Double standards or single-mindedness? 91
Michaël Zeeman

Questions of modernisation and Indian cinema 101
Paul Willemen

Traces of liberty, here and elsewhere 111
Kumar Shahani

Report on the debate on visual arts 121

Report on the debate on performing arts 127

Report on the debate on literature 139

Report on the debate on film 151

Authors and contributors 163

Literature 165

Preface

In 1992, the Royal Tropical Institute theatre hosted an international symposium and a series of public lectures and discussions under the title «Cultural Diversity in the Arts». The central theme was the consequences for the arts in Europe of the contribution to the art and culture of European countries of artists of Arab, African, Asian and Afro-Caribbean origin – the 'new' Europeans. The project «Meeting Worlds» is a follow up to «Cultural Diversity in the Arts». This time the accent is on the conflict between tradition and modernity in the world of art on a global scale and the conflicting notions that go with it. On 3, 10, 11 and 18 December 1997, four public meetings between artists and thinkers from the Netherlands, Britain, Africa, India, and Asia were held on issues such as 'world culture', 'new internationalism' and the relation between 'tradition and modernity' in the arts of the non-Western and Western worlds.

Special thanks go to the keynote speakers for their challenging lectures, and their vigorous contributions to the debates: Okwui Enwezor, Nigerian-born, New York-based curator, artistic director of the 1997 Johannesburg «Biennale»; Maarten Bertheux, curator of the Stedelijk Museum Amsterdam; Lamice El-Amari, Iraqi-born, Berlin-based theatre critic and university lecturer; Catherine Ugwu, London-based British curator of live arts and independent consultant; V.Y. Mudimbe, Nigerian-born, US-based professor of literature and African studies at Stanford University in California; Michaël Zeeman, Dutch writer, journalist and television presenter; Paul Willemen, Belgian-born, British-based professor on film history at Napier University Edinburgh; Kumar Shahani (India), art filmmaker and writer from Mumbai (Bombay), India.

The four encounters between these eight speakers were chaired by Din Pieters, art critic and chair of one of the committees of the Netherlands Foundation for Fine Arts, Design, and Architecture, Dragan Klaic, director Theater Instituut Nederland, Xandra Schutte, literary critic and journalist and Gerdin Linthorst, film critic and journalist for *de Volkskrant*. We are grateful to all these for creating an atmosphere in which a meaningful debate between so

many different views and thinkers could take place. We also wish to thank Pearl Dias for her commitment and managerial efforts, Frank van der Schaar and Anita Rosmolen for their invaluable contribution to the audience development activities and Ruth Emmerink and Nina Simone Bakker for typing the transcripts of the recorded debates.

We also wish to thank the many people who were consulted in support of the programme and who assisted with our audience development activities: Maria van Bakelen, Erik van den Berg, Marriët Bakker, Pauline Burmann, Emile Fallaux, Simon Field, Rustom Bharucha, Sandra den Hamer, Dickie Parlevliet, Els van der Plas, Arthur Sonnen, Ritsaert ten Cate, Sarat Maharaj, Tijmen van Grootheest, Marineke van der Reijden, Mani Kaul, Miryam van Lier, Eltje Bos, Andries Oliphant, Njabulo Ndebele, Marijke de Vos, Jan Kees van de Werk, National Film Development Centre in India, Cinemaya in Delhi, Theater Instituut Nederland, Beroepsvereniging van Film- en Televisie-makers, Mondriaanstichting, Boekmanstichting, Vereniging Vlakke Vloer Theaters, Tropenmuseum, Vereniging van Schouwburg- en Concertgebouw-directies, Nederlands Literair Produktie en Vertalingenfonds, Uitgeverij Querido, Vereniging voor Kunstzinnige Vorming, Fonds voor de Letteren, Fonds BKVB. We want to thank the museum 't Coopmanshûs in Franeker for providing the slide of Clifford Charles' work «All Packed».

We would also like to express our gratitude to the Ministry of Education, Culture and Science in the Netherlands (OCW), the NCDO (National Committee for International Cooperation and Sustainable Development), the Amsterdam Fund for the Arts, HIVOS, the British Council, Unesco and the Prins Bernhard Fund, for supporting the series of lectures and the publication and their confidence in the project.

Ria Lavrijsen, programme curator
Otto Romijn, Royal Tropical Institute Theatre director

Introduction

"If you tell the truth you are in trouble. But if you see the truth and you keep quiet your spirit begins to die. The position of the artist is a terrible one."
The old painter Dr Okocha, one of the main characters in Ben Okri's novel *Dangerous Love* (1996, p. 96).

When referring in the West about art from the non-Western world one often tends to think of traditional forms of art. People think of wood-carvings, masks and traditional drumming from Africa, Kathakali or Bharata Natyam Dance from India, the Peking Opera from China, and the traditional classical music or calligraphic art of the Arab world. Literary traditions from Africa are far too often reduced to the tradition of oral storytelling, while there is a history of modern writings such as poetry and the contemporary African novel which dates back more than a century.

Of course it is important for traditions to be known, preserved, respected and passed on. Without a past there is no present. But artists originating from cultures and countries outside Europe producing contemporary work are highly critical of the common expectations in Western countries that 'non-Western' cultures should above all be traditional and authentic. Rasheed Araeen, British-Pakistani writer and visual artist in the UK has been criticising this attitude towards the 'other' for some time. He writes: 'By attributing a very different social and historical space to the non-European peoples, they are turned into the "others". First, the "other" is reduced to the level of a victim, then the West looks in the "other" for some kind of purity and authenticity; the result is the promotion and legitimisation of exotic cultures or art activities which are pre-modern or are removed from the discourse of modernism' (Araeen 1991, p. 55).

In the late nineteenth and early twentieth centuries Picasso, Brancusi, Modigliani and many other artists were inspired by traditional African sculpture and icons. African artists for their part discovered the tradition of academic Western realism at that time and around 1906 they started using the easel and began to explore and make work on canvas. But the colonial powers did not like that; craft was what these African artists were supposed to make. The Tanzanian-born, Belgian-based visual artist Everlyn Nicodemus criticised

9

this attitude as follows: 'This patronising and belittling, colonial Big Brother attitude retarded the flowering of an autonomous African art in most African countries until independence' (Nicodemus, 1994, p. 98).

It is not only in Western cultures that dynamic processes of change and innovation have been taking place, this has also happened in many non-Western cultures. In this context I like to quote Catherine David who said: 'It is very dangerous to go on claiming that modernity is a particularly Western invention and story, and that it has affected the others only on the rebound or by borrowing or reproduction. I believe that modernity has touched everyone' (David, 1993, p. 46). For David it is crucial that the many different ways it has touched people within the West itself as well as in Africa, Asia, the Middle East etc. be acknowledged.

This means that we must refuse to take the Western European and American canon as the only and exclusive criterion. It is a plea for a new sensitivity and approach in which we start looking at the way other communities have experienced modernity, even if those experiences originate from compulsion and traumatisation.

A few years after having made this public statement in Rotterdam, Catherine David was appointed artistic director of «Documenta X» in Kassel, Germany (1997). David noted that the pictorial figurative tradition was exhausted, and decided to concentrate on machine-made art. For the African-American artist Kerry James Marshall it must have been strange to be included in this «Documenta» with collage paintings of figurative elements. Many in the art world wondered whether David preferred machine-made images to hand-made images, since photography, video and film have a supposedly greater 'political potential' and are apparently more capable of dealing with globalization and post-modern and post-colonial complexities and fragmentation than paintings. The fact that she prefers machine-made art has been interpreted as a deliberate exclusion of painting and this has not been universally welcomed in the art world.

Western modernism, inspired by the emergence of the modern industrialised world, was anti-bourgeois when it started. However, it went through a process of appropriation and once it was accepted by the newly formed elites and privileged classes it became a dogmatic movement which preferred avant-garde movements such as abstract expressionism, futurism, conceptualism. Is post-modernism now mimicking modernism again by introducing a new orthodoxy: the exclusion of painting? Is Catherine David

10

suggesting that painting is an outdated and backward medium and that machine-made art is the latest form which should be preferred as the most important or the most relevant?

Today, the art of painting is practised by many contemporary artists in the West and artists living in or originating from African, Asian, Afro-Caribbean, Arab or Latin-American cultures. Are the works of all these artists to be excluded from the history of post-modernism in the same way women, African-American and non-Western artists where excluded from modernism?

There seems to be a sort of consensus today that traditional notions of chronological development and separate styles are no longer acceptable and that history cannot be seen as an evolutionary process. 'Who still dares to state that humanity progresses, and that each stage evolves irreversibly from the previous one?' (Meijers, 1996, p. 18). Why then do we need to introduce new hierarchies? Why do we not feel the need to acknowledge artistic excellence in its own right?

If we understand the post-modernist spirit as one that 'insists that history is a variable, being subject to change, fragmentation and multiplicity' (Hanru, 1994, p. 30) are we being faithful to the full integrity of post-modernism, if we introduce new kinds of hierarchies overnight? What about contributions to contemporary art by artists who do not have access to 'machines' such as video- and film camera's and technology such as computers and the Internet, but who express their personal artistic aspirations through painting? Is an honest post-modernism not supposed to acknowledge the fact that artists in different places in the world do experience different histories and modernities and do work in totally different contexts? One can indeed question whether Catherine David is sensitive enough herself if she prefers machine-made art to such an extent that artists in the West, the periphery or the Third World who work with other media are excluded from the start.

Interestingly, Stuart Hall considers globalization to be a process of profound unevenness and «Documenta X» proves, that, although trying to grapple with the political and poetical aspects of post-modernism and post-colonialism, it cannot disconnect itself from this unevenness. 'Some parts of the modern globalization process are producing the global post-modern. The global post-modern is not a unitary regime because it is still in tension within itself and with an older, embattled, more corporate, more unitary, more homogenous conception of its own identity' (Hall, 1997, p. 182).

Dealing in an ethical manner with the post-colonial heritage in a post-modern context does not prove an easy enterprise. This process of re-mapping

the world seems to be impossible without conflict and one often faces the danger of mistranslation and misunderstanding. Sarat Maharaj has described it as follows: 'We are unable to totalise this mapping of the world, each time something slips out of our grip. We grapple with the leftovers, the remainder of the untranslatable' (Maharaj, 1994, p. 35).

To show how, for instance, those who compile exhibitions are in fact operating in the battlefield, the following are a few examples of recent exhibitions that have attempted to deal with post-colonial and new internationalism and the way these have been received.

«Documenta» has been criticised not only for excluding painting but also for its Eurocentrism. 'The Eurocentrism was more obvious in «Documenta X» which, despite its avowed concern with issues of globalisation, consisted almost entirely of European and US artists' (McLean, 1998, p. 57). Later, however, McLean tempered his reaction to «Documenta X» noting that a surprisingly large number of the artists shared the diasporic fate of the coloniser and the colonised. The first Johannesburg «Biennale» was criticised for being too international. 'The First Johannesburg «Biennale» might have been an interesting beginning if had not started out on the wrong footing, focusing more on the international than the regional or African' (Altbach & Hassan, 1996, p. 57). The second Johannesburg «Biennale», entitled «Trade Routes: History and Geography», was accused of preferring an international audience although it was described as 'an attempt to elaborate the debates around the economic globalization, particularly those that arise out of the analysis of modernity as a circular system of exchange and site of translation, as transnational/cultural transactions that do not always arrive in neatly tied packages, as the South African born British critic, Sarat Maharaj wonderfully put it' (Enwezor, 1997, p. 7). 'Hosting an international biennale in a nation with such a tiny leisure class merely emphasises the problems of exhibition practices existing in all countries: questions about whose story is being told, whose history, whose religion, whose meaning, whose future' (Budney, 1998, p. 90). The «Magiciens de la Terre» exhibition in Paris in 1990 was examined because work by 'contemporary Western profane artists was placed next to artistic objects made by monks and priests of the South which were robbed of their sacred aura' (Cámara, 1995, p. 320). Praise also went to Jean Hubert Martin, the curator of «Magiciens de la Terre», because he appreciated and acknowledged artistic excellence as it was expressed by Third World *magiciens* which was not based on the Western formal and conceptual tradition (Van der Plas, 1991, p. 41).

«Perspectives: Angles on African Art» at the Center for African Art in New York in 1990 was criticized as well, but again for totally different reasons. Susan Vogel, the initiator, worked with ten co-curators. Nine of them were asked to select ten photographs for the exhibition from a hundred photographs of African art objects. The only person who was not offered any pictures was Lela Kouakou, a Baule artist and diviner from Ivory Coast. Susan Vogel considered that Kouakou would be familiar with the art only of his own people, and thought that he would have chosen only Baule-objects if he had been given the opportunity to make a selection (Appiah, 1997, p. 420). So an African informant only knows 'his own' culture and a rich and powerful collector such as David Rockefeller – one of the ten co-curators – is considered to be well-enough informed about other cultures to make an appropriate selection. Rockefeller is supposed to possess an individual and subjective taste, Kouakou is supposed to have no subjective taste, he can only represent the taste of his collective Baule community. Before we even have the chance to find out Lela Kouakou's opinion, he has been 'otherised'.

To move away from the old dichotomies between the West and the rest, one has to enter a complex field where the tension between the local and the global, the pre-modern and the modern, the collective and the individual, the industrial and agricultural, the rural and the urban, autonomous and functional art is played out and negotiated.

Otherising

We are no longer living in the nineteenth century, we are entering the twenty-first century and still we have not yet found out how to deal with this process of 'otherisation'. Two examples, one from the Dutch and one from the Belgian cultural context, show how persistent this phenomenon is. The first concerns Fra Fra Sound, a Dutch band which plays Afro-Caribbean jazz with musicians of Surinamese, Dutch, British, South African and Latin American descent. This band is interesting because for the hybrid and cross-cultural orientation and the search for a mixture of musical styles such as salsa, kaseko, jazz and South African kwela. I have no hesitation in characterising this band as a Dutch band because I consider their music to be a valuable contribution to the culturally diverse Dutch music scene. It is part of the heterogeneous national music of the Netherlands. Some years ago, an advisory committee to the performing arts foundation – Fonds voor de Podiumkunsten – responded to

their application for a subsidy as follows: 'The importance of the band is that it aims primarily at giving young Surinamese musicians a chance to be introduced to this kind of music. The commission regrets that less and less effort is being made to explore the background of Surinamese music. The group is heading too much towards the direction of a Fusion band. It is therefore in danger of losing its original purpose, without having gained a new one' (Fonds voor de Podiumkunsten, 1994). Vincent Henar, the Fra Fra Sound band leader, who is a black Dutch person of Surinamese background, regards this as 'an attempt to limit us, and Surinamese musicians in general, in our artistic choices and "sending us back to the bush"' (Henar, 1994).

The second example relates to Western classical music. In March 1994 the Belgian newspaper *De Standaard*, published a review by music critic Vic De Donder about a performance of the Royal Philharmonic Orchestra of Flanders in the Concertgebouw in Amsterdam conducted by the African-American conductor Michael Morgan. 'A black man can also conduct Mahler' read the headline in *De Standaard*. In his review Vic De Donder wrote that the conductor's 'frail appearance and typically negroid mannerisms would sooner lead you to expect him to start singing (Negro) spirituals, than to conduct a large symphonic orchestra. Not withstanding he conducted the Flemish Philharmonic with a firm hand.' When the director of the Royal Philharmonic of Flanders wrote to this music critic to express his shock, De Donder was surprised at the response. He had only meant to describe the atmosphere, he said (quoted in *de Volkskrant*, 1 April 1994).

For a long time Europeans have been interested in the 'other' and their culture. With the advent of modernisation they started to worry about the way non-Western cultures would be influenced and how cultural traditions in Africa and Asia might be damaged, or even disappear, through this process. In the meantime, Western cultures changed tremendously through industrialisation, technology and modernity. While we considered the cultural changes in Western culture to be part of our 'progress' and the dynamics of Western culture, we asked the non-Western cultures to preserve their pure and sacred traditions. This attitude even resulted in the emergence of a new branch of scientific research, anthropology. According to Jan Nederveen Pieterse, discussions about the 'other' represent the twin faces of the Enlightenment: the romantic gaze and the modern gaze. 'The romantic gaze highlights the diversity of cultures and infuses it with meaning – as in reverence for the noble savage, discourse of authenticity and 'roots'. The modernist gaze views different cultures as multiple paths leading towards the

citadel of modernity (Nederveen Pieterse, 1996, p. 176). In the romantic ideal the 'other' is supposed to represent an authentic, traditional, and pure culture. In the modern ideal the 'other' is supposed to throw off this 'otherness' and to engage in a process of assimilation and mimicking of Western culture, to become part of a so-called universal modern culture.

In the 1960s the world of art in Europe and the United States assumed that the vital, experimental art of the century flowed essentially from a single source, the avant-garde movement in Europe during the first decade-and-a-half of the twentieth century. Influences of other cultures – the tribal art of black Africa, for example – were acknowledged, but the art world was not prepared to give these art forms equal status. 'If these cultures showed the influence of Western art, and this included the influence of modernist ideas, it was assumed that this was a weakening and corrupting element, rather than a vivifying one. For early modernist commentators the situation was clear: Western art (a category that also came to include the art produced in the United States) was by its nature dynamic, and its true virtues were allied to this dynamism. Non-Western art retained its true qualities only if it remained static. The West made a claim to universal hegemony in art, and at the same time mock-humbly acknowledged itself to be a corrupting influence' (Lucie-Smith, 1995, p. 8).

Because most cultural critics in the West claim to have one universal norm – mostly understood as Western – this stimulates a process of assimilation. Thomas McEvilley describes it as follows: 'The idea of the universality of aesthetic judgement was no more than imperialistic ruse to force the rest of the world into imitation of Western sensibility (Mc Evilley, 1994, p. 310). At the same time, however, the West asks the 'other' – and that is the paradox – to be exotic, traditional, tribal and to express a collective and pure authenticity. Although we know that no culture is static, essentialist notions of culture persist.

Chris Ofili, a black British artist, seems to be intrigued and fascinated by the stereotyping of the black subject and to a certain extend he makes it a theme in his work. 'It's what people really want from black artists. We're the voodoo king, the voodoo queen, the witch doctor, the drug dealer, the *magicien de la terre*. The exotic, the decorative. I give them all of that, but it's packaged slightly differently' (Elliott, 1996). Ofili has made a trademark of the way he supports his paintings with elephant dung. As if saying: okay if you give me shit, I'll give you shit back. The strange thing is that his work and collages are highly aestheticised pieces in which thousands of dots, graphic lines, and little

photographs of more or less famous black people make up decorative images. Ofili does not seem to be particularly angry about the stereotypes that are imposed on him. You get the impression that the most effective way to deal with it, in Ofili's eyes, appears to be to play with them in an ironical, humorous and aestheticised way. His work bears the recognisable stamp of his personality, and instead of representing a collective culture he presents a highly individuated style of painting.

The burden of representation

The 'other' artist seems to be pushed or forced into an awkward position. On the one hand there is pressure to assimilation, on the other hand there are the people who 'otherise' the artist by dictating how to represent 'otherness'. This pressure towards essentialism, with ghettoisation as a result, can come from the outside as well from within the community. In the 1950s the African-American painter Norman Lewis felt attracted by the abstract expressionists, because of their insistence on each artist's right to determine how they should paint. Lewis was a socially conscious individual, who was constantly under pressure to paint pictures that expressed a socio-political viewpoint. However, because he wanted to explore the expressive force of abstract painting he was considered by some of his black friends and colleagues to be a traitor. He should have painted social protest paintings instead of abstract work (Bearden & Henderson, 1993, p. 321).

British-Ghanian cultural critic Kobena Mercer feels that it is not fair that 'other' artists are expected to speak as delegates, as surrogate politicians, who make the aesthetic dimension of their work subservient to the sociological context. 'In a situation of exclusion or marginalisation when only one or two minority voices can be heard within the public culture as a whole, it is often assumed that such voices "speak for" the entire communities from which they come. This relation of delegation, in which the part stands in for the whole and in which one equals all, not only denies differences within the black communities but creates a burden of responsibility on the part of the black artist which is impossible to fulfil and which negates the very idea of individual freedom of expression on which modernism has been based' (Mercer, 1997).

The achievement of Enlightenment and modernism has been the individual freedom of expression and the establishment of the autonomy

16

of artistic criteria. There is, however, a debate in the modern world acknowledging the fact that time-related, ethical and non-aesthetic criteria have been discarded in the arrogant moments of high modernism (Maharaj, 1993). A fruitful way out may be to assess the autonomous aesthetic and artistic criteria in relation to the societal, historical and cultural context. But a problem arises when we think of the two thirds of the world's population who have not yet even had the chance to enter the modernity of the industrial era. Is it fair to expect these communities to celebrate the highly individuated and autonomous artistic expression, like the cultural elite in the West does? But why should one deny any artist, regardless of their social or cultural or background, the right to make a transitional move to the production of a highly individuated kind of autonomous art? The Indian director Kumar Shahani feels that people in the West usually have recourse only to the decorative surfaces from tradition in the non-Western world. 'As a result, in the cinema at any rate, what comes to be known as "Senegalese" cinema of even "African" cinema is not what lies behind the formulation of a visual image or an audio image but is what is presented, like the costume [...] it restores the idea of a Third World culture, as an "underdeveloped" culture, which is supposed to catch up with, and one day become, First World culture. Like the witches of the medieval ages we, the artists, respond by accepting these notions unconsciously and in turn begin to emphasise elements like ethnicity through costume and through obvious behavioural patterns [...] It seems to me that the whole history of internationalism has in our times reinforced precisely this kind of response from groups who would like to work to self-determination, but who end up following a self-image – one that is imposed upon you by a form of patronage which you begin by reacting against but end up accepting through a series of vicious somersaults' (Shahani, 1990).

So on the one hand a sensitivity towards context and community is desirable, on the other hand it is advisable to have an eye for the individual artist, who may not wish to represent his community. Stuart Hall has asked: 'is post-modernism a global or a "Western" phenomenon?' (Morley & Chen, 1996, p. 131). If it is a global phenomenon, it is not possible to escape the global unevenness and the minefield of many conflicting notions that go with it. To deny the 'other' artist the right to speak in an individuated voice is to deny the right to self-expression in the realm of 'the beyond' or the 'in-between' – to use Homi Bhabha's terminology – a space where individuated and personal artistic excellence can be explored and researched.

One artist who explores how to reside in the realm of the in-between is the South African visual artist Clifford Charles. In 1993 he worked for several months at the Thami Mnyele Studio in Amsterdam. Charles uses the body as a vehicle to explore the social and political ramifications of South African society. He strongly opposes the pressure to define 'Africanity' in an essentialised way. 'Does African mean making wire cars, does African mean making tourist sculpture? Or does African mean re-inventing traditions that have died? People will respond differently, because they understand African in a different way. On the one hand our histories have been denied, on the other hand there are influences from other cultures and histories. There is a negative and positive side to it. I ask myself: what image can I present without negating any history. Through apartheid we had to practice the civilised established way, which was the white way. So we negated our African base. In contrast, we tend to move to the extreme African traditions, and again we are negating the history of what has happened in terms of Western influence. The movement tends to go backward. Now the establishment is defining "African", but it is still very much linked to the supremist racist ideology of South Africa, that Africa is primitive, naive, uses junk and does not have the aesthetic and sophisticated tradition and material that Western artists use. This perpetuates the racist ideology, that is very prevalent in the established art world. They want the black artist to work within a certain code, because then they can keep him or her on that level, and it justifies their power base. There I see a parallel with processes taking place in Europe. The Western art world inevitably has to recognise that artists of other parts of the world are going to impact on them. As a result, the impact is going to challenge the existing codes, parameters and institutions. What for me is prevalent in South African culture and in other African countries is the "parabel", the metaphor. That is the essence of my African base, working with the proverb, with the metaphor, speaking in a tongue that is not direct, speaking in layers, that is crucial for me' (Lavrijsen, 1993). Njabulo Ndebele, one of the most prominent intellectuals in today's South Africa, shares with Clifford Charles a scepticism towards this tendency to 're-invent traditions'. Ndebele does not wish to deny the importance of the tradition of storytelling and oral literature but feels that the written word has undeniably greater impact in the social contest for power. 'The truth of literature is to be found in its power to allow readers to formulate insights independently of outside authority. [...] To allow them to recreate themselves by enabling them to freely write their own texts. It may be wondered why I have put so much emphasis on the written word. What about oral literature?

The central belief behind my emphasis is that the written word is an inescapable fact of modern life. This is not to deny the importance of oral literature but merely to assert the fact that the relatively greater impact of the written word in the social contest for power is undeniable. To assert the contrary is to dangerously romanticise the oral tradition. It is to deny the mass reader the opportunity to experience the efficacy of self-education through reading. The aim is to enable the ordinary reader to domesticate the written word for its own liberation' (Ndebele, 1991, p. 143).

In the Netherlands the argument is often cited in the multicultural debate that, in order to respect other cultures and to stimulate participation of members of the migrant communities, storytelling traditions should be given a platform. The idea is that storytelling in theatres and museums may attract people from these communities. Of course, it can be enjoyable and attractive to be in the company of people who tell stories. These people and these traditions deserve deep respect, without doubt. However, the transitional move of the storyteller from an informal and private setting to a public space is only a responsible act if the storyteller involved has the ambition to be represented in this setting and has had the time and space to prepare to perform on a public stage as a professional performer. If a storyteller, irrespective of cultural background, is not used to this kind of setting and acts in a way that is perceived by the viewer as 'amateurish', neither the audience nor the storytellers benefit. Although it is good to stimulate participation, organisers often present the storytelling tradition without taking into account the specific context in which this tradition flourishes. I see Njabulo Ndebele's opinion as an encouragement to talented members of disadvantaged communities to engage in any kind of writing – creative, literary, journalistic, intellectual and scientific. 'We need to create a broad literary culture founded on the understanding that writing in all its various forms represents the attempt of the human mind to reach out towards ever increasing intellectual refinement. It represents an attempt at disciplined reflection,' writes Ndebele. Reaching out for intellectual refinement and reflection is as relevant and urgent for the black community in South Africa as it is for members from poor and migrant communities in a Western country like the Netherlands. To empower gifted people ensures that they can speak for themselves politically and poetically, and this is in my opinion preferable to the celebration of a newly re-invented tradition.

When Stuart Hall was involved in a photographic exhibition organised by the Commonwealth Institute in London he discovered that the people who

were invited to make pictures, images and photographs did not want to show their crafts and did not want to dress up, metaphorically in their traditions. 'They had to locate themselves somewhere, but they wanted to address problems that could no longer be contained within narrow versions of ethnicity. They did not want to go back and defend something that was ancient, that had stood still, that had refused the opening to new things. They wanted to speak across those boundaries, and across those frontiers' (Hall, 1997, p. 186). It is in places and moments where the 'other' can escape control, and make a difference, instead of representing difference (Bhabha, 1994) that what post-modernism means can be explored in all its integrity.

Nomadology

Looking at today's uneven global world control cannot easily be escaped. It is in the West that control is exercised by market, capital, racism, sexism, otherisation, exclusion, privileging the rich and denying rights to the poor. Outside the West, control is often exercised through corrupt politics, state control and the limitation of freedom of speech and artistic expression and censorship. In many countries around the world artists face authoritarian nation states that feel it is morally acceptable to limit freedom of expression when those in power are criticised. It is a painful moment in Ben Okri's novel *Dangerous Love* when Omovo, a young painter, is confronted with the fact that one of his paintings is taken away from his exhibition by soldiers. They accuse Omovo of mocking the progress of the country.

In the beginning of this post-colonial era freedom of speech and freedom of expression was celebrated in the newly independant countries. People felt free and felt that their voices and creativity were no longer going to be stifled by a colonial oppressor. But this euphoria did not last long. Those in power, the leaders of the one-party states, had definite ideas of how writers and artists should serve the development and unity of the nation. Many governments and military juntas still do not allow much space for critical voices, or for a free and open culture and have introduced censorship.

The driving force of the artist is precisely the existence of a variety of worlds and a multiplicity of personal histories and confrontations that formulate in the artist's imagination. The artist invites the viewer or reader to travel through this 'other' artistic world that is deriving from personal imagination. Kenyan writer Ngugi Wa Thiong'o describes in the novel *The*

River Between a young girl's fear of circumcision. You do not have to be either an African or a woman, to appreciate and understand the book. You can understand why this girl flees from her village and her family: she must do so to get away from this act which threatens to destroy her sexuality. However, it is quite probable that traditionalists within Kenya do not appreciate his novel and do not consider it as representative of their culture. It seems unavoidable that when artists create and present highly individuated stories instead of 'collective culture', their work becomes controversial and is censored. It is exactly because of this that so many artists who are considered too critical, too elitist and not serving the nation's unity, have to flee their homeland and are forced into exile.

Because of this enforced exile, Stuart Hall is sceptical about the post-modernist notion of nomadism (Clifford, 1997, p. 44) which suggests that everybody can travel and be inspired by other cultures at any time. Of course it is possible that people who travel empathise with human beings in other cultures, and it is quite possible that travellers acquire a deeper understanding of individuals and the social make up of other societies. But the artist or intellectual who is forced into exile, poor migrants coming from North Africa, the Arab world, Asia or Latin America do not travel out of choice. They are forced to leave family, home and language. Imagine what it means to start a new life, to communicate in an unknown and strange language as if you were a child? Although in many cases exiles have a traumatic life experience, Edward Said considers them to be the post-modern citizen *par excellence*. An exile has to confront the multiplicity of experiences from the past and the present and make one out of it. 'Most people are principally aware of one culture, one setting, one home; exiles are aware of at least two, and this plurality of vision gives rise to an awareness of simultaneous dimensions, an awareness that – to borrow a phrase from music – is contrapuntal' (Said, 1984).

The post-modern citizen *par excellence* may be the migrant or the exile, but women who have managed to have a life and culture outside the traditional family and private setting, working class and poor kids who went to school and gained access to the academic world and other environments, also face the challenge of a multiplicity of experiences and the need to make one out of it.

As much as we should oppose censorship and authoritarian rulers outside Europe, it is important to oppose any control that may be exercised under the guise of multiculturalism. It is remarkable that in the framework of discourses on multiculturalism within Europe some kinds of individual

artistic expressions not always seem to be appreciated. Now and then opinions are voiced in the Netherlands that it is wrong, for instance, to introduce Hafid Bouazza's prize-winning book *De voeten van Abdullah* ('Abdullah's feet', Arena, 1996) to young Moroccans. In this book Bouazza, a young Dutch writer, born of first generation migrants from Algeria and Morocco, plays in a rich and hybrid literary language with the taboos on certain erotic and sexual practices within the Moroccan community. Some people consider his literary work to be unrepresentative of 'his' culture. 'Bouazza is drifting away from his culture, in fact he is opposing it', I recently heard in a debate on arts education. Does opposing a culture mean that one is no longer part of the culture one writes about? Or perhaps the work of the migrant artist should not be considered simply as a representation of the place of origin or the place of arrival, but as a methaphor for the process of travel (Papastergiadis, 1991, p. 46).

It would indeed be insensitive and unwise to present this kind of work to children who are too young to be exposed to Bouazza's sexual references, but there is no reason why it should not be introduced to young people around the age of fifteen or sixteen or to young adults, regardless of their cultural background, so that they can make their own judgements. To label the book inappropriate is a rather parochial attitude reminiscent of the white middle classes who claimed to know what was good for people and what was not, and who claimed to know how 'civilisation' had to be understood. This kind of patronising attitude was generally a disguise for 'moralistic control'. It is a challenge to strive for a wider understanding and wider acceptance of freedom of artistic expression within the framework of multiculturalism.

Understanding 'other' cultures?

Another myth that inhabits the multicultural discourse is the idea that people from one culture cannot understand other cultures. Some years ago the late African-American theatre director Rufus Collins, who takes much of the credit for training two generations of black actors in the Netherlands, asked me what I thought of his theatre production of Derek Walcott's *Viva Detroit*. *Viva Detroit* is about a white American woman, who goes to the Caribbean with enough money to 'buy' sex from gigolos who she feels are attractive enough for her to share a bed with. I was not too happy with the production because I felt that the characters were too stereotypical. But I have no qualms about it. I would

have liked to have seen more of the white woman's loneliness and of the black gigolo's despair about the fact that he had to sell his body in order to live. I hinted that I was not quite happy about the production. Then Rufus, the director, said to me: 'You are European and you do not know or understand these people.' And that was where our conversation stopped.

British-Indian writer and thinker Homi Bhabha commented about this issue of sharing universal values when I interviewed him in December 1992: 'When a community enters into an act of representation, by making paintings and writing plays about their experience, you take that experience and you give it a public presence [...] In that very act [...] you deny the *a priori* presence of yourself as belonging to a closed always self-explanatory form of being. Only through that sense of alienation, by putting yourself in art, you produce a certain public image. At that point you cannot claim to possess a unique inexplicable sense of experience which is not accessible to others. That act of public representation means that the very subject of oppression and of cultural specificity becomes, in the very process of representation, alienated to itself. That opens up within the act of representation an area which others are invited to identify with.'

I believe that in many cases it is possible for people who have different histories and who come from different cultures, to share, appreciate and understand each others aesthetics and works of art. So in a sense there is a potential to share certain universal values. Take for instance Caryl Phillips's novel *Cambridge*. Phillips sets his narrative in the uneasy time between the abolition of the slave trade and the emancipation of the slaves. Part of the book is the story of Emily Cartwright, a young woman sent from England to visit her father's West-Indian plantation. Emily feels unable to sit at the dinner table with a black person. At the same time however Emily objects to the rudeness of a slave master on a West-Indian plantation. It is the special and subtle literary style and this moving combination of inhumanity and humanity that enables the reader to enter into Phillips's novel. Phillips forces the reader to reflect on morality and ethics in the nineteenth century and to ask: how would I have acted, how would I have felt at that time? Or take Toni Morrison, the African-American writer and Nobel Prize Winner. Her books can be read and understood by people who have not experienced slavery and racism themselves. Morrison's characters are so fully human that she enables us to share their emotions and to appreciate her work.

But it would be naive to think that Western people are always open and unprejudiced towards art and cultural expressions of the 'other', that they are

always willing and eager to understand and appreciate signs and symbols of all cultures without being informed about the specificities of people's histories and cultures, or that we are all part of one harmonious global world, where the diversity of cultures is shared through absolutist universal values and without any of the tension, competition or inequalities involved. As Homi Bhabha points out in the interview: 'It is utopian to imagine that all the walls of all the great museums would somehow crumble and we could have festivals in the park or community arts centres, as if those would be free spaces or non-ideological spaces.'

Faceless universalism

Apart from the 'exotic' or 'otherising' attitude there is another kind of attitude which is as insensitive as the one I have described. This attitude – in the words of the African-American writer and thinker Cornel West – is one of 'faceless universalism' (West, 1990). Modernity and modern aesthetics in Europe and the United States were shaped differently to that in non-Western countries due to historical, political and cultural reasons. But within Europe itself people from rural areas, working class or poor migrant families have experienced other kinds of modernities compared with people in cities and youngsters who were born with a silver spoon in their mouth or who grew up in intellectual, enlightened well-to-do environments. To try to understand the various and conflicting modernities within Europe we may as well try to understand the various modernities of communities on a global scale who – even in this post-modern era – do not have easy access to education, modern technology, the media and subsidies.

I do not want to suggest that the international art world consists of a group of white chauvinistic males over the age of forty-five who deliberately conspire to keep women and the 'other' out. It is however crucial to recognise that art and art institutions and the assessment of art are closely related to existing canons, decision makers, and their power. According to French sociologist Bourdieu, intellectuals, scientists and artists ought not to strive for economic interest in the first place, but their activities are often not as unselfish as they would like us to believe. In the arts as well as everywhere else you find competition, prestige battles, immaterial and material interests (Bourdieu 1989, p. 34-37). The Dutch sociologist Abram de Swaan once gave an interesting definition of an erudite person. 'An erudite is somebody who

has the power to confine or limit the conversation to the books he has read' (quoted in *de Volkskrant*, 2 April 1994). So it is not the books or knowledge that qualify a person as erudite, but the power. That is why it is wise to be critical of anyone who pretends to be erudite, regardless of their origin.

I confess, I hate the term 'politically correct' as much as I hate any other chauvinism, be it class or ethnic chauvinism. The oppressed, however much compassion I feel for them, do not necessarily occupy the moral high ground. The absolutist and binary divisions between men/women, white/black, oppressed/oppressor and self/other are not very fruitful. At the same time, however – and this may sound paradoxical – I feel, we urgently need to rethink questions such as whose stories are we going to listen to, whose books are we going to publish and read, whose works of art are we going to exhibit in our museums, which plays and concerts are we going to programme and which audiences are we going to serve, or what kind of students are we going to educate. Which communities are going to be served, who is going to get the resources for social and cultural development? Remarkably, ten years ago, Salah M. Hassan, assistant professor of African art history and visual culture at Cornell University New York, was refused an American scholarship because the Americans did not consider African art history, a field he wanted to major in, to be a 'developmental area' (Hassan, p. 37-38). All over the world knowledge is considered to be power and this is no different in the world of art in the West, as well in the South. One of the most crucial elements in the attempts to set up a dialogue between artists and art historians from the Arab world, Africa, Asia, Afro-Caribbean, and Latin America on more equal terms is to create a situation in which members of poor and disadvantaged communities have access to information, training and technology and can engage in international debate.

Europe's tradition of being critical

It is difficult to change power structures. At the same time there is some reason for optimism. The critical attitude towards the mental basis of Europe and the refusal to consider everything our parents and grandparents did as 'good', has been characteristic of European culture for some time. This is no reason to be self-satisfied about every aspect of European culture, but the ability to be critical is a reason for optimism. The logic of collecting, perceiving and being reflective about it, may represent a Eurocentric logic, but

is a positive aspect of European culture (Maharaj quoted in Lavrijsen 1993, p. 83). If we are able to consider the things our parents and grandparents did in a critical way, we may equally consider global practices and ideas in a critical way. Although I am more of an idealist than a romantic, I refer here to the Martiniquan writer Patrick Chamoiseau, who is opening a new and challenging perspective on the process of creolisation. 'For a Creole poet or novelist, writing in an idolised French or Creole is like remaining motionless in a place of action, not taking a decision in a field of possibilities, being pointless in a place of potentialities, voiceless in the midst of the echoes of a mountain' (Chamoiseau, 1989, p. 108).

I hope that people involved in contemporary, global, post-modern and post-colonial culture and the industry of representation have no intention of embarking on idolised and purely national or ethnic cultures in Europe, the Arab world, Asia, Latin America, and Africa. I truly hope the world of art can mobilise the creative energy to oppose those who want to be motionless, voiceless and pointless. It is impossible to define national and global cultures as homogenous cultures, so we have to think about how to approach the issues concerning intercultural, cross-cultural, the international and global and the unevenness that complicates these issues. A starting point might be curiosity, mutual respect and a subtle combination of engagement, commitment and critical distance. The real challenge is to find the space between populism on the one hand and elitism on the other. An indifferent cultural relativism belongs to lazy minds.

The arts cannot solve all inequalities deeply rooted in our cultures; it is in the arts however that a reflection on 'cultural, social and artistic differences' can take place in a creative and artistic way, beyond the boundaries of narrowly defined 'ethnic' identities.

Eight lectures which were presented in the framework of «Meeting Worlds» in December 1997 in Amsterdam, are included in this book. Okwui Enwezor reflects on the way global culture ignores the particularities of alternative modes of expression. Enwezor is interested in exploring how cultural forms of expression within the disadvantaged locales of displaced communities can be bent to new uses and how these transgress established categories of meaning. For Enwezor the movements of populations from rural to urban, agrarian to industrialized, village to cosmopolitan, national to post-national and transnational provide keys to new expressions of the meanings of identity and concepts such as hybridity, ambivalence and indeterminacy. 'How do we

secure new communities, embody diverse identities (sexual, gendered, racial), reterritorialize vestiges of the cultures of home; experiment with new ways of being and making; new economies of exchange and circulation of stories, symbolic and political values?'

Maarten Bertheux states that all innovative art is fuelled by contradiction and protest. So one would expect a good curator to understand the conflicting notions and the battlefield of the past as well as today's conflicting global world. Bertheux, however, feels that the modern art curator is not equipped to deal with these contradictions: '... modern art curators are faced with being acquainted with just a small section of art-production beyond the existing centres. Furthermore, we have no proper understanding of how to assess migrant art and the profusion of styles in today's multicultural cities.' Bertheux demands a less chauvinistic outlook and a willingness to take risks, but it remains unclear how this ill-equiped generation of curators, currently in decision-making positions, will deal with the unevenness and the colonial heritage that is affecting post-modern global art practice. In a follow up to «Meeting Worlds» it might be interesting to debate what kind of equipment and insight is needed in this post-modern time to make exhibitions which are indeed risky and refuse to be free of obligations.

Lamice El-Amari writes about developments in Arab theatre resulting from the meeting with 'Western' theatre, both negative and positive. Her paper examines the relationship between tradition and modernity in Arab theatre. She pays special attention to the relation of Islam to theatre. Here, rather than a theoretical treatment of the subject, historical examples of performing arts from various periods, are cited to disprove the widely accepted notion that Islam prohibits theatre. To underline the positive consequence of meeting worlds she touches on the work of some experimental Maghreb artists who valued both Arab performing arts and culture and the advanced theatre experiments that have taken place in Europe in the twentieth century.

Catherine Ugwu, curator of many live arts shows, looks at the ways art is represented and interpreted. She reflects on cultural grounding, the positioning of difference, how aesthetic and cultural distinctions come into being, what they mean and to whom and how they are (and could be) represented, particularly in relation to Western cultural brokers. She clearly illustrates how concepts of conflict run through all of the given agendas. Many artists from Africa or China are subject to the tension between rejecting Chinese or African traditional art forms and the refusal to embrace the

cultural imperialism of modernism. Catherine Ugwu asks the crucial question: 'How are such artists remaining true to themselves and defining new aesthetics that exist somewhere between East and West?'

Valentin Yves Mudimbe reflects on the way the uniqueness of individuals can grow in our global city, given a stronger universalist perspective. Mudimbe feels strongly about the fact that it is impossible for a person to establish themselves as a fixed identity. Reducing a person, a human culture, to an immobile essence is impossible. Every individual lives and acts in a world influenced by history and in relation with others.

Michaël Zeeman feels that, internationally and globally – beyond the European-based literary canon – an interesting new literature and a new sort of contemporary writing is emerging in the Western as well as the non-Western world, whereby the tradition of storytelling and oral histories is combined in an adventurous way with the so-called achievements of the modernistic novel. A new kind of 'hybrid' writing is emerging.

Paul Willemen deals with the issue of modernisation and Indian cinema. He feels it is wrong to approach Indian cinema from the critical and theoretical standards derived from Euro-American film cultures. Ashish Rajadhyaksha (co-author of *Encyclopaedia of Indian Cinema*) pointed out that Willemen was arguing from a position of three hundred years of individualist philosophy. How should Indian culture then deal with individuality and subjectivity? Paul Willemen suggests that modernisation can be measured by a cultural text's commitment to individual subjectivity compared to the requirements of the submission to status (caste, class etc). Indian film is not a pre-modern film, it negotiates different sets of complexities in the struggle between the old and the new.

Kumar Shahani reflects on how market and capital are trying to stand in for life and nature and how standardisation of goods is increasingly essential to global capitalism. Money and the lack of moral standards seem to be becoming the norm. Shahani is worried by the fact that children are confronted with the politics of identity and difference, a culture that belongs to the adults. But he still has hopes and dreams: children will build an 'elsewhere', which is not affected by the negative effects of the stubborn rhetoric of political correctness. Shahani sees traces of liberty in the resistance of generalisation and in the highly individuated art work which has freed itself from the membrane of temporal form.

Ria Lavrijsen

Between localism and worldliness

Okwui Enwezor

Daughters of the Dust, the skilful and imaginative work by filmmaker Julie Dash, is a film based on the epic tale of dislocation, migration, and acts of cultural survival forged under the despotic and inscrutable memory of slavery. Executed with an economy of narrative intensity, the film makes clear through a series of *mise-en-scènes*, flashbacks, cultural constructions, that once a paradise is lost it can never be regained. Far from relying on the abstractions and exaggerated sense of selfhood that often accompany and sometimes disfigure the narration of the social crisis many exiled communities experience during moments of transition, in-betweenness, and loss, Dash's film meditates on questions of memory, love, kinship, faith, apostasy, hybridity, political and cultural agency. In the film, explorations of individual freedom and desire are posed against communal, racial, and family cohesion, while using a metaphor to conjure and wrestle with the demons of displacement. The film is built around the structure of the microscopic social and cultural text, through the minutiae of domestic and personal narratives sited within the grand territory of history. Although she does not address explicitly the issue of return, it remains clear, throughout, that one of the structural concepts of the film relies on how to imagine one's identity in the temporal shift of modernity, that is, how to broach the unspeakable terror and the near impossibility of return, once one's consciousness is propelled forward by that *idée fixe* of modernity known as progress.

Yet the film remains vividly one that attempts to articulate the story and the beleaguered temporality of the African presence in the New World. I want to use this sense of beleagueredness to touch on the recent debates raised by Ebonics in the United States. As many people see it, Ebonics is part of the ongoing project of the fraught legacies of slavery and racism, the uneven mixture of Africanity and European cultural norms. This hybrid process produced what today many refer to as 'black English', which put another way is a kind of linguistic otherness. However, the question is not so much whether Ebonics can be pegged into a valid pedagogical category as a language of choice for those African American students who are said to be

deficient in standard English, hence their poor academic performance. The question that raises more immediate concern is whether Ebonics is a valid vehicle for socio-cultural expression. A very cursory survey of hip hop makes such question unnecessary. One could certainly affirm that Ebonics is as valid to hip hop as Latin is to the liturgical language of the Vatican and as a tool for making visible expressions of desire, selfhood, identity, etc.

Listening to the various voices in Dash's film, particularly the tone and texture of their 'English', and how they bend and render certain 'English' phrases into new systems of meaning, provides another key into how we listen to the Ebonics debate. Whether it is a subcultural argot or deformed language, such deep-seated ideological and political meditation on culture, language and translation locates the pedagogues of identity and cultural politics in the thick of the struggle over issues of race, selfhood, community; in the recesses of cultural expressions and social freedom. That this issue would reemerge deep in the giddy celebration that characterise globalization, does offer us an opportunity to look more searchingly on the kind of narratives that accompany what, today, is considered global culture. Especially if it is a global culture that is inattentive to the particularities of alternative modes of expression clustered within many sections of the world.

My point here is not to compose a praise song to Ebonics, but then neither am I interested in demonizing it. Simply the fluid positions from which *Daughters of the Dust* and Ebonics emerge say something about the notion of translation, and turns language not just into a site of contestation, but one which constantly suffers revision as we follow the tangled routes of the movement of populations, cultures, peoples, from one part of the world to another. On this account, I am as interested in exploring how language spoken from the disadvantaged locales of displaced communities can be bent to new uses, as I am fascinated by the anxiety they produce in so-called settled communities and the way they transgress established categories of meaning in those seemingly settled parts of the global village. It would seem to me, if we follow a little bit longer the Ebonics question, that the main issue isn't that the students who have thus far failed to fully assimilate into the settled community of the 'English' language (partly because of their socio-cultural background and partly because as someone put it, they have been too hooked on Ebonics) but the very nature of what we call English today. Quite acutely, we can see that colonisation works in mysterious ways. In this case, what the English language seems to have suffered is a revision. Such a revision contests any essentialised notion that language, along with culture and identity are

fossilised objects of social and cultural discourse. As can be seen in this debate, any encounter, however deeply rooted in systems of oppression, violence, and cultural erasure, places itself at the service of an inevitable and insociable dissolution of a prior order; it fixes us in the emergence of a new temporality. In this case the revisionary portents of diasporicity become equally, an analysis of the ideological crisis of the colonial language. It opens up new paths for us to experience how post-colonial procedures have inscribed themselves in the discursive sites of global politics and culture.

But let me return to *Daughters of the Dust* as a particularly poignant moment around which one may experience the objectification and limits of a colonial language, through the mass cultural medium of film. As we watch characters and listen to their voices, we hear clearly through the different accents and ways of employing the English language, how the complex weave of tongues have been seasoned by movement. Diasporicity, fragmentation, dislocation, re-territorialization, exile, etc., all these motifs of transnational human culture and fraught modernity, collude to make new meanings of identity. They produce new cultural possibilities out of the scatological travelogue of twentieth century migrancy. Beyond languages and accents, this film has other uses for me as well. Told on the eve of the migration of the Paezant family from a place called Ibo Landing, in the Sea Islands of Georgia, in the United States, their migration (that leaving behind that is less a movement of progress than a wound) is an exemplary text on that form of scattering and separation which bears portentous familiarity to the context of the legion African artists I will be discussing further in this essay. The presence of these artists in many parts of the world, capture in manifold ways that reality of arrivals and departures that are played out everyday in many airport terminals, train stations, docks, etc. throughout the world. How has the language of these artists changed since migration? How have their identities, sense of placelessness, or presence been altered by re/dislocation? Or, how have their identities, placelessness and presence affected, altered, or extended the normative forms of expression in the sites they occupy? Yet one question remains very clear: does migration necessarily mean the leaving behind of one's own country, culture, ethnic enclave, or does it involve other forms of travelling that are more than the physical transversal of borders?

This last question is important, if we consider how much things have changed in Africa, and for Africans in the last half century. The movement of populations from rural to urban, agrarian to industrialised, village to cosmopolitan, national to post-national and transnational provides keys to

new articulations about the meanings of identity, identification, affiliation, allegiance, alliance etc. They introduce concepts of hybridity, ambivalence, indeterminacy into the lingua franca of cultural and political discourse. They prise open routes into the values of ethnicity, origin and authenticity. Furthermore such reroutings not only question, they unsettle allegiances and make clear sites of myriad political, cultural, social and expressive thought. Such that speaking of 'black' Africa has become not only an inadequate point of classification and differentiation, but equally anachronistic. In this regards, various discourses are beginning to recognise the validity of Maghrebian, Caucasian and other histories as integral to the ways we define and expand the notion of who and what is African.

Thus, in speaking of Africa today – given its complex colonial and post-colonial history – we need to ask the obvious question: how have the struggles for independence, the problems of the national sovereign state, the expanding definition of national culture, citizenship, cosmopolitanism which are partially linked to economic malaise, social obsolescence and political destabilisation defined subjectivity for us? What role does the notion of individual freedom and desire play in constructing identity? How do such definitions provide affective processes of critical thinking, radical revision, translation, post-nationality, etc.? In terms of examining each procedure, what are the critical tools available for the work of the cultural historian?

These questions have a particular urgency, which means that in the peculiar circumstances of globalization, however parochial its current positions, we have to account for new diasporic formations that have become part of the post-colonial experience of African artists and intellectuals. We need to investigate and analyse the cultural and intellectual production that are based on this experience of diaspora; to explore how the conditions of exile and expatriation provide new motifs and challenges to the new discourses of Africanity in the late twentieth century. This investigation should contend not only with exile and expatriation in relation to movement into the crowded metropoles of the western hemisphere, but also with the transnational movements we see today occurring in Lagos, Abidjan, Johannesburg, Dakar, Cairo.

While movement and migration (forced or otherwise) have been a perpetual motifs of the twentieth century, and while many of us often fix on the problematics of dislocation and displacement, particularly those made through spatial distinctions; between here and there, home and exile, we mustn't forget that vast numbers of migrations happen internally, within

bounded national territories. Even when these movements happen internally, they are not always predicated on a shattered spatiality as we find in certain segments of Johannesburg where particular kinds of migrants cluster. Some of these clusters, in addition to redefining the spatial character of the city, bring to those sites new cultural archetypes, languages, etc., which often enter into competition with rooted, settled communities. Although these convergences often serve as real metaphors for conflict, it is the realisation of a new temporality within the spatial problematics of the city that makes the process of migration interesting. Thus, it is possible to live in one's own country, city, culture, and remain as distinctly alienated and distant from its social procedures as those who journey out to the strange beyond of the global metropolis.

This minimally recognised duality of migrancy, placelessness, exile, and displacement for me serve as real metaphors for what today's contemporary African artist embodies. They travel both at home and abroad; they travel physically and psychically; they migrate in-between the pixellated and information saturated sites of the cyberworld; they inhabit the complex matrices of popular culture (electronic, digital and aural virtualscapes) that form part of the transterritorial dimension of the global network and exchange systems. Additionally each of these artists bring very disparate attitudes and experiences to the zones where they trade not only in symbolic exchanges, but equally help in redefining and reshaping the contours of contemporary cultural practice. These habitues engage in critical conversation with the thorny issues of place, identity, memory. They acquire new meaning insofar as they detotalise and deconstruct a performative African psychic space from a homogenised, political economy of race and authenticity to one of multiple identities. In evoking some of the problematic terms that has fed the canon fodder of African identity discourse, I have no interest to repeat or solicit here all those worn out modes of post-colonial address, that insistently and invidiously set up the binary distinctions within the practices of those African artists who live on the continent or outside. Nor am I interested in the other distinctions that separate their practices between native/foreign-born; the authentic and inauthentic. In such echo chambers, nationalism, ethnocentrism and raciology circulate their noxious fumes. Still it would be fair to concede the point, that indeed, certain differences do layer some of the above distinctions. However, that would be an obvious point to make. They are only helpful insofar as we understand that we can only deploy them to establish paradigmatic attitudes that exist between disciplines, discourses, locations,

and practices. In so doing my argument rests on what I perceive as one of historical necessity.

But let us return, once more, to how those zones in which the strategic signs of African contemporaneity circulate and what they are bounded by. As I think of my own context of transnationalization: an Igbo, Nigerian-born, New York-based, Johannesburg resident, world citizen and latterly American citizen, navigating the soft, malleable world of identities and places, it seems I have developed a certain partiality to those kinds of cultural positions that are signed by contingency, indeterminacy, cosmopolitanism. I find in those resonant and affective moments a thrilling and new kind of contemporary practices being produced by African artists at home and abroad. The names are varied: Pascale Marthine Tayou, Georges Adeagbo, Moshekwa Langa, Jo Ratcliff, Bili Bidjocka, Folake Shoga, Wageshi Mutu, Mary Evans, Olu Oguibe, Kendell Geers, Kay Hassan, Oladele Bamgboye, Bodys Isek Kingelez, Yinka Shonibare, Ouattara, Ike Ude, Donald Odita, Abdoulaye Konate, Peet Pienaar, Tracey Rose, etc. They come from Johannesburg, Douala, Lagos, Cotonou, Kinshasa, Cape Town, Aba, Nairobi, Bamako, Dakar and live and work in New York, London, Amsterdam, Paris, Berlin, Tokyo.

Each of these artists (there are in fact, too many) work within many critical, avant-garde procedures, (video, film, installation, actions, performances, photography, digital technology). Although they do not eschew traditional means of making art, yet in confronting their works, I am forced to recognise their works as being deeply located within conceptual and post-modernist matrices. They speak to me in a manner that I will name as strategic performances; often based on the critique of various hegemonic social, political and cultural practices. Their works aim to destabilise, challenge, and reinscribe the global terrain of culture as a complex territory in which they could stake a claim as much as any contemporary practice coming out of England, the United States, France or Germany. In so doing, they invoke and highlight many transgressive and subversive moments, critical and radical articulations. For example there is Shoga's investigations of gender and hybridity; Bamgboye's exploration of place and memory; Langa's and Rotimi Fani-Kayode's interrogation of otherness and sexual difference, Oguibe's critique of imperialism, Bidjocka's flaneurship, Ude's theatricalisation of masculinity and performative inversion of gender codes; Hassan's meditation on displacement and violence; Mofokeng's exploration of the in-between spaces of representation; Geers' subversive conceptual and politicised gestures; Kingelez's utopian and post-modern vision of architecture and the

African city; Adeagbo's linguistic puns, taxonomy, and commodity fetishism. These are important new turns within contemporary art. They point not only to redefinitions of contemporary practice by Africans, they make exhibition making in the nineties a complex situation for the curator and the institution. Nonetheless, talking about these artists in this way does not give us a full picture of what it is to be an African artist in the age of globalization. All it says, and repeats, are what has always been known, i.e. that Africa is made up of multiple and disparate identities, cultures, territories.

However, in following this most traditional of analytic routes, what we are given, is a set of imperatives with which to examine what Homi Bhabha has termed 'measure of dwelling,' which speaks to how we define and determine belonging and place. What, in the late twentieth century are the conditions of belonging and dwelling for Africans who live in places other than Africa? Let us examine briefly two concepts; one of which is the *jus solis*, and the other *jus sanguinis*, as part of the hinge on which this measure of dwelling is either lived or legislated. Jus solis simply means belonging determined by place and the length of sojourn therein. While jus sanguinis, which is belonging based on blood, ancestry, and natal origin are conceptions of identity determined through biological, political, cultural, and territorial differences. In Cuba, the revolutionary slogan announced it quite forcefully, insisting on *patria o muerte* (fatherland or death).

In the context of the current local/global tension, and convulsive events that have attended the rise of nationalism, such sloganeering seem not so much quaint, but equally outdated. For if belonging is circulated and secured through parricide, and the atavistic attachment to land or place, as the Cuban emblem and places such as Bosnia and Rwanda seem to suggest, what happens when the reality of displacement or exile challenge the craggy edifices of these identificatory systems?

Whom does the fatherland refer to? The migrant or guest worker with minimal political rights, without claim, neither by blood nor the tenure of land? I think not. The reason I have repeatedly raised these issues, is, that very little of the perspectives over belonging, identity, nationality, exile, has adequately explored that hinge where many Africans dwell, think, create, or in some cases while away their time dreaming, paradoxically of home. And where exactly is home for these people? And where home has become unimaginable (except in the frayed edges of old black and white photographs) what set of images, within the nascent narratives of crossing, settling, dwelling, transterritorialization, do such immigrants conjure up to locate

themselves in the new land and to stitch the unruly patterns of home? How do they accommodate the locations of departure and arrival? What survives those journeys – whether voluntary or coerced?

But making sense of the new temporalities and spatial configurations many Africans have entered into today – between what James Clifford calls localism and worldliness – cannot happen until we learn to acquaint ourselves intimately with how African subjectivity has been defined within this reality. The reader can very well imagine that there are very few answers for such fraught questions, particularly as we focus on those expressive and social languages acquired in the temporal fissures of post-colonial migration. Such moments of migration – forged by contingent histories – repeat through various signs, little bits and pieces of remembered conversations (articulations predicated on the falling away, the fragmentation of collective memory). Even as they attempt to disguise those accents of foreignness and hybridity (that exemplary piecing together; part myth and part experience) one easily slips between different forms of speech – from colloquial Igbo to clipped British stiff upper lip English; from Lingala to Ivorien French; from Angolan Portuguese to Liberian Creole to Nigerian pidgin; from classical Yoruba to Swahili to Arabic, Afrikaans, and Hindi. All these at any rate describe Africa, at home and abroad.

In such a moment of contingent, indeterminate cultural histories, one would have to question why few discourses of contemporary Africa have taken little notice of these patterns and textures of migration and movement. There are reasons for this. First the degree to which the patterns of migration have been figured seem to always narrate that liminal space as only a temporary one. Hence the need to define and forge a broader affiliation of Africanity in a foreign place which diaspora suggests, was seen as unnecessary, for one always returns. Secondly, many African immigrants who left before or during the period of independence never imagined that various political and economic emergencies could so easily attenuate the desire to return. Moreover, many had found secure places for themselves in places where they had settled, and so those places became legitimate homes away from home. On a different level, many cultural historians still fixed in an absolutist demarcation of cultural and ethnic boundaries. And following certain anthropological and ethnographical practices persist in ignoring the cosmopolitan character of places such as Dakar, Lagos, Accra and Abidjan.

These cities from the early part of the twentieth century have accommodated a vibrant mixture of African cultures. Many of the most memorable moments

of this cosmopolitanism can be found in the enduring portraits of the citizens of these capacious cities, from such photographers as Mama Casset, Mix Gueye, Meissa Gaye, Seydou Keita, Ricardo Rangel, Peter Magubane, Alf Khumalo and Sala Casset who were working in the colonial port city of Saint Louis in Senegal, Dakar, Maputo, Johannesburg and Bamako in the period covering the 1920s up to the present. While these vibrant mixtures were happening, creating allegorical layerings and collages of modernity in the process, another group of African artists such as, Ben Enweonwu, Uzo Egonu, Gerard Sekoto, Iba Ndiaye, Skunder Boghosian, El Salahi, and Ernest Mancoba were already working in places such as London, Paris, New York, etc. These artists, conversant with the political movements of independence and social struggles of their home countries, wove into their critical practices questions ranging from post-colonialism to pan Africanism. In the specific cases of Egonu and Sekoto, both of whom had highly productive careers in England and France respectively, the post-colonial articulation of diaspora, displacement, ambivalence and contingency finds its most critical voices. In the work of the two artists, both of whom barely returned more than once to their home countries (Nigeria for Egonu, and South Africa for Sekoto) one finds the persistence of memory in the exuberantly and at times darkly limned aspects of life in the home country. They painted a vision of the world where the inward gaze explodes and looks outside; creating visual and psychological moments filled with desire, irresolution, ennui, and disjunctive spatialities that detonate like time bombs in the strange weather of euro modernist art which accorded them few acknowledgements.

Using some of these guides, if one could then project a more detailed picture of contemporary Africa in the late twentieth century, we will find that diaspora is not an equivocal term which excludes African artists. In its incremental and divergent formations, thinking around the links which diasporicity offers as a tool of critical appraisal of art of the continent, does indeed give us access into the transnational and translational regimes of contemporary production of her artists. It shortcircuits any essentialist reading of Africanity as embedded in a timeless warp of pre-colonial African traditions. James Clifford put it in a nice way when he wrote that diaspora could be 'seen as potential subversions of nationality – ways of sustaining connections with more than one place while practising nonabsolutist forms of citizenship'. It seems to me, that the terms under which we negotiate the sense of what is African in the late twentieth century, is predicated on the values of this nonabsolutist, non essentialised form of affiliation. This is what the artists

gathered under the rubric of this exhibition make clear. Theirs is a world that is not circumscribed by any absolutist identity or territory. In this sense the exhibition raises key questions, not only for the audience that will have its views of what and who an African artist is, but equally, those critical Western establishments which will, no doubt, continue to attempt to sequester these artists into disqualified ethnic categories.

But more importantly, the artists pose other, more salient, more lasting questions: like the Paezant family in *Daughters of the Dust*, as we cross and settle and resettle, how do the new accents we acquire during the course of migration or contact with other cultures change our positions of affiliation? How do we secure new communities, embody diverse identities (sexual, gendered, racial), reterritorialise vestiges of the cultures of home; experiment with new ways of being and making; new economies of exchange and circulation of stories, symbolic and political values? Indeed what are the ways one is and becomes African in the surging tumult and noise of the millenial clamor for a homogenised, and commodified global identity?

The paradox of freedom in modern art

Maarten Bertheux

A documentary by Wim Wenders about Japanese fashion designer Yochi Yamamoto featured an interview in which the conversation turned to multiculturality. This is a phenomenon that is particularly prevalent in the world's largest metropolises. Standing on top of a high-rise apartment block in Tokyo, against the backdrop of the sprawling city, the two gentlemen came to the conclusion that these cities no longer had any dominant cultural identity. In fact, these new world cities have become cultural melting pots, which are home to constant cross-cultural influences. A good way, perhaps, of explaining the plethora of different fashion styles, for instance.

Indeed, a post-modernist view of our time might lead to the conclusion that this perpetual stream of migrants, and the constant interchange of information by the media, have spawned a new type of world citizen, who thinks globally and knows exactly what the world has got to offer. Our clothes and consumer goods are distributed all over the world and launched onto the market through cunning advertising and sales techniques. A knock-on effect of this world-wide distribution of goods – most of which owe their enormous appeal to their designer labels or brand names – is that the original designs are copied and duplicated on a vast scale. Designers like Yamamoto are well aware of this, and that loss is calculated into the price of their designs. But this form of globalization is not just confined to consumer products. It is also prevalent in the field of entertainment and recreation. Hollywood, for instance, still has a huge influence on the supply of films and videos, and – more recently – computer games. In addition, publishers, hotel and fast-food chains, as well as television companies operate world-wide. Even the museum world is showing the same global approach.

Recently, a branch of the Guggenheim Museum opened in Bilbao. Commissioned by the city and the Basque province, a new 300 million dollar complex was built to enable the museum to showcase parts of its collection and mount exhibitions. Local politicians see this as an opportunity to attract both a national and an international public, as well as giving the city a cultural boost.

The Guggenheim is also busy establishing itself in other parts of the world, setting up joint ventures with museums that either do not possess a collection of the quality of the Guggenheim's, or lack museum know-how.

Viewed negatively, this imperialist approach of the Guggenheim can be dismissed as a commercial and market-oriented venture. But on the positive side, there could be a certain missionary zeal behind making high-quality modern art accessible to as many people as possible. Are a number of other major modern art museums also lend their collections to be showcased elsewhere in the world, thereby generating income which, in turn, allows them to finance other activities.

One of the crucial cultural-political questions we should be asking, is whether such far-reaching commercialisation of modern art museums is, in itself, desirable, and whether every peripheral museum should project itself as a clone of the major Western museums. When I visited the Museum of Contemporary Art in Tokyo a year ago, I was struck by the predominance of American art in the museum's collection. Although the museum is relatively new, it offers a good overview of Pop Art and Minimal Art, while also showing works by conceptual and Land Art artists. Among the paintings, there were fortunately a few Japanese artists exhibited alongside European or American artists. But these were in a definite minority. There was also a sculpture by Kusama, an artist who has exhibited in the West.

But what was more worrying, was the complete absence of – what I believe to be – a highly revolutionary Japanese art, that of the Gutai group. With their performances and unorthodox approach to painting, these Gutai artists produced artworks in the 1960s which I found utterly intriguing. And I had high hopes, while in Japan, of being able to see examples of this art, which I only knew from descriptions and illustrations. But when I made some inquiries, I learnt that these works were not represented in the collection. And that since they now fetched such high prices there were no plans at present to rectify this omission. Obviously, precedence was being given to the work of respected and canonised American art.

Of course, one can also quote examples of so-called peripheral museums which competently showcase the local art alongside the work of world-famous artists. In Australia you can see a painting by Kiefer hanging beside Aboriginal sand paintings. For an Australian curator – who must have a better general understanding of local art – the combination of these two artworks might be contextually easier to justify. But viewed with typical Western superiority, it is tempting to believe that the curator is prompted by feelings of

guilt about the way earlier immigrants and colonials treated the indigenous population. This could also be why the museum makes a point of showing the public that Australia also has another culture besides imported European modern art.

European museums also juxtapose works of art grouped under the heading of art-historical subjects, as well as works selected purely for their formal characteristics. Each museum tells its own story based of the way its collection is hung. But it also has to be said that some European museums are almost indistinguishable from one another because they exhibit virtually the same canonised art. While other European museums take their job of collecting national or regional art so seriously that they end up looking like provincial museums.

This method of operating on a chauvinistic or national level not only leads to stagnation; it runs counter to the artistic adventure that modern art stands for. After all, innovative art is fuelled by contradiction and protest. There will always be attempts to undermine or break through the prevailing ways of looking at things. These serve to change our carefully nurtured national or cultural traditions while in no way stifling the creative, artistic process. Indeed, they make art more complex and multi-faceted, multi-layered, less traditional, aligning itself with other developments outside the region or the national state.

The ability to absorb foreign influences has always been a particular strength of Western culture. This requires modern art museums to take a comprehensive view, not only of what is happening at home, but also far away. The ideal policy would be geared to establishing an international exchange, whereby art would enter into a dialogue with itself. It would also mean that these museums would have to maintain links with on-going developments in modern art, however difficult and incomprehensible these sometimes are. In turn this would open up opportunities for comparison. The more museum collections differ not only among themselves, but also individually, the more interesting it is to compare and assess.

At present the discussion is focused on quality assessment and the application of (aesthetic) norms. A frequently-heard complaint is that museum policy is determined by a relatively small group. And in principle this also applies to theatres and concert halls. Besides the directors, it is the major collectors, critics and artists who together determine what constitutes the modern art forum. Whether or not to admit a new star to the forum is

decided on the basis of this group's knowledge and underpinned by the current debate as to which qualities are relevant.

The arrival of modern art has forced our assessment criteria to broaden as a result of the expansion of themes and disciplines. The aesthetic norms that were based on the tradition of Western art history have been continually called into question by the twentieth-century avant-garde. And yet, there is no denying that – in order to be able to judge at all – we still cling to these norms. In the wake of a post-modern wave in art, which viewed a one-sided, formal and aesthetic approach as an inhibiting straightjacket, the trend has been to look outside aesthetics to norms related to politics, philosophy, ethics and social history. The complexity of our society, coupled with the deluge of images with all that this implies, is also reflected in art and has led to a myriad of different strands.

The last «Documenta» is a good example of an exhibition from which an old medium like painting was excluded, because – as a medium – it was judged to be regressive and inadequate for addressing themes like urbanisation, anthropology, migration and history. This has led to the predominance of disciplines with a certain narrative quality, such as photography, film, video and installations. Nevertheless it was a slap in the face for many art lovers, who experience and assess visual art primarily in terms of painting and sculpture. Suddenly it was no longer possible to judge quality according to the prevalent norms of traditional media.

«Documenta» featured a video by Oladélé Ajiboyé Bamgboyé which was accompanied by a documentary report of a ride in a demobus along markets and streets in Africa. It was unclear, however, how this differed from a professional documentary. Also on view was a video by Edgar Honetschläger, showing a series of Japanese people posing naked as if registering for scientific research. It was totally devoid of conclusions and evocative qualities.

Naturally there was also a great deal on offer that was extremely worthwhile. Lothar Baumgarten's photographic work, for example, which not only provided an extraordinary chronicle of the extensive period he spent in the Amazon region, but also included pictures of installations he had made in the jungle from natural pigments, as well as works in which he portrayed South America's colonial history through words and texts.

The point I wish to make is that there are different levels of artistic achievement, which is something that is far too easily passed over, particularly by the

new media. Take Baumgarten's work, for instance: it is not just about his involvement in the lives of Indians in the Amazon region, it is also about material transformation. In contrast, the South African artist Kendell Geers showed a video at the Johannesburg «Biennale», of images of remnants from the Dutch colonial past, which amounted to no more than a straightforward presentation of artefacts, leaving interpretation open. This type of approach – devoid of any personal application or viewpoint – is not enough. And, as far as I am concerned, it does not qualify as art.

Obviously, I could go on with these somewhat personal value judgements, such as noting that, in my opinion, David Koloane's paintings, expressing the aggression in South African society, are more significant than the illustrative drawings of his compatriot, William Kentridge, which also address forms of aggression and tyranny. But in giving these somewhat absurd and limited comparisons, I hope to highlight the fact that art criticism is dominated by many subjective viewpoints, and that it takes a long time before an artist is widely appreciated. All the more so when it is only the artwork itself that is being judged, and little is known about the background and intentions.

When I was in South Africa I gathered a great deal of information about the country's art, as I did during my travels in Argentina, Brazil and Suriname. But inevitably one approaches it from one's own Western background, and using those experiences to evaluate and compare artworks which are, to a certain extent, new.

Art from the so-called periphery has only recently begun to be showcased in modern art museums in the West, rather than in ethnological museums. In the 1980s, the show «Les Magiciens de la Terre», mounted in the George Pompidou Centre in Paris, juxtaposed artists from non-Western parts of the world and their supposed 'Western luminaries'. The exhibition posed the question whether, there might possibly be other experiences under the (artistic) sun – beyond centres such as Cologne, Paris, London and New York. In addition it highlighted the problem of the boundary between magic and art. Interestingly, one of the most frequent criticisms is that many examples of non-Western art cannot be classified as autonomous art.

With the exception of Venice and Chicago, the various biennials, such as those of Istanbul, São Paulo, Johannesburg, Sidney and Seoul, provide opportunities to see and compare art from different parts of the world. In contrast to the Venice «Biennale», these events no longer group work under different nationalities, resulting in more interesting exhibitions. Moreover,

these shows increasingly serve as a platform for professionals from all over the art world to meet and exchange ideas. In addition, today's international art journals are carrying a growing number of articles on non-Western art; and recent years have seen the emergence of specialised art magazine's devoted to the art of these regions.

For non-Western artists, the struggle for acceptance is, perhaps, even more difficult when their work is labelled as 'different'. This places them in a paradoxical situation: on the one hand their art is valued when it fulfils a vaguely romantic criterion such as 'authentic'. But on the other, the 'language' is expected to adhere to current views on contemporary art.

Our quandary may be summed up as follows: dominant Western art sets out its norms, while at the same time pretending to be entirely open to anything new. Meanwhile modern art curators are faced with being acquainted with just a small section of art-production beyond the existing centres. Furthermore, we have no proper understanding of how to assess migrant art and the profusion of styles in today's multicultural cities. This requires a less chauvinistic outlook and a willingness to take risks.

East meets West in Arab theatre

Lamice El-Amari

'Oh, East is East, and West is West,
and never the twain shall meet.'
Rudyard Kipling, *The Ballad of East meets West*

Kipling's famous statement denotes a singularly static view of the world and colonial supremacy. A vast empire on which 'the sun never sets'! An ever-lasting, uniform structure: the centre and its periphery. A strange vision today! Not only because the sun seems to be setting even in the heart of that old empire, as we have seen Irish, Scottish and recently Welsh moves for independence from the centre. But also because today there is not *one* centre, there are many. The development of these multiple-centres in power politics signalled the eclipse of that uniform vision, and have given rise to multi-cultural consciousness. Today the twain do meet, albeit not always amicably!

Europe between cultural diversity and new internationalism

Meeting the unknown has been art's eternal motivation. Ancient peoples, faced with an overwhelming unknown, created gods and religious rituals to appease these gods. These were protective rituals. In their struggle to feed themselves, they also created 'enlightened' rituals. The cave paintings of the hunting-gatherer period served as a means to understand the ways of the animal world (Sabri, 1982, p. 107-126).

Yet, while ancient people were geared towards survival, the modern approach to the unknown focuses on control, the perfection of the acquisition of human and natural resources. And not only on our planet: the unknown now is Outer Space. It also includes recent attempts to tinker with the biological structure of our race (e.g. the sheep Dolly). Our civilisation encompasses 'cloning' and mass-starvation under one hat! All these rituals and 'visions' are part of our handling of the unknown. As such, they manifest

the quintessence of our art and culture.

Our cultural history is a mosaic made of a long chain of encounters, of meetings with the unknown. An important link in this chain is the encounter between the self as an individual and the collective, unknown 'other' in the society as a common sphere of tension. Can universalism, with its drive towards uniformity, accommodate individual identity? Are we all the same or are we different?

How does an individual's identity function in the new world order? To take a personal example, I live in Kreuzberg, the multicultural centre of Berlin, known as Turkey's biggest city. It is the centre of alternative culture, and a truly multicultural community comprising mainly of Turks, but also Arabs, Kurds, Poles, Greeks, Russians, Spaniards, American Latinos and Germans. The younger generation on the streets accept their contradictory life-styles naturally: the traditional Turkish long dress and head scarf, and the contrasting 'power' look of young drop-out Germans in their black leather metal-studded trousers and exotic hair styles. Yet the alternative culture of German youth exists peacefully alongside the hybrid culture of third generation Turkish-German youth.

In this community an individual may receive any number of reactions in public. Being a German by citizenship only, I am also considered an *Ausländer* (foreigner). A warm smile! But by birth an Arab. Oh! The smile may freeze. Here comes the Turkish anti-Arab reflex. Historically, Turks looked down on non-Turks in their vast Empire, especially on Arabs. Luckily, this mixed welcome does not worry me. On the contrary, I enjoy it, because it helps me to understand the attitudes of individuals in foreign countries. It does not worry me because at heart I am a 'nomad', the kind of nomad Rosi Braidotti writes about (cited in Lavrijsen (ed.), 1993, p. 11-12; Lavrijsen comments on Braidotti's 'nomads' as being at home everywhere and nowhere. In contrast, Wole Soyinka, when asked where his homeland was, replied: 'It is in my head'). Europe does not claim to be a melting pot, unlike the USA. 'I am American' is an individual sense of identity, but 'I belong to the European Community' is a 'communal' identity of a different order. It presupposes a healthy balance between the individual and the communal.

This tension of individual versus communal can become tragic in the more complex dichotomy of ethnic chauvinism versus faceless universalism. Ethnic cleansing in former Yugoslavia clearly shows the dangers of ethnic chauvinism. But the pitfalls of its opposite, faceless universalism, are far from clear. Although its attractions (jeans, Coca Cola, walkmans, cellular phones,

soap operas, and the latest border-buster, the Internet) have been with us for a while, the utility of these things is seldom questioned. Objectively speaking, these pre-fabs for the world market are only outer signs of universalism. Although part of 'world culture' they are basically market culture. Globalization of the market economy and market culture have taken root rapidly. In contrast, the globalization of identity, the emergence of a new sense of identity – not of a 'nomad', but of a 'world citizen' – is a slow, long, and complex process. Changing human behaviour and modes of thinking, in any social formation, is a lengthy process. Here art, not industry, can offer hope. This is how I understand the interesting formulation 'art is essentially a history of broken identities' (Lavrijsen, 1993, p. 11).

In art, the process of effecting change is long and dubious. It is a mental process, both in creation and in reception. Though complex and slow, in contrast to the outward signs of the market culture, the effect of the mental, the artistic, is deeper and lasts longer. The throw-away culture is superficial; its aim is consumption and disposal. The artistic is personal/individual and inward. Its aim is contemplation, resonant retention and hopefully change. The re-unification of Germany is a case in point here. Market and societal structures changed fairly quickly. But the bridging of the gap between the mentalities in East and West is still a long way away. It has been said that the Berlin wall is now in people's heads. And this in a nation, that was divided for one generation only. In fact, in many official speeches marking the seventh anniversary of the German re-unification it has been acknowledged that while the re-unification of social structures have progressed fairly quickly, the re-unification in human terms will take a generation or more.

In a multicultural society, in addition to these conflicts within the culture or community, a further complication arises in dealing with another culture. The fear of the unknown 'other'. This fear is almost inherent in our race. Primitive peoples found a practical solution maintaining the status quo. They made an unknown God, whose anger they averted with sacrifices, and whose blessing they celebrated in thanks-giving festivals. In our time, cultural diversity can pose a danger to the status quo in a community. Caught in the web of ethnic chauvinism or faceless universalism, the only way out lies in accepting the 'other'. Not as a necessary 'evil' but as an equal, who raises our curiosity and respect, and whom we genuinely wish to understand. Cultural diversity presupposes difference (i.e. in time, place, status and, more recently, gender). Acknowledging the difference is a step towards accepting it. The other becomes, or should become, an equal.

53

Unlike the 'outward' uniformity inherent in universalism and its mass culture, it is the inner unfolding of a unique, distinct 'other' that can enhance human understanding. Towards this end, culture, and in a special way theatre, is conducive, if not decisive. Provided that there is an initial desire to know, it helps us understand modes of thinking of other people, and hence guides us towards discovering and knowing other cultures.

The interest of the West in non-European cultures emerged recently – only about thirty years ago – and it has been rather selective. In the case of the Middle East, it has been both selective and biased and, almost exclusively Judaic. (The *Encyclopaedia Britannica*, under 'Mesopotamia', shows how belated and highly limited the Western knowledge of that ancient culture is: 'Before the first excavations in Mesopotamia, around 1840, nearly 2,000 years had passed during which knowledge of the ancient Near East was derived from three sources only: the Bible, Greek and Roman authors, and excerpts from the writings of Berosus, a Babylonian who wrote in Greek. [...] In 1800 very little more was known than in AD 800. Apart from the building of the Tower of Babel, the Old Testament mentions Mesopotamia only in those historical contexts in which the kings of Assyria and Babylon affected the course of events in Israel and Judah.' These references could hardly have been sympathetic!) The Arab world, Europe's most immediate neighbour, is the one most misunderstood by Westerners. The stereotype image of Islam and the Arabs as the villains, the barbarians, has not really changed since the crusades. This image became sharper with the oil crises in the 1970s. During the Gulf War, the Arabs became international enemy number one. The recent rise of Islamic fundamentalism has strengthened this attitude. In general, the Arabs and/or Islam are still considered an enemy, tolerated as a necessary evil. Unfortunately, orientalists helped maintain this stigma with their Eurocentric evaluation of the culture(s) of the region. This is generally true of Middle-Eastern and Oriental university departments and of many international research centres.

The Gulf War has shown how dangerous the gap between Orient and Occident is. A new approach to the culture of the people inhabiting the Middle-East might contribute towards a more stable region. It is time this imbalance ended. If not for love of the Arabs, then surely for the love of a stable peace in the region (Martin Buber noted in *Jewish Newsletter*, 2 June 1958, that 'there was, in general, good neighbourliness between Jewish villagers and Arab villagers. Jews and Arabs not only co-exist but co-operate.

This would make possible an economic development of the Middle East, thanks to which the Middle East could bring a great essential contribution to the future of humanity').

Theatre arts in the Arab world

Although there is and always has been a wealth of performing arts in the Arab world, yet there is a widely-held notion that Islam prohibits theatre. This is based on the premise that early traditions of performing arts in the region do not qualify for inclusion in the accepted definition of theatre. For this, Arab theatre historiography is to blame. Arab and non-Arab theatre critique have upheld one particular form of theatre in the region as 'legitimate'. Writing about theatre history in the Arab world is a recent phenomenon, that started some forty years ago. Mainstream discourse about its birth was, and continues to be, a variation on the theme that Arab theatre began with Maroun el-Naqash in 1848, a Lebanese merchant who imported Western theatre from Italy (Landau, 1958). This Arab replica of nineteenth-century 'Western' melodrama was (and still is) seen as the only true form. Upholding this false notion and ignoring the existence of other and much older forms of theatre, calls to mind a scene in Bertolt Brecht's play *Life of Galileo*. Here Galileo tries to convince the church dignitaries of the existence of the stars. Galileo, sure of his discovery, asks them to simply use their eyes and look through the telescope. But the church dignitaries adamantly refuse to do so, saying: 'We must first discuss if such stars are necessary.' The polemic about the existence of theatre arts in the Arab world is just as absurd.

By setting the starting point of Arab theatre at a performance that copied an outdated Western form of theatre in 1848, the European canon was held up as the only and exclusive criterion for theatre work. This led in due course to the rejection of non-Western Arab theatre forms, and the propagation of the view that Islam prohibits the theatre.

Clearly, my views on Arab theatre arts contrast with most theories on the subject. It is therefore best to let history speak for itself. The present-day Arab world stands, geographically, on great civilisations: the Sumerians, the Babylonians, the Egyptians, the less ancient Phoenicians, etc. These peoples settled along river basins some six or seven thousand years ago. Therefore, the culture of the modern Arab world is the product of many 'meeting worlds': pre-history and history, the East and the West, the South and the North. It goes

back to the first settlements of recorded history. Islam, the dominant religion in the Arab world, is a relatively recent phenomenon that dates from the seventh century. Theatre, on the other hand, is as old as the human race. But 'Arabic' theatre is supposed to have begun only halfway in the nineteenth century. The apparent paradox is justified by a claim that 'Islam prohibits theatre'. I propose to question the validity of this much quoted claim by citing examples from recorded history. The following five episodes provide solid proof of performing arts in Islamic culture: of mega-stars, of professional acting groups, of grand spectacles, and of popular or secular entertainment.

El-Karaj

The first example dates from the advent of Islam in the seventh century. And what better place to look for a way of disproving the claim than at the household of the Prophet Mohammed himself! According to the famous historian Ibn Kheldoun, the young wife of the Prophet Mohammed, Aicha, was fond of playing a game known as El-Karaj, an imitation of mock battles on horseback, with her girlfriends. The central prop was a wooden horse covered by an oversized garment. Players would get in under the garment as if riding a real horse, and the action would proceed. This game could also be used to recite poetry, or to tell stories. Ibn Kheldoun wrote: 'One day, while in their mood of play, the Prophet returned home and saw (his wife and her girlfriends) at their acting. He asked her what the girls were doing, and Aicha, his wife, replied: "Playing El-Karaj." Then he pointed to the covered structure in their midst, asking "What is this?" Aicha replied: "A horse." Then the Prophet teased her, inquiring about two jutting pieces attached to the shoulders of the "horse", and she said: "These are his wings." To which the Prophet replied: "A horse with wings?", and Aicha answered: "Haven't you heard that King Solomon the Wise had horses with wings?" At this the Prophet laughed most heartily.'

It is important to note that this game was not only a private indulgence for women. It was a widely practised public event. Indeed, 'each district had its own Karaj, and people used to travel from one district to another to see these shows. It was the pastime of every locality in Mecca' (Ali Aqla Irssan, 1981, p. 240-243).

Acting in the time of early Islam

In the eighth century, the actor Acha'ab was, in our modern terminology, a mega-star. He moved in circles close to the Prophet. His father was a slave of Othman ibn-Affan (the third caliph of Islam, 644-656); his mother was reputed to have carried gossip among the wives of the Prophet Mohamed, causing trouble. The classical book of Arabic literature *El-Aghani* (*Songs*), by Abul-Faraj Al-Isfahani, describes him as follows: 'Acha'ab was born in Madina in AD 631. He was short, not fat, choleric, cockeyed, witty, very pleasant company, excellent singer also in Qur'anic recitation.'

The following story about Acha'ab is interesting not only because it confirms that performing arts did exist in the Islamic world, but also because it shows what great masters of body techniques these artists were! It describes an acting duel between two prominent figures: our Acha'ab, and his rival, El-Ghathiri, known as the 'Jester of Madina'. Acha'ab had heard that El-Ghathiri was imitating him. So Acha'ab, to establish his supremacy over El-Ghathiri, decided to attack him in public. He chose a *mejlis* (prestigious public gathering) where El-Ghathiri was performing and challenged him saying: 'I am told that you are imitating me, and you have taken away the people who were accustomed to listen to me. If you are like me, then repeat what I am going to do.' Acha'ab then grimaced, making the width of his face greater than its length, becoming unrecognisable. Then he relaxed, and challenged him again: 'Do this!' This time making such a long face, that his chin reached his chest, and he looked like a person using the blade of a sword as a mirror. After that he took off his shirt, and transformed his back into such a huge hunch that his body shrunk to the size of a hand. 'Or do this!' This time he took off his trousers, and began to pull at the skin of his testicles, until it touched the floor. He then rose and pulled himself upwards, becoming taller than any man. Those watching laughed so much that a few of them fainted. His rival, El-Ghathiri, conceded defeat saying: 'I am your apprentice, and your student.' At this Acha'ab left the *mejlis*, having re-established his supremacy (Ali Aqla Irssan, 1981, p. 41-43).

Professionalism: a jester topples the Judge of Baghdad

This episode, also from the eighth century, shows the power of performing arts in the Islamic world. A leading jester, Allawiyah, had a dispute with the

Judge of Baghdad, El-Khadi el-Kholinji. To get back on the Judge, he wrote a story *(Hikaya)* criticising him, and gave it to performing groups to show it in public. The *Hikaya* became so popular that the judge was obliged to offer his resignation as Judge of the Capital, and to ask for a minor post elsewhere. In fact, he was appointed in charge of the army in Damascus.

This tale offers proof both of professional acting, and of specialisation in writing for performance by certain groups. The fact that the judge himself had asked for demotion proves beyond doubt the social impact of performing arts in that period.

Grand spectacles for the Prophet's birthday

In *Islamic Civilisation* Adam Metz describes how the birthday of the Prophet Mohammed was celebrated in the city of Arbiel (Iraq) in the year 1233. He writes: 'The Caliph had ordered that about twenty huge wooden marquees *(serdaq)* be constructed along the main road. Each stand was to have four or five levels facing the road. The stands were to be decorated, and occupied by hundreds of artists: singers, musicians, puppeteers *(garagouz)* and shadow players. On the eve of the birthday, the Caliph himself would march in a procession through the street, with candles fixed on mules' backs to light his way. A three day public holiday would enhance the importance of the spectacle in the public eye' (Putinsova, 1981, p. 49).

Surely, no caliph, and no magic wand could conjure so many artists to fill all these marquees from nothing. Another proof that entertainment by professional performers was the rule, *not* the exception in the Islamic world.

Travellers describing plays

During the nineteenth century European travellers and explorers wrote about plays they had seen in the Arab world. Giovanni Belzoni, the Italian explorer, describes a 'show' he had seen during a wedding celebration: *A farce by local Arab actors entitled The Pilgrim and the Camel* (Belzoni, 1971, p. 19). The word 'pilgrim' in the title of the farce speaks volumes against the claim that Islam prohibits theatre. Devout Muslims enjoy themselves watching a play about a pilgrim on his way to Mecca! Also important is the date when Belzoni saw this farce: in 1815, long before the supposed birth of Arabic theatre in 1848.

In this brief tour of the performing arts in the Islamic world mention should also be made of another ever-present artist in Islamic culture: the story-teller, counterpart of the medieval European minstrel. Throughout the centuries distinguished narrators entertained sultans and performed in public spaces. People would queue for half a day to get a seat. This performer parades under many names through Islamic (Arab) history. In the Mashreq he is generally known as *el rawiya* or *el rawi* (the narrator). Other names include *mohabbez* in Egypt (which refers to the tuning of his musical instrument), *hadda'ai* (caravan chanter) in Jordan, *hakawati* (story-teller) in Syria, Lebanon and Palestine, and *gawaal* or *meddah* (praise giver) in the Maghreb. They perform on religious occasions that have gradually acquired a secular nature and have become popular festivals throughout the Arab world. The traditional setting of the narrator is *el halqa* (the circle). This is still the dominant type of performance in the public square at Gamai el Fana's mosque in Marrakech, where drama, comedy, poetry, songs, dance and culinary attractions naturally intermingle.

Critique of Arab theatre historiography

All this wealth of performing arts in the Arab world hardly supports the idea that Islam 'prohibits' theatre. So how could such false notions have persisted all this time? The Eurocentricity of theatre historiography forced a blanket rejection of all other forms. Indigenous cultural practices were considered primitive, and dismissed as a 'pre-theatre phenomenon' or even despised as Alfred Faraj has complained (Faraj, 1976, p. 58-59). Or simply and with deadly effect, ignored altogether referring to them as folklore. In this way, Arab theatre critics, taking 1848 as the absolute start, prevented a healthy approach to their cultural heritage. Consequently, the pre-Naqash theatre forms, described in the five episodes listed above, continued, like Galileo's stars to the Church, to remain non-existent!

In the 1960s Mohamed Aziza, a Tunisian historian, presented a theory about the belated birth of Arab theatre. Considering conflict to be 'the law of drama', Aziza justified the 'absence' of theatre in the region by the absence of conflict in Islamic thought. His view suggests that Islam had been conflict-free until the nineteenth century 'when the Arabic region was occupied by European powers' (i.e. non-Muslims). Then occupation, violence, divisions and conflict entered society and also literature. Aziza concludes: 'It was then possible for theatre to be born in 1848.' As simple as that, and overnight!

Aziza also makes an error in linking violence and conflict exclusively to (foreign) occupation. His view is refuted by the long history of internal power struggles and bloody wars in the Islamic world. Even at the dawn of Islam the last members of the family of the Prophet himself were misled by a false promise of support for political action, tragically abandoned on the battle field and brutally murdered. This massacre at Kerbela is commemorated annually throughout the Arabic and Islamic world in the religious ritual known as *el Taazi*: ten days of mourning and prayers, culminating in mammoth processions occupying entire cities. Aziza fails to recognise this massacre as a socio-religious conflict, and more importantly, only accepts the Persian Taazi as theatre, describing it as the 'grand exception' in Islamic culture, and ignores the Arabic Taazi. It is 'grand' indeed, for centuries an attraction throughout the Arab and Islamic world. Aziza's argument is widely quoted in Arab theatre critique. In fact his book *Le Théâtre et l'Islam* has become the standard reference work on the subject. Unfortunately his view is typical of the confusion in the discourse about Islam and theatre arts, in and outside the Arab world. (Aziza quotes the Comte de Cobineau: 'Le théâtre persen est une grande affaire' (p. 38) yet fails to see the disparity between this assessment and his own 'rough-and-ready' view of theatre in the Arab world.) Even a renowned scholar like Victor Turner has fallen into the trap (Turner, 1982, although this followed Landau's work).

The supposed prohibition of theatre is so taken for granted that its origin and its proof are lost in mystery. Not one direct quote from the Qur'an is ever given to support this claim. It is not even claimed as *Hadith* (sayings from the Prophet). Yet we have seen how the Prophet himself accommodated King Solomon's flying horses in his own home! The truth is that Islam prohibits the worship of statues, that is all.

Strangely, little or no attention is paid to the attitude of other major religions. Because, while an Islamic ban on the theatre lacks proof, the hostile attitude of the Christian Church to theatre is beyond doubt. This is also true of Judaism (Moreh, 1992, p. 1-6). The Western Church issued a direct ban on theatre in the fifth century, excommunicating all actors, and finally closing all theatres in the sixth century (Chambers, 1964, p. 1). This did not, however, prevent theatres from continuing. In view of this paradox, one is forced to ask, is the social power of one religion stronger than another?

In traditional societies in Africa, Asia and elsewhere, religious ritual and theatre are still intertwined. This is also true in the Arab world: el Taazi,

Issaoua, dervish rites, to name but those that have been observed for centuries, up to the present time. But while in these societies 'the integration of ritual and theatrical conventions is taken for granted', this is not acknowledged in the literature on Arab theatre. As already said, ritual is generally rejected as non-theatre. Indeed, the wealth of religious rites, ancient and modern, are kept outside the domain of art. It is almost sacrilege to consider them art.

A spectacular challenge to these views was posed by the Algerian experimental play *The Seventh Dimension* (1989). In the city of Constantine, a traditional stronghold of Islam, an amateur group used the sacred rite of Issaoua to question the inevitability of death – the theme itself is taboo in Islam – and to make a strong statement on Algerian and world politics. They describe their experiment as a combination of Antoine Artaud's 'theatre of cruelty' and Piscator's 'political theatre'. By manifesting the theatricality of religious rituals, this experiment also manifested the positive consequence of rejecting the exclusivity of the 'Naqash-Western' canon. *The Seventh Dimension* leads us to the subject of modernity in Arab theatre work.

East meets West again

The 1960s brought the influence of avant-garde experimentation in Western theatre to the Arab world. Coupled with a rejection of the traditional European canon as 'one and only', this led to a revival of Arab theatre forms and revolutionised theatre work in the region. While the first contact in 1848 with Western theatre suppressed indigenous oral forms, this second contact, a century later, proved entirely positive. Inspired by avant-garde experimentation in European theatre, artists revived the neglected oral forms in contemporary plays. The period of highly experimental productions in Morocco, Tunisia and Algeria ushered in a new chapter in Arab theatre work: modernity.

Fortunately, during the last thirty years, while the critics went on denying the existence of the stars, creative artists began to show serious concern with the nature and function of oral art forms. Rejecting the exclusivity of the 'Naqash-Western' model, each artist developed their own brand of modernity. The following survey of these pioneers shows the magnitude of this breakthrough: Tayeb El Siddiqi, Abdulkarim Berrchid, Miskini Saghir, but also Abdul-haq el-Ziruali (Morocco); Izz el-Din El-Madani,

Rajaa Farhat, Tawfiq Jebali, and Mohamed Idris (Tunisia); Ould Abdulrahman Kaki, Kateb Yacine, Abdulkader Alloula, and Slaiman Ben Issa (Algeria); Saad Ulla Wanous (Syria); Yousif el-Ani and Kasim Mohamed (Iraq). All of these, in their various ways, challenged the notion of the absence of performing arts in Arab culture before 1848. They freely availed themselves of oral traditions and created 'different forms of modernity' (Lavrijsen quotes Catherine David on the non-Western contribution to 'modernity'). But they had one thing in common: the rejection of the exclusiveness of the Western canon. This has indeed 'caused a revolution'. (Lavrijsen continues: 'This view may cause a little revolution, because it means (refusal) to take the West-European and American canon as the only and exclusive criterion.' The resulting 'revolution' in the Maghreb proved her prophecy.)

These daring experiments were born in the Maghreb, where there were favourable conditions that made a breakthrough possible. In this part of the Arab world, oral forms of theatre were widely diffused throughout society. It was easier for experimental young intellectuals to ignore the 1848 view and draw inspiration from popular 'cultural performances' which shaped their personality and thinking. And the decisive factor: they were exposed to the new-orientation in European experimental theatre in the 1960s. The geographic proximity to France, visa-free travel, and knowledge of the French language gave Maghreb artists a great advantage over their Mashreq colleagues. While Maghreb artists were able to experience the new modern trends at first hand, Mashreq artists were at the mercy of translators. Most of them still are.

Arab forms of modernity include experiments such as the revived traditional story-teller. This most dominant form of modernity, features under varying names in contemporary plays. Among others: *Gawaal* (Adk. Alloula – Algeria); *Hakawati* (R. Assaf – Lebanon); *Rawi* (S. Wanous – Syria), but also Q. Mohammed & Y. El-Ani – Iraq, to name the more prominent cases. The Israeli Hakawati group also belongs in this category. The setting of the story-teller, *el halqa* (the circle), was rescued for the modern theatre by El Tayeb El Siddiqi. To him, el halqa offers 'a harmonious unit – a multiple structure in absolute form'. A pioneer experimenter, Siddiqi, also availed himself of the *Maqamaat* (a long poem that is sung in precise musical scales), and of the concept of 'total theatre' set in a marketplace. Prominent follower, but innovator in his own right, is the Iraqi artist Qasim Mohamed.

Other modern experiments, some accompanied by manifestos, include the *Ihtifaliyah* wedding/celebrationist theory – akin to the American happenings

62

(Abdulkarim Berrchid, Morocco); historical tales and legends à la Brecht (Izz el-Din Madani, Tunis; Qasim Mohamed, Iraq; Saad Ullah Wanous, Syria); *garakouz*, mime, and folktales as Brechtian epics (Ouald Abdul Rahman Kaki, Algeria); *babat* shadow plays (Meskini Saghir, Morocco) and the story-teller in non-Aristotelian drama (Abdulkader Alloula, Algeria).

The paradox in Arab theatre critique is that while these artists are generally hailed as renovators who successfully use oral forms in modern plays, there is no acknowledgement that their particular success was in fact a *direct challenge* of the 'Naqash-Western' canon. The 'father' of Arab modernity, Sidiqqi, stated famously what his generation felt about the Western canon and the introduction of Western theatre in 1848: 'The Cardinal Sin in Arabic theatre was committed when Maroun el Naqash introduced the three bangs on the wooden floor of the stage, to announce the opening of the play' (Kharraf, 1980, p. 13). And yet the Western canon continues to be the only and exclusive criterion in theatre historiography. This paradox lives on in countless books and articles on Arab theatre and in pan-Arab theatre festivals. Unfortunately, this is also true of Western writing on Arab theatre.

It is to be hoped that in this age of multiculturalism, the recent although limited interest of Western scholars in Arabic theatre work will set the balance right in due course.

«Utopia 93»

In conclusion I shall turn to my involvement in a project entitled «Utopia 93». This international multicultural multimedia project is a search for a new language in which an art work is created by artists from various cultures and countries. During my work at Algerian universities in the 1980s, it was possible on a few occasions to arrange 'mini' Meeting Worlds, allowing Western and Algerian minds to meet as fellow artists. The structure was free, with participants eager to get to know each other. In long sessions we argued, often heatedly, and differed on equal footing. It was exciting to note during these meetings, that when equality rather than hegemony was the order of the day, remarkable new visions emerged regarding cross-cultural art work in today's world. In 1993 my desire to explore new horizons through international dialogue and cross-cultural co-operation led me to initiate «Utopia 93». As a dialogue through art between North and South, «Utopia 93» is an attempt to reach from the origins of culture to a cultural search for origin(s).

Its form is an international theatre workshop for individual artists who have achieved a particular professional excellence. The team pools varying modern developments in contemporary art from North and South. As individuals, all participants have a certain artistic curiosity, as well as an open mind and an experimental approach. The rules of play are absolute equality and mutual respect. Each individual artist brings their own culture-specifics to the project, but they co-operate across varied cultures and disciplines collectively producing a work of art. Utopian? Perhaps, but a worthy challenge.

So far two preparatory meetings have been held in Vilanova, Spain, and in Carthage, Tunisia. Thirty artists from twenty countries attended these meetings. Institutional patronage came mainly from Algeria, Spain, Germany and Tunisia. Additional support came from the countries of origin of most participants. This is a new form of sponsoring of multicultural art projects, different from sponsoring on an individual basis. Within the framework of «Utopia 93» a team of individual artists have tried to carry out the creative process themselves from beginning to end. This is a conscious departure from institutional sponsoring and diffusion of art works, where the criterion is usually national as opposed to individual; and where art-brokers have a free hand to make or break an art product.

However, the accelerating spiral of terror in Algeria brought the work to a virtual halt. The eight-week workshop planned in Algeria in 1994 became too risky for artists to attend. Then came the tragic assassination of the Algerian playwright Abdulkader Alloula in March 1994. In homage to Alloula, one of the most original artists from the South connected with «Utopia 93», I set up an inter-university project to produce his famous play *El Ajwaad* (1984). The play's epic structure allows a number of departments to work independently on individual stories. One scene has been presented by students from Germany at the annual «Performance Studies Conference» of New York University in Atlanta in April 1997.

The unabating cycle of terror in Algeria renders international solidarity with persecuted artists, there and elsewhere, not an act of charity but a necessity.

The art of conflict

Catherine Ugwu

Rather than discuss tradition and modernity in contemporary art or Western and non-Western artistic practices, I would like to focus on the distinction between art itself and the ways it is represented and interpreted. This is about cultural grounding, the positioning of difference, how aesthetic and cultural distinctions come into being, what they mean and to whom and how they are (and could be) represented, particularly in relation to Western cultural brokers. I hope to illustrate how concepts of conflict run through all agendas – from the conflictual nature of the issues at stake, to the negotiation and recognition of conflict necessary to resolve them.

Debates about representations of the 'other', issues of cultural diversity, empowerment and responsibility are not in themselves new and the cultural landscape of the world has shifted radically over the last decade. But such debates and shifts, although acknowledged, have unquestionably been marginalised within the dominant cultural infrastructures of Europe. But now, for reasons I will illustrate below, these can no longer be ignored by even the most powerful and influential of our institutions if they are to have a role and relevance, let alone survive, in the twenty-first century.

To dismantle the complexity of this debate I need to begin by considering notions of difference and the 'other' and questioning how meaning is constructed, interpreted and represented. Difference is a construct and only has significance in relation to something else – that something being what it is not. Notions of difference are intrinsic to the creation of meaning and the formation of culture, society and the self. For example, white people only define themselves as white in relation to black people and the British are only British because they can identify their difference from the 'other'. Cultural hegemonies develop on the defining, naming and ordering of difference. Ordering is the construct through which we impose meaning on our world. So when orders are disrupted and disturbed and the dominant cultural identity is destabilised it responds by naming and excluding an 'other'. Results of such closure of cultures to 'others' in contemporary society are as extreme as ethnic cleansing in Rwanda and the former Yugoslavia to the scarcity of black dancers in the Royal

Ballet Company. Depictions of the 'other' have been inscribed in the West by reducing them to simple and essential characteristics which are represented as fixed. Put simply this is stereotyping. However, the problematics of the stereotype in Western culture are more subtle and complex than this suggests, involving relationships of power which are cultural, economic and physical (for example the economic conditions which determine the complicity of black artists in inequitable cultural programmes – being forced to play the token black). It also involves fantasy (depicting as much what is imagined and projected as what is perceived as real) and fetishism (eroticised fascination for the 'other' that enables contradictory positions and experiences to co-exist). It should be said that fantasy and fetishism are currently held to be the most deeply rooted and insidious forms of racism and are believed to be the motivation behind the castrations by the lynch mobs of the Deep South.

Stereotyping therefore contributes to a collective sense of what belongs, what does not and what is different. To change the way that the 'other' is perceived and negotiated in our complex and hybrid world means the deconstruction of stereotypes and the pursuit of new strategies of representation. Some cultural strategies that have been employed to challenge stereotypical representations include the replacing of negative images with positive ones such as diversifying the range of racial representations and the complexity and hybridity of the black experience. Another strategy is what I now suggest to be the substitution of one stereotype for another. For example, the shift from the black man as 'savage' in Hollywood movies to the black man as 'gangsta' in the mainstream black film industry. This might re-appropriate images of black people in the movies but it does not necessarily subvert or overturn stereotypes. I believe that the impact of interrogating received stereotypes rather than creating new ones is a far more persuasive and influential strategy. That is, appropriating the stereotype itself and contesting it from within. Making it work against itself, exposing the dangerous terrain of fantasy and fetishism and embracing the conflict inherent in addressing these issues. Contemporary debates around representations of the black body – that contested site of meaning – have found a powerful voice in the work of Guillermo Gomez Pena, Coco Fusco, Rene Green, Robbie McCauley, Steve McQueen and Susan Lewis. They have all disrupted perceptions of the black body by taking the familiar and the stereotypical and deconstructing them at source. For example, Guillermo Gomez Pena and Coco Fusco's «Couple in the Cage» used the metaphor of the exhibition and classification of humans in twentieth-century museum culture to deconstruct the 'gaze' and the 'other'.

While Susan Lewis used her own naked body, in «Walking Tall» to defy expectations and perceptions of black female eroticism. These artists are not trying to make the unfamiliar familiar or acceptable but are acknowledging the complexity of difference and the ways in which received meanings can be destabilised and reconstructed. This goes to the heart of the matter and raises questions as to how do we, as cultural brokers, construct genuine representations of difference and resist attempts to make the unfamiliar understandable on our terms: terms predetermined by a limited frame of reference? And how do we as cultural brokers engage with the complexities of difference in a shifting cultural climate and changing world, a fluid world in which we must recognise that meaning is never fixed? Attitudes to the representation of difference and the 'other' are ever changing. Although issues of history, the legacy of empire and colonisation have always impacted on society and the contemporary art world, a number of other significant global and cultural shifts have come into play in recent years that demand to be incorporated into institutional policies and practices.

De-colonisation, globalization, cultural revivalism among indigenous people and the growing hybridity of identities have all contributed to the social and cultural shifts we are witnessing across Europe. Struggles around difference and the appearance of new identities in the political and artistic arenas have provoked powerful challenges to the dominant culture and have forced institutions, amongst others, to examine their motives and missions in studying the 'other', therefore undermining their roles as the keepers of the flame of universal knowledge. These questions of politics and ethics have impacted on the cultural landscape by demanding that institutions be accountable and responsible to the cultures they seek to represent.

Parallel to this there has been, in recent years, a growing consensus that there is no such thing as a universal truth and that knowledge is partial. Institutions, and what they aim to present and represent, can never be comprehensive or even objective but will always be selective, subjective and incomplete. If we accept that the presentation of artistic product is not, and can never be, an actual representation by one culture of another but the interpretation of one culture by another we are forced to examine how we approach the values and aesthetics of other societies. This has transformed the artistic arena and has forced cultural brokers to examine their ambiguous motivations for curating the work of any given artist. The need to manage such conflict has made our work morally and politically delicate even though our role remains a powerful social and cultural force.

The Western cultural institution

Within this context let us consider the Western cultural institution at the present moment. How institutions address the representation of other cultures and cultural difference itself is emerging as one of the key areas of debate of our times. It is the agenda for today's debate and is conveniently illustrated by my own participation as a black cultural broker in this debate.

Driven by the politics of consumption, institutions desperately need to retain and maintain their role and relevance. To do this they must engage with and appeal to a diversity of constituencies both with what they do and how they do it. This is not a matter of blindly putting on what they think people want to see or a matter of de-politicising work and pandering to the mediocre. Today's sophisticated and discerning audiences not only want to see reflections of the cultural shifts and the multiplicity of identities and experiences of European nation states but also demand to be challenged, inspired and tested. The power of the audience in contemporary culture cannot be underestimated. The ivory tower is a thing of the past and public image is all. This means that the public may in a way possibly not experienced previously, have some impact on institutional policies and programmes and can ultimately question their authority in a number of ways. This is not just a matter of market forces, there are many recent examples of ethical and political challenges to institutions. For example, the public debate about the highly charged issues of child abuse raised in relation to «Sensation», an exhibition of young British artists at the Royal Academy in London. It was also illustrated in the cries of cultural imperialism levelled at «Africa 95» in London – this was a celebration of the arts of the African continent, but it was generally felt that the programme had been predetermined by the agendas of white Western institutions.

Art institutions are systems of representation and, although contested sites, their role and received responsibilities still allows them to prescribe and proscribe meaning in keeping with specific discourses and perspectives. This may mean bestowing cultural value and interest in geographical terms (such as the «Japan Festival» in 1993 in London), or in relation to contemporary phenomena (the explosion of the African art market and its relationship to «Africa 95») or in response to political upheavals (such as the ICA's «Fortune Cookies» season considering the impact of the return of Hong Kong). In this sense the value and significance placed on much contemporary art is contrived, altering from one historical, cultural, social and political context to

another. This privileging of regional and geographical issues, which naively aspire to construct a national identity, enables curators and institutions to avoid the more important, but perplexing debate of post-colonialism. Alongside this, geographical surveys of this sort are more often than not facilitated and financially supported by governments, whose aim is to promote and encourage economic exchange and capital enterprise.

To survive, institutions must begin to recognise and respond to the forces that inform and impact on their selective processes. We must question the ways in which we construct difference and whether it is simply to suit our curatorial needs. We must question whether we are truly representing the work of an artist or whether we are using them as evidence to support a thesis. Are we essentialising artists and presuming that a work from another culture is the essence and spirit of that culture? And if so, are we fixing the 'other' and proposing a permanence and indisputably to the world which echoes the aims of the coloniser? Are we therefore presuming that institutional and curatorial practices are descriptive rather than interpretative activities? If we are we are in big trouble.

This has a particular urgency in relation to the representation of traditional work which is often presumed to be authentic in that it has survived the social, political and cultural forces of a particular context, for example Trinidadian carnival. For many this is perceived to be the genuine article, a ritual enshrined in Caribbean culture since the slave trade. What people often fail to realise is that carnival itself is an amalgam of many traditions, beliefs and practices which were suppressed and frequently destroyed by the transatlantic slave trade. Carnival has shifted and evolved in response to the political and social realities of the post-industrial world. Many choose to see it as an authentic spectacle but in doing so they negate its contemporary social and cultural significance.

Traditional and authentic practices may look the same but we must recognise that their meaning is never fixed. In relation to non-Western traditional practices this is particularly important as we often fail to acknowledge the impact of colonisation and de-colonisation on these cultures and the hybrid and syncretic cultural forms and products which have, and continue to be, the result of these political and social interruptions. We must distinguish between the physical presence and appearance of an artist, company or art object, which is usually undisputed and what it means, which continually changes.

Another example might be the work of dance artists. That they are a

dancer is universally undisputed, but what their practice means is contested depending on the context and what informs our collective and individual understanding. Our reading is dependent on other forces acting upon us, such as history, cultural values, social conditions, all of which are in a state of flux. Interpretation and evaluation are therefore ambiguous and complex terrains which can provoke other forms of conflict within institutional structures and critical discourses.

Having acknowledged the selectivity and partiality of our curatorial processes we must unpick the representational strategies we all currently deploy. Familiar examples include the texts we write on our press releases, publicity materials and catalogues. Contextual information simply cannot be purely descriptive or objective and the process of its creation is therefore not a simple one. Whatever the motivation our intention is to lead an imagined audience through a complex and difficult terrain. Inevitably therefore curators interpret, select, order and reconstruct meaning and this by implication determines certain interpretations. This is the act of making the unfamiliar familiar and the unknown understood that I referred to earlier and involves degrees of translation and prioritisation. This is a danger zone and must be monitored carefully, particularly in relation to a whole bunch of practical limitations such as the need to attract large audiences, to appease sponsors and funders and the usual problems of copy restrictions etc.

Alongside and often complimentary to the use of text is use of images which again are used to predetermine a particular reading of the work – the most cynical example is that grass skirts and smiling faces always suggest an exotic spectacle rather than choreographic artistry. The repeated use of these promotional tools has the cumulative effect of what at first seemed different becoming familiar. For example, the artist William Yang. William and his work could be identified and interpreted in a number of ways – he could be described as Chinese, Australian or both, he is a performer, a photographer, a writer and gay activist. His performance work embraces elements of theatre, biographical and autobiographical storytelling, portrait and landscape photography and deals with issues of sexuality, cultural identity, memory and family. All of these issues inform his work, but the publicity copy will constrain him and his work towards one or other of these points to make intelligible in a few words and in a particular context something very complex. When presented as part of the London «International Festival of Theatre» he was presented as a theatre maker, when presented at the ICA the following year he was contextualised as a Chinese Australian artist exploring

identity and when presented at the Walker Arts Centre in the USA he was represented as a gay artist confronting the Aids crisis. This inevitably guides the interpretation of him and his work and in some way effects its individuality by fixing and consolidating its meaning.

Issues of context are also critical when dealing with non-Western practices since this is work that is culturally, spatially and temporally displaced. We must address how we represent this journey of redefinition from its point of origin, to its relocation in the West. For example, the presentation of the *Seka Barong* of Singapadu by the London «International Festival of Theatre» in 1995. This ritual performance by forty members of the Balinese village of Singapadu is usually seen at traditional Balinese temple festivals. On this occasion it was located in the very formal and very Western Queen Elizabeth Hall at London's South Bank Centre. For me this was a displacement too far. Of course there are always constraints on context (funding and spatial limitations) but we must recognise them as part of our curatorial processes and find a way to effectively and honestly work within them and not just give in to them. Collaborations and dialogues with artists are central to this process.

Having recognised the selectivity of our curatorial processes and the ways in which we represent them, we now need to examine the power of the institution and what that means within contemporary culture. Within this I must distinguish between the perceived power of an individual curator and the power of the institution as a whole. Often there will inevitably be tensions and conflict between their ideals and values. There will also be tensions and power struggles between artists, individual curators and institutions. Although there will be inequity and an imbalance within these relationships, the recognition of power and its responsibilities must be at the centre of our operations. It is fine for curators to acknowledge their powerful role as an arbiter of meaning but often the relationship between the artist and the institution is never fully explored. For example the presentation by the Live Arts Department at the ICA of Ron Athey's piece «Four Scenes from a Harsh Life», which involved ritualistic scarification and blood letting. This was an incredibly important work which touched upon some of the most crucial debates of our time. We were aware that its presentation would be problematic and involved the negotiation of a number of issues from health and safety regulations to recent legal rulings in the UK that prohibited one person inflicting injury to another even if the act was consensual. All these concerns were discussed thoroughly with Ron and we all believed that although it was

possible to adhere to all health, safety and licensing issues in order to present the work with integrity it might be necessary to confront and challenge recent legal precedents. ICA Live Arts then decided that we had a responsibility to inform the ICA's director and board of the issues and implications the presentation of this work might raise. To our surprise the director and board, following legal advice, asked us to cut the sections of the piece that might possibly result in legal proceedings and criminal charges. This was an internal decision and as such was an act of self-censorship. In this case we were lucky and with the agreement of the artist the edited presentation did take place. However, this incident highlighted for all of us the conflicts between ideas of artistic freedom and institutional priorities.

Power is not just the weight of presence, it also relates to the power of knowledge that our institutions hold. By knowledge, I mean the right and ability to determine meaning and signify value within society. In this sense cultural events such as «Africa 95» are imbued with not only artistic significance but with an historical, social and political importance. The power of the institution and its curatorial policies are central to the development of critical discourses and again must be monitored carefully. In the sense that one possible role of an institution is to legitimise certain practices, they inform a body of critical discourse from a very specific context and according to particular visions and values. For example the almost complete invisibility of African art and performance art, to name but two from mainstream critical discourse only serves to illustrate the weight of the institution in determining our critical frameworks.

We have however, in recent years witnessed the emergence of significant new ideas in live practices, which by questioning traditional art form definitions have shaped and defined broader cultural and critical frameworks. A diversity of artists and a range of practices from theatre to installation, film to music, visual art to dance, popular culture to opera have crossed each others paths and blurred each others edges and in the process have opened up the possibilities of new time based forms unrestrained by tradition or convention. This process of developing new forms that relate to our times in the language of our times, offers artists, particularly those historically disenfranchised and marginalised within the dominant culture, new languages with which to articulate positions of difference and new forms to interrogate how we must begin to negotiate the hybridity of individual and collective identity, and experience the world at the end of the twentieth

century. The explosion of ideas and activities in artistic practices have contributed to the emergence of refreshing new voices and to an energy and sense of enquiry in contemporary culture and critical discourse that is proving to be highly influential.

The legitimisation of practices by institutions is also part of the process of increasing the visibility of marginalised artists and cultures. This in itself is also highly conflictual and problematic. It does not necessarily recognise the cultural and racial differences that are at the heart of Western aesthetic discourse and can result in the creation of new 'ghettos'. Being made visible is an ambiguous pleasure and often involves notions of appropriation and assimilation. The presumption by a great number of institutions and festivals that increasing the number of countries represented depicts a genuine form of internationalism is naive. The belief that equity in the cultural arena can be achieved by all nationalities being presented together, in equal numbers, is unsatisfactory, tokenistic and does not recognise historic relationships between 'the West and the Rest' (Hall, 1992, p. 306).

In recent years, cultural institutions and their curators have attempted to address some of these concerns. It is common for contemporary curatorial practice to attempt to detail the intricacy of the processes which lead to presentation, this year's «Documenta» catalogue being an exemplary example. There are efforts to provide and incorporate adequate information which demystifies and reflects on the role of the curator and details when works were selected, by whom, from where, for what purpose, what the originating culture was and what other aspects should be examined and highlighted to gain a more thorough understanding of what is being viewed. We must not however, presume that we, the curators, cover ourselves if we say this presentation is subjective, partial and incomprehensive; is this not possibly just the first stage of construction?

Parallel to this we must not allow the conflicting needs of the institution to sift out meaning by over-contextualising and over-explaining. We must find ways to leave room for individual responses and interpretations while providing appropriate frameworks.

Curators are consistently trying to unpick and understand the exact nature of the relationship between themselves and artists. For example, by exploring the extent to which specific interpersonal relationships between the curator, artist and community can be mapped into and incorporated in the

presentation and representation of work. Accepting their responsibilities, curators are also attempting to examine what possible continuing relationship there might and should be with the artists they present and represent. Alongside this, efforts are being made to include other voices to balance authorship and consider the ways in which artists can be involved as partners in presentation. For me it is critical that we all continue to devise ways to ensure the voices of artists have a significant presence in institutional processes.

This does not, however, sufficiently problematise the manner in which such presentations acquire meanings. It particularly fails to address the fact that culturally diverse performances, particularly from the South and East have more often than not entered Western institutions purely as the result of unequal relationships of power and suspect motivations. The questions of context can become far more problematic and conflictual than the above suggests. The attention to these issues could suggest artists are knowing agents and involved in an equitable partnership with curators. But to do so ignores the institution as the dominant party in this relationship. Again I cannot emphasise strongly enough how important it is for curators and institutions to, whether they like it or not, admit to and recognise their power.

Many non-Western contemporary artists are acutely aware of the need to negotiate a position in relation to the realities of their life, often as represented for them by their geographical location. For example, contemporary artists in Hong Kong are subject to the tensions between rejecting traditional Chinese cultural practices and a refusal to embrace the cultural imperialism of modernism. How are such artists remaining true to themselves and defining new aesthetics that exist somewhere between East and West? For me, it is in this space that we find the most relevant work in relationship to these debates. Looked at in this light has it occurred to Western institutions that non Western artists might have chosen to reject modernism as another form of European cultural imperialism that denies their identity?

Curating is a complicated and negotiated process and I hope I have touched upon some of the issues we must embrace in relation to Western and non-Western art and tradition versus modernity. We must encourage open and truthful dialogues, even though this can provoke debates in the public domain that we may not feel comfortable with. We hold public roles and are publicly accountable for our decisions and not just to our paymasters. I would like to suggest that the opening up of these debates and the exposure of the

institution can only help us as we curators gain an insight into our social responsibilities and moreover contribute to the development of the sectors and artists we represent. Furthermore, we must look to broaden the base of our institutions and examine who the decision makers are and how they have come to be so. We must begin to actively encourage the integration of other voices and other perspectives in the fabrics of our institutions.

I am a realist and I am aware that perfection is unattainable but that is no reason to despair. On the contrary, our fallibility leaves infinite scope for innovation, invention and improvement. An open institution that recognises fallibility and has begun to question itself is a superior form of organisation to a closed structure that claims to have found all the answers. I find myself at the end of this paper struggling to understand why the cultural arena can seem so ahead of the times and yet so behind. Perhaps what is most encouraging about the contemporary artistic arena is the hope it offers of a consciousness that is cultural rather than racial.

We have the capacity to acknowledge difference without fetishising it, and the freedom to represent without having to be representative – let's use it.

On diversity and meeting worlds

Valentin Yves Mudimbe

Two words, two concepts: difference and diversity. They seem transparent in our contemporary city. Yet, it is perhaps useful to problematise them by focusing on various aspects of their meaning, the fabric of languages expressing them and the slippery notion of identity sustaining them. These are means and tools that contribute to what might seem an excessive political pertinence that, sometimes, consecrate dubious essentialisms. Our meditation, in its imprudence and hesitations, dwells on a plea: on which basis could one dream for another horizon; one which, respecting the uniqueness of individualities and their existences, would magnify in our global city a somehow stronger universalist perspective?

Thus, difference and diversity. What they imply and signify today is a new configuration in which empiricities and individualities are conceived, apprehended and, through discrimination principles, in turn, define themselves in terms of what makes them 'other' vis-à-vis a reference. Thus, it is a separation which seems to indicate 'otherness' or a deviation thematised theoretically from something. Let us be more specific. Diversity calls to mind diverse and to diverge, as well as divert. They constitute a semantic web. Despite their etymological differences, diverge from the Latin *divergere* manifests originally the value of 'to extend', 'to incline,' 'to deflect' or 'to turn aside' and, by extension, might mean 'to be specific and differ in opinion, in form, or in behaviour'. Diverse has a root vert from the Latin *vertere*, 'to turn'; it leads to *diversus*, which means 'several or multiple kinds, forms', etc. Divert from the Latin *divertere* brings to mind the meaning of 'distraction, of deflection of a course of action' and, indeed, 'of objectives'. And, finally, diversity is from the Latin *diversitas*, or the fact of being 'unlike and presenting multiple aspects'; thus, in this sense, 'multiple forms'; or, simply, what is signified by singularities, 'in a given cultural context'. One could therefore say that diversity is a synonym of difference, and implies dissimilarity and variation. The most remarkable thing about these words and the concepts they bring to mind is that they suppose, at least, two entities or individualities, which are apprehended and compared through discrimination.

Difference, on the other hand, although presenting a number of values already noted, such as dissimilarity, modification, or distinctive features, etc., presents a particular dimension – that of 'finite distance' of use, for instance, in mathematics, where differences generally indicate the amount by which one quantity is greater than or less than others. To this value, one could add the rather complex meanings of expressions, such as 'split the difference', that has the meaning of 'making concessions' or 'compromise'; 'to cause, to create a difference' or 'to separate'. Then, one could, for analytical purposes, emphasise in the web of diversity the terms of a comparison coming from a distinction of entities; and, in that of difference, the reality of an objective distance between two different entities which, when necessary, can lead to tough compromises. This reference might or might not be there, explicit, in the society, in its symbolic tensions, or in their terms of ordinary and normative conceptualizations.

In the case of differences, the distance can easily be perceived in a number of levels or contexts with their own language and their own apprehension of what's out there. Concrete illustrations might be the following. The history of written African literature could be visualised in its originality and divergence from, let's say, European literature; and, in that distance, rightly or wrongly, it has been postulated as being different. Secondly, the same distinction could be made apropos the dynamics of African arts from avant-garde experiences in Europe in the nineteenth century to the popular paintings in contemporary Central Africa. A more telling example would be the Afrocentrist ideology and practices from Blyden through Du Bois to present-day African-Americans who rewrite the history of humankind from the viewpoint of the alienation of black peoples. In this example, diversity becomes a theme for both separation and distance, a symbol of a deviation that can be transcended in compromises only with difficulty. The United States, better than China or Japan for instance, actualises very well the tension and complementarity of the two concepts. Diversity, for better or worse, seems to play on a political theme. It sanctions cultural, racial, or religious variants and, in the name of both democracy and pluralism, pledges – or more exactly is submitted to – the necessity of a new 'melting pot' policy in which, to play on the title of a recent book by K. Anthony Appiah (Appiah, 1992), the United States founding fathers' mansion would testify to a new humanity and its varieties. On the other hand, administrative and social procedures in everyday life are likely to be intelligible only when linked to elaborate systems of managing peoples, their facticities and their origins, from biological, cultural, or socio-economic frameworks. These

techniques – be it in the administration of the immigration, the police, community institutions, political structures, and even university organisations – comment, in actuality, on the pressing concern that made them possible: how to master the differences circulating in the American city and the 'languages' expressing them?

Here, we should clarify the issue of contexts and languages. One could easily refer to both Paul Ricoeur's (Ricoeur, 1974) and Pierre Bourdieu's (Bourdieu, 1987) methodological grids concerning languages of knowledge. Let us distinguish three abstract levels.

There is, at least in principle, a language of everyday life and experience in all communities. This is a level we could call, after Michel de Certeau (De Certeau, 1984), an everyday life language. Its particularity is that it doesn't need a map as an introduction to its organisation or to the way it defines identities and their histories, as well as the differences implied by these histories. This is a language which is direct and, at the same time, doesn't need systematicity. It speaks to members of a community and, thus, can afford the luxury of being highly productive and, at the same time, can afford to be incoherent. At a different level, one could distinguish two competing languages: an objectivist language versus a phenomenological one. In terms of theoretical characteristics, the first one could be signified as essentially oriented towards objectivity, and the second as fundamentally organised from a subjective economy. Scientific discourses – be they in biology, in economics, or in linguistics – would tend to claim to be objectivist. They are organised on the basis of strict models which, when carefully used, might pretend to disclose the objective geography of what's there. They vary in space and, indeed, in time, even within the society that has produced them.

On the other side, phenomenology – by bracketing preconceptions and any knowledges anterior to the perception of the analyst – emphasises rigorous demands for the one perceiving and analysing. It appears that it doesn't acknowledge the objective quality of what's being there as a prerequisite for philosophical considerations The enterprise is enigmatic insofar as it links intimately the perceiver and the perceived. Indeed, after Paul Ricoeur, one could expect and imagine a different level – that of hermeneutics, for example – and accept to understand this language, after Foucault, as encapsulating the totality of knowledge and skills that allows one to be capable of reading meanings in a context or in a social formation. Hermeneutics would be, then, a possible locus of transcendence of diversities and differences; or, after Pierre Bourdieu, one could align this level with the

vision represented by a possible theory of theories – that is, a dimension of knowledge or a purpose of knowledge which, in a permanent way, will actualise a critical and perpetual evaluation of all other languages, differences, and significances.

The distinction of levels of languages might lead to a reflection about diversity of knowledges and truths, according to societies and historical periods as convincingly illustrated by traditional disciplines such as history of ideas or comparative anthropology. George Canguilhem has proved this fact beyond a doubt by studying the criteria of normality and those of abnormality (Canguilhem, 1991). In his *Discourse on Language* (in the *Appendix* to Foucault, 1972), Michel Foucault has a question that goes in the sense: 'People have often wondered how on earth nineteenth century botanists and biologists managed not to see the truth about Mendel's statements; but it was precisely because Mendel spoke of objects, employed methods and placed himself within a theoretical perspective totally alien to the biology of his time.' Today, such epistemological conflicts seem, on the one hand, to depend on the primacy of concepts of diversity and difference; and, on the other, witness to the fact that, even in objectivist disciplines inscribed in a specific cultural tradition, time could account for ruptures and, in this sense, shifts in disciplinary paradigms. This point illustrates and, in actuality, prescribes a lack of permanent unity and an affirmation that, if we can accept an essence for objects and empiricities, there is no such an essence already given insofar as individual humans, human communities and knowledges are concerned. In effect, to presuppose an essence preceding an existence for human beings could lead and, as a matter of fact, has led to extremely dangerous solipsisms, as in the case of Nazism positing a German essence or in the thinking of theorists of the slave trade ratiocinating on the African human nature. Today, a number of cultural theories are, unfortunately, still depending upon a dubious primacy of diversity and difference over a common human condition and oppose, for instance, a supposedly essential Negro emotion to the Greek reason. Even Léopold-Sédar Senghor, one of the most brilliant and generous theorists of universalism, seems to have lapsed in this strangeness, at least back in the late 1940s and throughout the 1950s. It confuses biology and culture, exactly as, with the most respectable intentions, some U.S. Afro-centrists, in the name of black diversity, are resurrecting the most naive and racist presuppositions of the nineteenth century in Europe. Indeed, it is surprising that Jean-Paul Sartre, in his *Black Orpheus* (1976), reflecting on the difference represented by black poetry in French, would have made the same

imprudence in celebrating Négritude and its androgeny. In this case, however, there is a major new perspective – which, in fact, is also there, but more discreet, in Senghor's commentaries on the Negro difference: Négritude would constitute a weak stage of a dialectical progression and, in this sense, would be dedicated to its own destruction and its metamorphosis in the synthesis represented by the revolution of the proletariat.

It's not my intention to conceive here a general critique of what languages of difference and diversity indicate, and less what they revolt against. What they signify is paradoxically, in a confusion of domains (mainly history, culture and biology), the expression of a project though this seems ambiguous and questionable. In any case, the objective promotes an essentialist identity and, as such, invites us to interrogate the concept. In effect, in human existence, the projection of an essence can emerge only from a will of becoming a work of art. As Sartre put it once, the ordinary temptation of the human is to become a god; a formula that Simone de Beauvoir translated magnificently in her *Ethics of Ambiguity* (1994) by stating that 'the passion of man is the reverse of that Christ: Human poses himself as human in order that God may be born'.

Referring to Sartre's *Being and Nothingness* and to the fact that, for him, it is from an existence that the human can make himself an essence, it is clear that we should face the unthinkable – that is, marking the impossibility of conceiving any identity in terms of an essence and preceding an existence; and thus, a meditation on what would seem irrational, since in its perception as well as in its formulation, it contradicts the logical principle of non-contradiction: the unhappiness of existing that hides, despite our dreams for rationality, the evidence that 'I am what I am not' and 'I am not what I am'.

This affirmation, which is not in disagreement with the truth of existing as well as with the main paradigms of the reigning discourses on humanism today, states simply an evidence: there is no way one's identity can be reduced to the simplicity of the mathematical equation, A is B. In order to clarify the point, let's imagine concrete reactions or responses to the question: 'Who are you?'

The individual asked that question, or even myself, would tend to begin by a recitation. In the narrative, the person would be temporalising one's self: naming an origin, situating oneself from that origin (parents, grandparents, education, etc.) and, thus, literally defining oneself from behind. Thus the paradox: to the question in the present 'Who are you?', the response historicises and temporalises existence by reducing it to the status of an object, a dated

object. The past takes on a status of a being-in-itself, a thing, the way a table is a table; and the narrator chooses elements to be presented as constitutive of the being. In this first moment, what is experienced is, in reality, a failure of apprehending oneself as a totality. The past has been reduced to a being-in-itself, and the present with its promises is overlooked. A second moment comes on: in effect, one can question the person in meditation about this failure and its mysteries. Is it possible to liberate oneself from this impossible horizon in which you are imprisoned or, more exactly, what's happening to you? The response is easy. It speaks about a route which is also one leading to a failure. What's happening is that the I, reflecting on its identity, doesn't witness the epiphany of any perfection. What occurs in the course of this intellectual exploration is a radical tension: the reflecting I does not coincide with the I reflected upon. The subject working on understanding its identity is, at the same time, the object to be understood and identified; thus, there is no way of bringing to light a unique, visible and complete identity. Against the experience of this second failure, a desperate one can always claim that I am a Self – perhaps divided, but I am a Self in the objective.

Yet, the quotidian experience indicates the Self as a being-for-others exactly as the other is a being-for-me. For concrete illustration, the first lines of book II of de Beauvoir's *The Second Sex* (1974) could be used and extended to anyone. She notes that 'one is not born, but rather becomes, a woman. No biological, psychological, or economic fate determines the figure that the human female presents in society'; and also: 'only the intervention of someone else can establish an individual as an "other".' Woman, female in these statements could easily be replaced by black, yellow, white, etc., and even by such concepts as Christian, Jewish, or whatever other qualifier postulating any specific 'nature'. In implying the possibility of an already given and absolutely stable identity, the qualifiers; or more exactly, these signifiers proclaim simultaneously something else: the being immersed in a selfhood is for me the 'other' who is possibly my alter ego and, consequently, the whole operation of pigeonholing identities might be the best negation of any absolute alterity. That it has a political function would be both its pertinent foundation and justification. The United States exemplifies this. Its complex cultural, racial, religious, sexual grids are objects of debates and bitter negotiations within the social relations of production, as well as in the organisation of political power.

Indeed, a more rigorous exegesis of the concept of identity would reveal, as noted by Jacques Derrida, commenting on 'violence and metaphysics'

(Derrida, 1978) the urgency of separating notions often confused in polemics about identity, namely: identity and ipseity, Same and Ego or idem and ipse. But that is a different issue. Our purpose is, simply, to emphasise a fact: the impossibility of apprehending oneself as a fixed identity. And this has an implication which, in its banality, indicates the beauty of conceiving oneself as a project in the complexity of becoming a perfection. Only corpses have a firm and definitive identity.

The last failure reinforces an idea from Heidegger: to be, to exist, is to perceive oneself as being-in-the-world, as being-with-others. Does not this gross acknowledgement constitute also a challenge about identities in general? Let us afford a contemporary echo. Introducing the special number of *Dédale* on post-colonialism (1997) Abdelwahab Meddeb, director of the publication, chose to face a taboo issue: the Western aporia which, in the past, justified the Occidental universal mission, today, seems to signify and reflect its own contrivances. A strong moment, in Meddeb's argument, indicts directly post-colonial thinkers and addresses a bad usage of this crisis that could lead to a universal reawakening. Maddeb writes: 'Whatever may be the will to reappropriate (a past), the integral recovery of sovereignty identifies itself with a chosen chimera. The desire to rediscover a lost perfection does not differ from a mourning, nor from discovering one's orphanage. The refusal to think of a politics based on the economy of remains and their useful supplement suscitates carnivorous acts which bring nothing to a fantasy for substitution. Such a lack would exacerbate only a sacrificial crisis. Indeed, such is the drift in which agents and supporters of fundamentalism choose to lose themselves, not knowing that their gesture is an ultimate effect of the Western post-colonial effect' (my translation).

The main issue could be that, against the extreme romanticism prescribed by certain mythologies of diversity and difference today, a real challenge might be unfolding: a question about the universality of such a failure, on the one hand; and that of the finitude of any human existence, on the other. Should we follow carefully Sartre, we can label its eruption in the stony reality of a common original sin. As Sartre put it in *Being and Nothingness*, a propos our concrete relations with others: 'Whatever our acts might be, in fact, we must accomplish them in a world where there are already others and where I am de trop (superfluous) in relation to others. It is from this singular situation that the notion of guilt and of sin seem to be derived. It is before the 'other' that I am guilty. I am guilty first when, beneath the other's look, I experience my

alienation and my nakedness as a fall from grace which I must assume. This is the meaning of the famous line from the Scripture: "They knew that they were naked." Again, I am guilty when, in turn, I look at the 'other' because, by the very fact of my own self-assertion, I constitute him as an object and as an instrument; and I cause him to experience that same alienation which he must now assume. Thus, original sin is my upsurge in a world where there are others; and whatever might be my future relations with others, these relations will be only variations on the original theme of my guilt.' This common and universal experience of alienation, instead of separating us through utopias of diversities and differences, constitutes the very basis of a universal human condition. Indeed, it is always possible, using or manipulating many cultural backgrounds, to overimpose on it a flow of historical and cultural traces that divide or unite. Thus, for example, from a strictly African viewpoint, one could, in the name of difference, stabilise prescriptions made for naming 'classical' types of 'otherness' vis-à-vis the West and their most recent discursive negations. For example, in history, the qualifications of African societies as a-historical experiences that could be but only objects of anthropology is first questioned in Georges Balandier's work as exemplified by his *Sociologie des Brazzavilles Noires* (1955) and then amplified in more subsequent studies by, for instance, Claude Meillassoux and Luc de Heusch in *Anthropologie Économique des Gouro de la Côte d'Ivoire* (1964) and *Le Roi Ivre* (1972). In the same vein, from the presuppositions of evolutionism that marginalised Africa at the genesis of history, one may face today a counter-discourse in the monumental histories of the continent issued by the Cambridge and UNESCO volumes; or more telling, the transformation that takes place from Lévy-Bruhl's *The Notebooks on Primitive Mentality* (1975) to Placide Tempel's *Bantu Philosophy* (1959), Paulin Hountondji's *African Philosophy: Myth and Reality* (1983) and D.A. Masolo's *African Philosophy in Search of Identity* (1994). In the first phase, the utopia of an ethnocentric perspective negated a culture and its achievement in the name of its difference. Ad montem and ad valem, the recognition of a form and a meaning of a human experience might sanction the dangerous immobility of a curious essence. The examples used signify, at least in principle, the plural dimension of our contemporary perspective looking for the possibility of a valid universal method. The new modes of apprehending identities and differences impose themselves as an invitation for negotiating differences in order to promote a sane diversity by clearly distinguishing the concept of space from that of place, and temporalising them rigorously. The space is a rational and

basic organisation from which signifying practices can produce a place. Or, to quote Michel de Certeau, 'A place (lieu) is the order (of whatever kind) in accord with which elements are distributed in relationships of co-existence. It, thus, excludes the possibility of two things being in the same locus (place).' If space is 'a geography constituted by dynamic elements which meet, intersect, unite, cross each other or diverge', it is obviously a terrain of differences or diversities and nothing, absolutely nothing, prevents it from metamorphosizing into a place of universal habitability; and, in this sense, if well used and in a critical good faith, cannot it be, in its distortions, a source for the liberation of experimental universal paradigms?

My reasoning is simple and designates transformations of representations; or, to use a concrete example from the socialisation of the Cogito, the I might move to the community as a subject and even conceive the human race as a subject. These different moves are, in their own right, variations of a fundamental mode of being and existing, witnessing to routinised propositions: 1) we are all, individually and collectively, an endangered species; 2) individually as well as collectively, despite our diversity and difference, we inhabit a history, a language, and a tradition as superfluous existences; and 3) as individuals and collectivities, our project is to become works of art.

One of the most powerful temptations today against universalism resides in the invocation of economic inequalities in our global world. Methods do exist that could manage such a predicament beyond our non-comparable desires. The objective here should not be to establish lazy equivalences but to understand variations. The Marxist grid, which to my knowledge hasn't been disqualified by the failure of communism, could be used as a possible epistemological tool. No one has demonstrated convincingly that we should discard absolutely its lessons as cadres from which to analyse and understand the variety and diversity of historical social formations. More specifically, it might be a new pertinent to think in terms of a framework of interpretation that would distinguish, on the one hand, an economic space worked out by a dialectic between the processes of production and the social relations of production. And, on the other hand, in the superstructure of any social formation, firstly, the political structure qualified by a dialectic between an organisation of production and a political discourse; and, secondly, the ideological space in which one could distinguish the reciprocal insertion of speculative discursive practices and an intellectual configuration. In brief, about diversity and difference, our present day predicament is that we have rightly accepted, against the evolutionary dogmas of yesterday, a perspective

more respective of empiricities, individualities, and communities. These are given and perceived in their own right as constituting systems with their own rules and their own norms. That they have a particular historicity is not a question. It's not comparison that gives them their original existence. It is not even comparison which founds the rationality of their spaces. Finally, comparison so far has not really posited them vis-à-vis the privileges of the experience of their own shadow. Their identity is a process of becoming in its own right, in negotiations with other processes, other experiences that might be their doubles; or, more precisely, their question – an important question about their being-in-the-world. Its most challenging precariousness resides, and paradoxically, in the logic of the pluralising and unifying method which, in this century, has re-valorised the old Kantian question mark: 'Was ist der Mensch?'

Double standards or single-mindedness?

Michaël Zeeman

It was a slightly discomforting experience, last summer, after the book had made its jubilant tour around the globe, starting in India and quickly jumping over to Western Europe, Holland included, to read the review that *The New York Review of Books* had at last printed of Arundhati Roy's breathtaking novel *The God of Small Things*. Reading the novel had in its own way, for most of us, both professional readers and critics or just devoted, open-minded readers, already been a discomforting act in itself, but compared to the result of the comparatively long period of time the *New York Review*'s critic took to balance and formulate his opinion, the uneasiness the ordinary reader probably experienced, was a relatively mild form of that state of mind.

Ordinarily, *The New York Review*, known globally for the quality of its articles and the elaborate nature of its opinions, is never afraid to express its opinions on the books that dominate public debate in a certain period. But this time, somehow, it appeared to hesitate. Even now, in July 1997, the literary critic who had been invited for the task, seemed, although he had clearly done his job and had obviously taken the time to find the required expressions, not to have made up his mind. This was an unusual style of literary criticism, and even more unusual for the paper in which he was expressing it. His piece, although it contained an adequate description of the novel's contents and offered a clear overview of the novel's merits and its relative weaknesses – or failures – seemed in the end to forget to offer a conclusion. It was a series of glosses, of reflections as well as notes on the general nature of criticism, but it somehow did not reach a conclusion. Although the reader of *The New York Review of Books* learned a little about the idea of Arundhati Roy's *The God of Small Things*, about the various plots of the stories and about the result of Roy's obvious intentions, the piece shed no light on what the critic thought of the novel.

Uncharacteristically, I was not really surprised. The Dutch newspaper for which I write had had its own problems with the book, as it has in the past and still has when formulating a standpoint on many books comparable to Roy's

Booker-prize-winning novel. Or on a more down-to-earth level, when looking for someone to accept the dire task of formulating a critical view, any at all, on behalf of the book-review editors. In that state of confusion, it is not alone – its concerns are not limited to the present Dutch situation or to the peculiar conditions of literary criticism of foreign writing, in translation or in the original language, of the Western world at large. The professional world of criticism, outside the strictly academic periodicals, has, here as much as in France, England or America, encountered the same problematic minefield when confronted with some relatively new varieties of contemporary literature. It is not without reason that a paper of note like the French daily *Le Monde* introduced a special column in its Friday books-section, *Le Monde des Livres*, to function as a container for any sort of literature that would not find its natural, that is culturally well organised and historically superbly defined place elsewhere on its much lauded pages. The same applies to the French monthly *Magazine Litteraire*, which is able to review literature from whatever origins and devotes specials to, for example, literature and post-structuralist philosophy or to literature from Lebanon, but has great trouble reviewing important literature from, say, contemporary India or Africa.

China and Japan do not present problems, certainly in these French critical columns. Nor is Africa problematic, as long as it is Northern Africa, the Arabic world - here my 'culturally well-organised' and 'historically superbly defined' demarcation lines are highly useful. Even if a novel from Africa or India does not stand up to the standards of literary appreciation of the periodical's editors the problem seems to be less tangible than in the case of the *New York Review*'s exemplary treatment of *The God of Small Things*. Merciless opinions clearly bother less about their own motives for their opinion than hesitant or favourable ones.

These comments about criteria and the uneasiness associated with their expression in this field, may be seen in a much wider perspective; in talking about the discomforting effect a certain genre in contemporary literature has on editors, I would emphasise its wider effect, affecting as much the choice itself as the choice of critic. It is best illustrated by an example that is as revealing as it is endearing. When the editor of the *Times Literary Supplement* (TLS) – while different in outlook and ambition nevertheless easily comparable in status and authority to the *New York Review* - had, in September 1995, to select a critic to review Salman Rushdie's long awaited major new novel, *The Moor's Last Sigh*, he made a choice that may, in this context, be considered characteristic.

The horns of the dilemma on which the editor of the TLS painfully sat, are easily identified. Salman Rushdie's last major novel till then – if we forget about *Haroun and the Sea of Stories*, which is a sort of children's book and more of a collection of short stories than a novel, and if we also forget *East West* which is not really a novel by any standard, and certainly not a 'big novel' – had been *The Satanic Verses* – and with what disastrous effect! Everybody is aware of the immense problems it created for its author, for an impressive part of its potential readership and, moreover, for international relations on a much wider terrain than the one of literature or culture alone, and of the deep questions that consequently arose about the liberty of the writer, the scope of what is known in America as the First Amendment – which almost sounds like the First Commandment, which in a different culture was so painfully offended by what Rushdie wrote, whereas the reaction to his writing directly boomeranged into the spirit of that First Amendment.

The Satanic Verses became much more satanic than its author had ever intended, however diabolical his character where the challenge of fixed opinions is at stake. Its effect not only endangered the relations between Europe and the Islamic world, or mutual relations between European or Islamic countries themselves, but it was, in the discussion that followed the fierce review that Rushdie got from Baghdad, a review that became a matter of life and death and, deplorably, remains so today, also the source of painful new questions, questions that touched the fundamental viewpoints of writing, criticising, reviewing and attacking in what we call the civilised world. Books and writing were the issue, yes – but also behaviour and reception, perspective and its consequences.

In taking on Rushdie's new book, the TLS editor had a depressingly difficult task. Readers from around the globe were, evidently, watching his every move: the choice he made for the person to review Salman Rushdie's new novel, would be a political as well a literary-political decision if ever there was one.

He chose the Turkish writer Orhan Pamuk, and since Pamuk is a good friend of mine, his name above the review as I took the issue of the TLS out of its hygienic, anti-sceptic 'French letter', made me laugh and shiver – how would he, Pamuk, have dealt with the extraordinary invitation that had landed on his desk?

This is not the place to discuss the merits of his book review, or those of the TLS, neither is it the place to discuss the variety of receptions Salman Rushdie's book received. The issue is the choice of the well-known Turkish

novelist Orhan Pamuk, who is a best selling and intellectually highly acclaimed author in Turkey but who has also been favourably met in the American world and the other English speaking countries of the Western world, as the reviewer. Pamuk is a son of Turkey, whose family comes from Turkey's Asiatic western coast but which for the last two generations has been living in Istanbul. He, with the natural sensitivity that made him the gifted writer he is today, feels attached both to the rural background of his ancestors in Turkey's Asiatic mainland, and to the urban society of Istanbul in which his parents met and in which he was born and brought up. His professional surroundings are, in this context, spectacular: he usually works, as many Istanbul artists and intellectuals do during the hot months of the summer, on an island in the Bosporus or the Dardanella, literally between East and West, Europe on his one side, Asia on his other. In between is only the narrow bridge that nowadays connects European Istanbul with its Asiatic quarters, or, on a wider scale, Europe with Asia. It is almost symbolic of Pamuk's writing and although I am not at all sure that the editor of the TLS really was aware of the physical conditions under which Pamuk would write his review, it is almost as if he finally chose this critic deliberately on purely geographical grounds. Instead of his name he should have printed a map with the position of his writing cabin above the article.

Problem solved, or at least, delegated.

But, alas, no, it was not.

The real problem is, of course, only actualised in the difficulties of choice and selection I have sketched. Selection of reviewable books is one thing, and the choice for an adequate reviewer may be an important second – the real issue is the confusion which is aroused by a certain part of contemporary literature. That is not a childish, a simple or a naive confusion, far from it. It is not the confusion that is raised by a limited scope of reviewers or readers, lacking information or training, missing specialised knowledge or sheer incompetence on the side of editors or critics – although I know of obvious examples of these mental states that have effected the silence that has fallen for so long on much of the non-original English literature in the English speaking world, as was the case in France with the similarly strange new literature flooding into Paris.

But the landscape of literature, in our day, even in its conventionally jingoistic areas, has changed so deeply, as have the staffs of critical periodicals, all on the basis of an even earlier deep change, namely that of the literary faculties of the universities, changes that are sooner practical in their

origins than ideological, changes namely, that were provoked by a developing student population, the consequence of migration and a changing population, that an explanation in terms of naivity of critics and editors is too limited in its scope.

Editors are, in growing numbers, at least children of mixed cultures, and however well-bred in universities of their new countries, university is, as we all know, not the only mother of a person's world view and knowledge. The changes in literature, conveniently caught by the English headline 'the Empire strikes back', have their complements in literary criticism, editing and publishing. France has its North-African writers, bringing in a whole new blend of French literature, revitalising it, as it were, where England has seen its literature deeply changed ever since V.S. Naipaul was considered the most important living author on its shores, and Romesh Gunesekera, Hanif Kureishi, Abdulrazak Gurnah and finally Salman Rushdie himself are the jewels in the crown of contemporary British fiction, no longer ornamenting the British literary family, but dominating it.

I sometimes think that the recent revival of Scottish and Welsh literature within the mainland of English letters is a direct consequence of that 'Empire strikes back' phenomenon: after far away India and Sri Lanka, the Caribbean and English speaking Egypt, South Africa and East Africa indeed struck back, the much nearer and much more timid, that is: culturally intimidated peoples of the northern and western outskirts of the British Isles found the courage to underline their own, individual identity. It is at least rather strange that the so-called Scottish renaissance of recent times directly follows the Indian one of the 1980s.

No, the critical difficulties are not a matter of ignorance or epistemological limitations, of the traditional narrow-mindedness or myopia of the hearts and eyes of those who direct the cultural discourse. The real issue lies much more in the heart of our concept of literature, of literary development and artistic progress, that is touched by the recent developments in literature – or even, not touched, but missed in such a spectacular manner, that it makes everybody who has been using that concept of literature and literary development – by now I no longer dare stipulate its progressive character without further explanation – feel slightly uneasy.

That is, again, the uneasiness of the absent verdict in the high standard reviews of Roy's novel – and it is, moreover, an uneasiness that is no longer shared by the reading public, or at least, not by a large section of that reading public: Rushdie's novel became a world-wide success, and not only for its

journalistic attraction, since it is by no means an easy read, and although there is no real difficulty in pointing out the weaknesses of Roy's novel – these are, especially in the beginning of the book, so obvious that any reader could do it: here is an author who develops in the course of writing her book – its readership was easily able to take the barrier.

The conventional idea of literary development has always been able to answer the surprises dished out by new literature by simply defining this development in terms of the new – in progressive terms. The typical twentieth-century idea of artistic development, be it in the visual arts, music or in writing, is the idea of the avant-garde. Art regularly brings in something new, new in style, treatment or outlook: arts adds – and it may be that the introduction or addition of something new is shocking, after the nineteenth-century shocks we can no longer really be shocked by anything on score, paper or canvas. We are prepared for the shock, we expect the avant-garde – and we only worry when to much time passes without the noisy declaration of some group of artists of something new. Even a Scottish renaissance will do: a renaissance is something we know and know about, and why shouldn't Scotland turn history upside down and have its renaissance ages after waving its archetypal Scottish Enlightenment?

Our expectation is still satisfied.

It is a typical product of the romantic view of the arts and their contribution, in this case modified by the fruits of artistic modernism – the modernism, that is, that so intensely changed the outlook on the arts in the English speaking countries and had a far more logical or even natural place in the development of the continental cultures of Europe. I am not going to split up the continental and insular concepts of modernism in all its variety and intricacy, but stress the open-endedness of its general drift. Art has to develop, something new is a natural consequence of that development – so let us look out for something new. If Virginia Woolf concentrates on the onomatopoeia in her *The Waves*, or T.S. Eliot includes half of the existing world literature in his seemingly original verse of the *Waste Land* – let it be and let us call it modern. Modernist culture, or rather: the cultural philosophy of modernism had the immense character to swallow irregularities and digest them into neat modernist ideas, however self indulgent they may seem. In literature the field could include Joyce's *Finnegans Wake* and some of modernism's strong defenders contentedly point out that even post-modernism must be a form of modernism, since it doesn't even have its own catch phrase.

But how on earth can a cultural philosophy, a much varied school of

criticism, able to cope with Joyce's experiments and accommodate Beckett's experimental prose which cast doubt on the fundamental characteristics of language and communication, the founding elements at least of any literature, fall into miserable self-doubt when confronted with a relatively and at least comparatively conventional novel such as that of Roy, *The God of Small Things*? Here is a story with a beginning and an end, however sad, a story in plain language, with a structure that, although no longer strictly chronological, is nevertheless not really unusual in twentieth-century, post-cinematic literature, a structure of flash backs and flash forwards, placed in a style of inner monologue, magical realism, melody and poetic description.

That is, I believe, all a consequence of the specific use of conventional storytelling techniques used in this type of novel-writing, the sort of techniques that add to the conventional image of story telling, however open ended or progressive. There is something strange in that technique and its application in what may roughly be seen as a variation of the Western novel, although on closer inspection it is no such thing. A comparison may clarify the point. Twenty-five years ago the main modern theatre makers, the avant-garde of Paris, Berlin and London, suddenly discovered the Eastern tradition. Indian and Japanese theatre, with their age-old folkloristic traditions: a highly fruitful source for renewal of the Western avant-gardist theatre. The avant-garde sought to renew itself in the deepest tradition.

Apart from the work of Peter Brook and the continuing experiment of Ariane Mnouchkine's Parisian «Théâtre du Soleil», the incorporation failed. In the best cases the energetic journey of theatre makers to the East influenced the set of stage images of our theatre and formed a lasting addition to the canon of selected plays at festivals. However, they present a juxtaposition, an ostensible presentation of what is essentially contradictory, of non-digestability – *thereby emphasising the limits of modernism*. A happy marriage here is no longer a lasting one, moreover it is a marriage without consequences, a barren womb and a waste land.

This is the case in the genre of contemporary literature and its criticism: it is distracting itself from the domain of a modernist reading and interpretation or evaluation, even if that modernist reading and all that is post-modern. The idea that literature develops moving backwards through an incorporation, while it has had its counterparts in European literature itself, conflicts with the concept of artistic development.

Of course we have seen this kind of development in Western, European literature. Writers from the nineteenth century have incorporated their own

legacies of folk literature, myths, sagas and folkloristic poetic styles, where twentieth-century and even contemporary writers from mainly eastern or southeastern Europe have used their folkloristic traditions. The way the Albanian writer Rexhep Quosha, for example, has used age-old Albanian oral literary techniques to tell his dramatic stories is a good illustration of my point. But in both instances that is an example of modernist inclusion – of addition in order to progress. It is not what Arundhati Roy and Salman Rushdie, to name just two impressive examples, are doing. They are changing literature in a much more fundamental manner than mere enlargement ever would do.

Questions of modernisation
and Indian cinema

Paul Willemen

When Ashish Rajadhyaksha, one of India's leading film critics and historians, and I began compiling our *Encyclopaedia of Indian Cinema*, we started from the assumption that it was wrong to approach India's mainstream cinemas, of which the Hindi cinema made mainly in Mumbai (Bombay) is the best known, according to the critical and theoretical standards derived from Euro-American film cultures. We rejected the notion that Western film criticism had elaborated a universal standard against which all cinemas were to be measured. Instead, we took the view that films were shaped by the cultural and historical constellations within which and for which they were made.

At the same time, we refused another commonly adopted strategy: to look for the specificity of Indian cinema precisely in the areas where it appeared to diverge from the conventions of Euro-American cinema. When one applies the insights of Western film theory, with its emphasis on realism and subjectivity, to Indian films, it quickly becomes clear that Western film theory is not capable of dealing adequately with the peculiarities of Indian cinema: demarcations between the sacred and the profane, that is to say, between the real and the supernatural are deemed irrelevant or are marked differently, so that the Western category of realism, itself a compromise formation between declining aristocratic and rising bourgeois cultures at a time when the organised working class first makes its appearance on the political map of Europe, cannot operate in the way Euro-American aesthetics assumes realism to function; the assumptions underpinning Western cinema's notion of spatial and psychological coherence do not apply or, at least, do not apply in the same way, so that spatial relations in a scene may not be as fragmented or disjointed as Western aesthetics would claim them to be; although there is much singing and dancing in Indian films, they cannot be regarded as forming part of the musical genre familiar from Hollywood, mainly because the genres in Indian cinema are different from Euro-American film genres and cannot be distinguished by the same criteria.

However, it would be a mistake to identify the specificity of Indian cinema precisely with the 'blind spots' of Western cultural theory: Indian cinema cannot be reduced to its differences from Western aesthetic theories. Instead of positively valuing, on principle, the areas of Indian cinema which elude or resist Western theory, Ashish and I opted to question the adequacy of Western film theories as such: if those theories cannot deal with the historical and cultural dimensions of Indian cinema, how much confidence can one have in their ability to deal with the historical and cultural aspects of the films made in Europe or in the USA? During one of our endless arguments about aesthetic and narrative strategies deployed in Indian films, arguments that also often revolved around the description of the narrator's position and the kinds of 'looking' positions associated with Indian cinematic narratives, Ashish objected to one of my formulations pointing out that I was arguing from a position accustomed to three hundred years of individualist philosophy, whereas in India, these notions had arrived very recently, with colonial rule, and could not be taken for granted.

Ashish's remark prompted me to reflect on the way Western notions of aesthetics and storytelling presuppose and take for granted the notion of individual subjectivity introduced during the Renaissance (with the invention of perspective) and given a philosophical formulation in the subsequent centuries by Descartes, Spinoza and others. The American cultural theorist Martin Jay even coined the phrase Cartesian perspectivism to describe the link between the aesthetic and the philosophical movements over a two-hundred-year period from the Italian Renaissance to seventeenth-century philosophy, when capitalism and the bourgeoisie were increasingly challenging the political as well as the cultural-ideological rule of the feudal aristocracy (leading to the eventual triumph of the bourgeoisie and capitalism in the middle of the twentieth century at the price of two world wars), a period that resulted in the programme enounced by 'the enlightenment', a programme which, incidentally, still awaits its realisation.

Indian cinema would then be a cultural practice in which the pre-capitalist and the (colonially induced) capitalist cultural formations continue to coexist in different measures. Indian films address these tensions and conflicts, necessarily bearing the imprint of the long and convoluted histories of the subcontinent, and the contradictions they inflict upon the way Indian people experience their lives. Historically, melodrama fulfilled a similar function in Western societies: they tell of the conflicts that arise when a rising bourgeoisie,

with its moral and cultural values, comes into conflict with a declining aristocracy. Remember that melodrama was a genre that came to prominence at the time of the French Revolution at the end of the eighteenth century. The pre-capitalist, pre-Renaissance aesthetic aspects which seem most relevant in this context were discussed by Michael McKeon in a wonderful book, *The Origins of the English Novel* (1987).

Briefly, pre-Renaissance aesthetics in the West assumed that the order of things, the world, had been designed by God and was revealed in the sacred texts as known and interpreted by the professional guardians of ideology: the clergy. Moreover, the social order was rigorously stratified into status divisions, and to each caste-estate, a number of essential characteristics were attributed: the king, at the top of the status hierarchy, was deemed also to be the richest, the wisest, the most beautiful, the strongest, and so on. The nobility, the clergy and the other castes were equally rigidly defined down to the non-people called, in French, villains. Legitimate identity was bestowed by people from a higher caste on those of the lower orders.

Contrary to the innovation introduced by perspective of identifying a unique point of view structure occupied by the individual (mirroring the vanishing point which still remained identified as God's point of view), in feudal society legitimacy was bestowed upon individuals when they appeared in the field of vision of an authority: the ritual of the 'audience' granted by authorities, the practice of appearing as petitioners before noblemen.

Many of the pre-capitalist ideological elements supposedly displaced by the Renaissance and the Enlightenment have in fact remained very much a part of our own cultures and can be seen to operate not only in films, but also in social rituals (the public appearances of royalty, star worship, governmental practices, art exhibitions, etc.). The reliance on and the belief in a revealed world (underpinning the valuation of realist representations) and the value-frameworks associated with status hierarchies have persisted alongside the modernising emphasis on the notion of individuality as required by capitalist legality and political aspirations and strategies.

Two brief examples may clarify my point. The persistence of films telling the stories of Frankenstein and Dracula, and the fact that the films about both characters tend to be made at the same time, as is demonstrated by the Universal horror films of the early 1930s and the Hammer films of the late 1950s, suggests that they negotiate a similar set of tensions. However, they do so from opposite sides of an imaginary line: whereas the Frankenstein story

tells of the threat to a religiously modelled world posed by a rational-scientific future (the Baron tampers with God's prerogatives), the Dracula story tells of a religiously modelled world that should have passed but is not dead yet (the Count and his world have no place in the era of scientific rationalism, but there he is ...). The films are about the same issue: the transition from a religious-status society to the world of Cartesian (or should one say, Spinozan) reason.

The second example of the continued relevance of the 'old corruption' in the 'modern' world, is the evolution of the melodrama. Initially, the kind of melodrama elaborated during the French Revolution – a significant marker in itself – concerned itself with, among other things, the drama of lineage: noblemen who betrayed the values of their status and 'ordinary heroes' who often turned out to be of noble descent. The problem posed by these dramas and the novelistic forms that flowed from them, was that it was no longer sufficient to know a person's social status (family line) to be able to tell what kind of person one was dealing with, but the values associated with 'status' did not change: the aspiration remained that of being 'noble'. In narrative terms, this took the form of stories of 'status inconsistency'. More recent melodrama, especially that produced in Hollywood, dramatises the same conflict, but in slightly modified terms, also focusing on the figure of those who are supposed to 'reproduce' people as well as the social order, women. In the Hollywood melodrama, the problem has become a generational conflict: the parents 'know' who is an appropriate mate for their daughter because they can tell by 'traditional' means, that is to say, they understand the importance of 'social identities' as embodied by the status and reputation of a family. However, sons and daughters, already more individualised, transgress the rules of status societies and insist on picking a 'wrong' mate. The solution to this drama may be presented in favour of individual choice or, on the other hand, individual choice may be presented as the source of tragedy. In either case, what is at stake is a negotiation between two sets of cultural-historical social forms, understood as alternative options.

This kind of conflict is given a further turn of the screw in contemporary comedy romances, usually set in New York or Los Angeles: two individuals who know nothing about each other except that they are potential mates, meet. Here, the frenetic comedy barely hides the sense of underlying panic at the absence of 'traditional knowledge'. Implicitly, the horrors of parental interference and oppression have turned into a regretted absence as the lovers embark upon a nightmarish journey of mutual discovery, threatened at each

turn by yet another unsuspected piece of information about their partner's history and character. The medieval, lineage-dominated world organised according to a status hierarchy may seem distant from *When Harry Met Sally* (Rob Reiner, 1989) or *Pretty Woman* (Garry Marshall, 1990), but without its shadowy presence, the films simply could not exist. In effect, these comedies are modulations of melodramas, rehearsing and negotiation the coexistence of (at least) two conflicting ideologies belonging to radically different historical epochs.

Modernisation can then be measured according to the way a cultural text (a film, a book, a festival, an exhibition, and so on) orchestrates the tensions between identity (fixed by institutional arrangements and pressures) and subjectivity (the individual's complex ways of relating to the social environment and which always exceeds the boundaries imposed by institutionally defined notions of identity).

Not that I am arguing for 'good', liberating subjectivity against 'bad', oppressive identity. It would take too long to provide all the reasons why 'identity', however limiting and oppressive, is not only inescapable, because institutions will impose them in some form or other regardless of our wishes, but necessary: without some administrable 'identity' defining us as part of an interest group enmeshed in shared social institutions, political management and change would be unthinkable, which is one argument against the absurdity of the more radical kinds of anarchist utopias.

The point here is that the tension between subjectivity and identity is, at present, a defining aspect of our lives and that identity considerations should never be allowed to impose a straitjacket on our subjectivity: if subjectivity is not allowed to transgress the boundaries imposed by identity, totalitarianism rules.

When seen in this light, it follows that different societies will narrate these tensions and conflicts between, on the one hand, 'the old', 'traditional' order of things and its 'moral' values, and, on the other hand, the 'new', modernising framework operating with notions of individual subjectivity. Modernisation can be measured by the yardstick of a cultural text's commitment to individual subjectivity as against the requirements of submission to status (caste, class, gender and so on) identities. In addition, in a society like India's, the very shift from caste to class identities generates an extra set of complexities within the problems attached to status identities.

However, it is not only in Indian cinema that these problems are writ large and generate specific narrative and representational strategies. The realisation that Indian films are shaped by the need to negotiate these tensions in ever evolving historical and economic circumstances, made it clear that so-called advanced, modern societies were just as caught up in such negotiations between tradition and modernity, except that these negotiations would necessarily take on different forms.

Consequently, the notion of modernisation applies just as much to Hollywood and to European films as to Indian or other cultural practices. It is a mistake to attribute a linear chronology to Western societies suggesting that, with the Renaissance and the Enlightenment, the 'old' traditions were definitively replaced by modern notions of individual subjectivity. The resemblance between Indian films and, for instance, aspects of medieval Western plays and epic tales which refuse to make a clear distinction between fantasy (gods, magic and so on) and reality or which operate with status-stereotypes and rely on the world as fixed and revealed in specially designated texts jealously guarded by institutions, does not mean that Indian films are in any way pre-modern compared to Western films: it is just that the Indian films have to negotiate different sets of complexities in the struggle between the old and the new. Western films are just as riddled with feudal ideologies and institutionally fixed definitions of identity, except that we have to look for them in different ways. Both the Indian and the Western films are equally involved in the very same questions of modernisation and subjectivity, but because the histories are different, the narrative and representational forms must and will be different.

At this point, it may be useful to remind ourselves of Marx's question regarding the works of art produced in ancient Greece. Marx wondered, given that cultural forms arc shaped by the histories which give rise to them, why the art of classical antiquity appeared to transcend the boundaries of its time and place. In other words, Marx raised the question of an artwork's apparent universality: 'The difficulty we are confronted with is not that of understanding how Greek art and epic poetry are associated with certain forms of social development. The difficulty is that they still give us aesthetic pleasure and are in certain respects regarded as a standard and unattainable ideal' (Marx, 1971, p. 217). Marx tried to solve the problem by assuming that cultures go through periods of maturation in the same way that human beings grow from children into adults: 'Why should not the historical childhood of

humanity, where it attained its most beautiful form, exert an eternal charm because it is a stage that will never recur?' These are not among Marx's most insightful comments. Strangely, he underestimated the ease with which one might understand the connections between artworks and 'forms of social development'.

Returning to the notion of realism touched on earlier in this essay, assumptions have been made about the way realism somehow 'reflected' the power and the world of the rising bourgeoisie. And yet, there are many aspects of nineteenth century realist works of art which relate far more to the persistent domination of patrician values stemming from medieval state structures and their ideological-religious justifications. The evil aristocrats of nineteenth century novels and melodramas do not convey a rejection of aristocratic values. On the contrary, they betray a middle-class submission to those very same values, including the obscene idealisation of religious values, and the bitter realisation that aristocrats do not necessarily embody aristocratic values. Similarly, the narrative system deployed in realist novels, with, for instance, the figure of the omniscient narrator, betrays the presence of a scarcely secularised version of a god-like figure who is omnipresent and from whom not even a character's innermost thoughts can be hidden. Moreover, both Roland Barthes and Michel Foucault have argued, persuasively, that the very notion of the author, commodified and individualised as that figure may have been by capitalist relations of production, derives from a medieval religious way of thinking. So, the very least one can say about an apparently 'transcendental' and 'universal' art form such as the realist novel, is that things are a great deal more complicated than any straight reference to its contemporary 'forms of social development' might suggest. In the years since 1859, when Marx's text was first published, it has become clear that works of art cannot be understood in terms of a simple reference to the relations of production which pertained at the time of the work's production. Similarly, the notion that civilisations 'mature' in stages analogous to the maturation of a human being, with Greek art belonging to humanity's childhood, is an untenable proposition.

Nevertheless, Marx's question remains: how is it possible for cultural productions which are formed within one set of social-historical conditions to be 'appreciated' in other social-historical configurations. Or, in plain language: how is it possible for us, late-twentieth-century Europeans, to appreciate Indian cinema? Or any other non-European cinema, for that matter. The question deserves a book-length answer. That an 'other' culture's art can

indeed be appreciated beyond that culture's boundaries is undeniable. The difficulty is to explain how this is possible, and in order to resolve that particular difficulty, it is necessary to return to the very point Marx assumed to be easily understood: exactly how do texts register the histories within which they arise? To my knowledge, no theory of artistic production to date has produced even a half satisfactory answer to that question.

On the other hand, slipping rapidly to the conclusion that there must be something universal in works of art which are appreciated internationally and in different cultural epochs, is, to say the least, premature.

To what extent can it be said that, say, a Hollywood film such as David Lynch's *Lost Highway* (1997) or a Scottish film such as *Trainspotting* (1995) is 'understood' by North Americans or by Scots? There are plenty of examples, especially in modern (and even more in modernist) art which show that 'locals' and 'contemporaries' are not always the ones who best understand or appreciate a work of art.

What then do we mean by 'understanding' a cultural production, a text, or, indeed, what are we appreciating when we say we 'appreciate' something as strange to us as an Indian film? And do Indians necessarily understand these films better?

For the time being, my own answer to such questions is twofold. It is true that an Indian film of whatever sort is thoroughly irrigated by the currents that shape Indian history, and a familiarity with, to extend the metaphor, the appropriate navigational charts is essential if we are to make sense of what we see and experience. However, the way we construct such charts, the factors we take into account or discard, depend on the mode of analysis we employ. In other words, and returning to the issue of cinema, if we accept that a film is a cultural product generated by a specific historical constellation of forces, one of the key issues is *also* the way we understand history itself: the way we think history functions is a constituent part of the way we read the presence of history, that is, social-cultural specificity, in films. To give a concrete example: I find Kumar Shahani's films easier to understand, once someone has explained some of the 'special knowledge' relating to the different kinds of music employed in the film, than the latest James Bond film, mainly because I can detect that the film works with assumptions about the workings of history which I share. In that sense, Kumar Shahani's work, although thoroughly 'Indian', addresses all those who ask themselves similar questions about cultural dynamics and developments. If I realise that individuality is not a universal but a historical concept, I can relate to the way Kumar Shahani poses

the questions of individuality and subjectivity in an Indian context, which is as 'historical' as my own conceptual world and implicated in similar forces (industrialisation, urbanisation, conflicts between religious and rational modes of thought, and so on).

In the end, it comes down to the question: what do we think these texts are mainly about? It is my contention in this essay that trying to understand films is, among other things, about trying to understand how films from different cultural spheres, including our own, negotiate and represent the tensions between status identity and individual subjectivity in the form of culturally anchored narratives.

Traces of liberty, here and elsewhere

Kumar Shahani

There is a great risk in being oneself. It is the risk that you take at this moment, as listeners, while you let me act, let me speak.

'In Europe,' I was told by my blue-eyed one, 'you will not see it anywhere, you won't find that expression in the gaze that tells you everything, c'est pas cultive, tu vois ...' Perhaps it is the speech then that does not dissimulate? Twenty years later in a far more eclectic ethos in Paris, someone warns me: 'You give yourself away too easily, for nothing in return. Why are you so naive, innocent, vulnerable?' In India, or on the sub-continent, the intensity of passion makes the beloved turn away the eyes.

What is one to believe? Such ethnic myths that ring true!

Shall we believe in that unknown being out there, can we? In that drive, not far from the Mediterranean, kissed by trees of translucent gold, green as in a fairy tale, she tells me of her many lives, the more exotic and opaque as one has grown, in time and distance.

Can we believe in a continuum of our being?

In that being that has no definite point of existence because in one's act of recognition, one may posit an essence which is only a projected identification?

It cannot be helped, you might say. How should I know you, given that I have to be correct about all that distinguishes you: gender, nationality, sexual behaviour, musical preferences, class in the process of becoming?

Neither you nor I are in any way positioned like a Renaissance painter, inventing perspectival laws, proposing and being proposed ourselves by a spatialised fragment of time. Fixed forever.

Neither you nor I can boast that we carry within us that secret child to whom will be known the way of voluntarily finding freedom to exit and to enter, perhaps to stay within the womb?

Annihilation may stare us in the face: not through nuclear arms alone, nor through ecological disasters. Over and above everything else, it is the deadening logic of a system that bewilders its own processors.

The more a system appears to have its own agency, the less the presence of the subject. The world is a conspiracy without conspirators, forcing us to

celebrate as near magico-religious omnivores. A kind of paganism in reverse where the object gives breath to the worshipper. Bewitching still lifes stir the quick and hungry. All representations seem to trap within idealised geometries the intelligence, judgement, desire and their propulsions into the too transparent presences of cultivated nature.

The impossibility of naturalistic representation, I imagine, engaged all the artists of Asia that came into contact with it in the colonial era, even as they were provoked into the desire to possess reality like their imperial conquerors, who had, back home, far away, introduced along with that very form, democracy and the monetisation of labour.

In India, representative functions were pressed into the service of iconism. That which was representative was worshipped, held up as an ideal or an avatar on the grounds of what she or it signified, in both the spiritual and material contexts. In fact, I think that it is important to remember that while this-worldly and other-worldly manifestations and significations have been around as distinct in the human mind from the beginning, there has always been a desire for the sacred and the divine to inhabit the secular space. Thus, through the European hegemony, a new iconography began to appear with a curious trajectory. The Mannerist postures of the Elizabethan stage entered the founding of our modern arts: oil painting in Ravi Verma, cinema in Dadasaheb Phalke. There were all the photographers as well who introduced posed, centralised and flattened events, trying to achieve some freedom from the convergence of lines imposed by the camera's lenses and privilege the hieratic. The most elaborate explorations of this phenomenon have been done, separately, by our eminent critics and cultural theorists: Geeta Kapur and Ashish Rajadhyaksha. The Italian film-maker, Michelangelo Antonioni, in a personal conversation with me complained about the experience he had in China of his subjects' insistence on assuming those grandiose postures that Shakespearean heroism demands, preventing him from creating a documentary event, subverting every desire in him to know, to present his knowledge of the East to the West.

Yet, curiously, mannerism had originated in Italy and entered Britain via the theatre because its own visual tradition had been damaged due to the opportunist religious squabbles that dominated the evolution of the early Christian-capitalist state. In other words, mannerism had entered postures and behavioural patterns which naturally affected architecture and, indeed, our world view at a time when the Protestant and Islamic anti-iconism, specially vis-a-vis the feminine figure, had been internalised by cultures at the

fringe of these religions, outside of the so-called Semitic stream, Britain and India. Ironically that very iconism began to prevail when the realistic representative function was sought to be re-introduced in India as a colonised response to the metropolitan control of the world through an exclusively objective factuality of positivist science:

The nobility and dignity of harnessing the forces of nature rather than seeking a consonance with it.

Now, both these tendencies were present in precedent polities, in Europe as well as in Asia. But, the earlier realisms that accompanied these economies were mediated by forces that were quite dissimilar, except in one single element. That element was the proselytisation of mercantile capital; the differences within the praxis of the mercantile classes being the state of technologies over historical time, the relative ability to cross the seas, the possibilities of social organisation over large land masses in the Eurasian world, for a while linked and civilised by North African Islam. There has always been so much that every canon leaves out, so much that it suppresses that there is always scope for subaltern narratives to emerge or to be developed as the mainstreams of contingent cultures.

The pleasure of the consonance was differed for the sake of the control of nature, as of the self in Buddhism. It was the consciousness of desire, not its suppression and the aim, in Sufi-ism as well, was the emancipation from it rather than control. Its art, therefore, kept re-affirming the desire to live in compassion, needing neither God nor gods, only the enunciation; even as it posited the Self as aspiration to *shunyata,* an insubstantiality (literally 'emptiness': the desirable state of mind, focusing on the spirit). Thus, not only was the Ego denied or deflected into an activity for the other but also its ethics of formulation of the world was in transience: observant, non-appropriative, containing a fullness that only nature in its fructifying prosperity and plenitude can offer. The monks of the Buddhist path had believed in stabilising the polity by removing all traces of violence and by strengthening the village economies through an alliance with the peasants who would accept the higher technologies of agricultural production. In the cities, their alliance was with the traders whose routes were not to be attacked by those who used the weapons of war and those of the mind, the Kshatriyas and the Brahmins, the castes that held their lore and their logos in their orality.

Hence, the development in the East, even through the later mercantilism that came from the Islamic world, of the revelatory rather than the scriptural. In the West, it was the akshara, the indestructible Word, which began to precede

creation if not the creator. The Koran possibly lies at the unprecedented synthesis of the two. But, the sustenance of the belief in a non-theistic order within and without Islam led to a split between the invisible algebraic and the visible geometric, between the unstruck sound and the notated code, between the performative and the permanently signifying, between becoming and being. All this, while we had to feed babies, aculture and denature them with rituals, discovering knowledge systems that move in opposite directions to reality symmetrically or in contrapuntal movements now meeting, now opening out, always with a telos sanctioned by divinity, society or science – shaping our ends, rough hewn as they might be.

Today, for the first time there are neither means nor ends proposed by the system except profit, generated more through the movement of capital than the surplus that it conceals in its production. The frenzied exchange takes place between cyphers that change their neighbouring figures so swiftly that all value has too little depth or direction, as the major part of the world gets left behind.

There is a proliferation of values without subjects and objects, Activity in itself, the market standing in for life, nature. That is the single metaphor or, if you like, allegory. All its instances in event or person or object work as metonymies, neither present nor absent, just displaced.

For the first time, perhaps, anomie is the norm of the rational society. All the latent master narratives act themselves out in modes that seem irrational, localised, contingent, reduced in significance or collapsed into digits.

The standardization of goods so essential to global capitalism and of human relations within the institutions of profit have fetishised fundamentalisms as seductively as the blandishments of commodities:

Speech without interlocutors. 'Grass-root' visions with a kind of virtual vitalism of the 'folk'. Individual and altruistic impulses narrowed down to slotted identities. Idealised notions of difference that engender similitude.

As the ideology of Christianity was necessary to capitalism, and is the underlying discourse of the European heritage that we all share, the idea of capitalism was essential for the nation state to emerge, dialectically destroying notions of biblical nationhood, sometimes wiping out peoples, the propositions of internal subcultures and the alien through many repetitions of the crusades, disguised in new identities, quickening the oppressed aspirations of those that such an exchange subjugates.

History is so cruel that some people would wish it away, in triumph as in defeat. Introduce instead the comfort of belonging somewhere!

114

When my daughters were asked who they were at school, they did not know what to claim, because until then they thought that, like everyone else that they met, they were on their way to becoming themselves. Shyly, they began to ask how they should locate themselves – through language, caste, territory, food habits, nationality, dress, the colour of their skin?

I would tell them of the first actress that I had to direct and, who while trying to establish an emotional rapport, asked me where I was born. I told her the truth: Mohan-jo-daro in the Indus Valley, Larkana. She was quick: How old are you then? Her playfully incredulous voice, the rite of passage to sublime dissimulation.

In every initiation, does not the form precede the content? The splendour of ritual celebration before the sacrifice. In historic reality too, the convulsions repeatedly shook us into those caesurae that we had fondly believed to be single episodes of a distant past: the partition and our independence. The renewal of the politics of identity and difference in the post-fragmented world brought riots and bomb blasts to Mumbai (Bombay).

Our children were shocked by the culture of the adults. To overcome the paroxysm, one hopes that a new kind of learning will be discovered by them. Henceforth, they will have to build over here an elsewhere, not quite present upon this earth, never yet, but of which glimpses are seen in all civilising insights, sometimes opposed in origin and development. The Future has left its traces in anticipation of a tryst that no single nation or tribe or civilisation could ever bring us to, at the appointed hour. Instead, the carnage, the displacements, all the traumas of separation.

As if the figures of birth have to be re-enacted collectively! So, collective figures of fertility continue to demand real and extensive sacrificial killing, long after religions and reason have sought to correct their own momentum of annihilation. The figures of annihilation that have dominated our minds since Hiroshima have developed into a nervous system external to our individual bodies, networked into language, communications, simulacra and opaque representations that gain their currency even as they lose their relational link to the represented. We have to keep guarding ourselves, of course, from the falsifications of positivist transparency. It always stands exposed whenever a phenomenon has shown its complexity, irreducible to inviolate fact and/or appropriation into knowledge. In all its forms today, specially the most politically correct ones, the residues of totalitarian linguistic designation have turned all assertions of reality into stubborn rhetoric. Give me any day those figures of speech instead, those embellishments of music, those ornaments

that open out an infinity of meaning to the imagination and to praxis, oblique in their naked desire.

The forced factuality of electronically generated images has, in fatigued addiction, created an insatiable hunger that can only make sense within new hybrid formations instead of originary and teleological concepts. The Europe that I have loved and known is one that has not sealed its borders in terms of location, ideas, mercantile concerns or the movement and imagination of people. Amongst Pascal's predecessors, one is often reminded, the most significant is St Augustine, the moor. And all those anonymous mathematicians of algebraic art. The peripatetics and equivalences of Descartes and Karl Marx could have been predicted by the boatmen who set out from the riverine towns into oceans whose turbulence could be measured by the distance between stars. When St Joan in her cell says that she should not be burnt because she is not impure, I think of all our epic heroines that anticipated the holocausts and witch hunts. Yet, we continue to speak of the West and the East, essentialise them and hope to transcend separate histories that meet in an elsewhere through the presence of multiple ghettoes in our pluralist personalities, wishing to re-integrate through a division of labour in the ersatz bazaar of biologized differences.

Forever, the differences are presented as if they were fixed objects, instead of being deferred in perpetuity, as they could be in name and form, to accommodate both the pleasure and the pain of multivalence. The desire for union may spring from the primal scene. But the imagination can reach beyond the realisations of inheritance and identification with pre-destined objects. Rhythmic renewals of life affirmation and self-perpetuation do not lock themselves in clever elisions and erasures of identity and difference, having posited them in the first place, but in mutations that are as awesome as geometry to the ancient Egyptians, the compassionate, creative emptiness of Gautam Buddha, the speed of light to Einstein, the infinite opening up of chaos to knowledge and beauty, the freedom that inheres in the praxis of the cohering senses. In that active projection of the universe, the delight and wonder of existence is like strewing petals upon divinity incarnate or confetti upon those who intend it.

The subversion of intention by pre-supposing it and by preordaining it is the logic of the market's sovereignty in the service of overproduction. The great possibilities of searching dialogic forms are shut off by the instant rounding off of the signals of perception. The new interaction can reduce mental impulses to formulae, directly isolating and satisfying computed

116

needs. Through these isolations the body disorients itself from what it has learnt through evolution, the adaptive changes in the organism that linked our changes of perception with our ability to act upon the world.

It is our species that has co-ordinated its senses sufficiently to clone experience, even as it has fragmented it, voided it of its significance In this environment it is courageous to offer up one's work for contemplation. Geeta Kapur speaks of the Thai artist, Montien Boouma who has 'self-repose as part of his aesthetic, the circumambulation of the body in the installation form and the peculiar form of hypostasis produced by his temples. Such spaces may be designated as predisposed precincts of meditation that gives to the act of spectatorship a deliberate reticence and to all the senses together, an indexical charge of mortality and jouissance'. (Dismantling the Norm)

From the beginning of cinema, the great film-makers whether in the United States or Japan, whether in Europe or India, born in the age of Imperialism, wished to offer the wage labourer a possibility of constructing a self-image as dignified as an empty vessel into which you could pour the elixir of life. Often it did not matter what ideology prompted the making of the film. Griffith's depiction of the suppressed races as being on the edge of capitalist civilisation did not prevent him from critiquing it, nor from restoring the historical subject, no matter where he came from, what colour of skin he wore. Dadasaheb Phalke wanted not only himself and his audiences to enter history but wanted the gods too to participate in it. Ozu's cinema had begun to propose that every being, every tree, every square in the sliding walls of his homes bear a trace of individual form, albeit emerging from an aristocratic attentiveness. Dreyer's depiction of the passion showed womankind as dissenting, courageous, individuated in the face of the most terrifying institutions.

To think that these films were offered as commodities in a world market earlier, speaks well for those who were building unconsciously that system, post-colonial, post-modernist that we inhabit today. And amongst them, the heroic Joris Ivens, a source of inspiration not only to me but also to all the young people that I have met anywhere at any time in my life span. Already, all the way back, in the period between the wars, he had initiated the liberating discourses that could free human action both from the state and from the market, precisely because the logic of these very institutions, the movement of commodities and what they contain, irrespective of origin in nature and culture, makes primitive preoccupations with identity and difference both ridiculous and redundant.

In India, the artist that I know who is working for years now to dismantle the post-modernist fetishisation of inner desire and to celebrate the capacity to create, simultaneously, is Vivan Sundaram. It is not only in the art object that he presents both the terror and joy of living, outside of a third-worldist communitarianism, but also in his political praxis where one's individual participation is often forced into asynchronous modes between local and global awareness, he frees himself from that abstracted alienation that information as commodity generates.

In fact, today the fetishised nature of leisure itself, therefore of free time and free thought is so spellbinding that the exhaustion created by it can be compared to the mental and physical voiding of the person at work, when and if work is available in the globally determined structure.

This loss of initiative is happening right in front of our eyes: regressions to fundamentalist positions even amongst those who attacked historical totalisations from new, liberating viewpoints.

It appears often as if the object into which we would earlier project our being has itself lost its autonomy; that its destiny is in its self-annihilation in offering itself to be either instantly consumed or in its disappearance like a television spot.

In fact the trivialisation of choice has subverted fulfilment because desire is computed into needs to be satisfied in a state of near panic. Will we have any existence in the market tomorrow, we have to keep asking ourselves.

There is a transference of one's own particular nervous system into the fatalist levelling of the World Information Order, dictated by GATT, TRIPS etc., that respects no other traditional regime of authorship nor the appropriation of one's natural and cultural resources by a community, cancelling out alternative cultural responses to those put in place by the multinationals.

Shall we still continue to dare to speak of free will and predestination? Of voluntarism and the historical forces that overwhelm us? Of the contradiction between the Ever-self-revealing and the Rational? Of the multi pronged conflicts that emerge between *dharma* (obligations, responsibilities), *artha* (material wealth), *kama* (desire, love), *moksha* (liberation, relief) – of the impulse to realise oneself in action, in material and sensuous joy, even as we aspire to spiritual freedom: full blown creativity?

Organised religions, ideologies and above all formulations anonymously generated by the market have turned those very questions into brutalising moral codes that bring to mind images from the Leviathan, a Kalyuga.

The point is to free those very questions from their membranes, sometimes

linguistic, sometimes visual, often embedded in musical and other temporal forms.

Our freedom lies in seeking the synapses in the world system's impulses that we can recover as our own at every given moment which can change the world at the distances the information order affords us, even as we signify it in gestures of everyday living, empowering discourses that can be relayed through meeting points, sometimes as anonymously and as invisibly as digitised knowledge, sometimes in open, performative praxis that resists any pressure of generalisation, individuating abstracted currencies into tangible pleasure and pain.

These then are the traces of liberty, not left by a disappearing past, but perhaps by an immanent future.

Report on the debate on visual arts

Din Pieters: Before we start, I would like to tell you something about an African artist I saw last weekend at the Rijksacademie in Amsterdam. Students and participants from all over the world presented their work. A young artist, called Meshac Gaba, from Benin asked the public to donate two guilders for the foundation of a museum of contemporary African art in Amsterdam. I gave some money and I received a badge in return. Dutch people like giving money for good causes. The artist collected plenty that day. Afterwards, I wasn't sure if a museum dedicated to African modern art in Amsterdam was such a good idea. I prefer to see a mixture of art, from Europe or elsewhere, in a museum like the Stedelijk Museum in Amsterdam. Okwui, would you support an institute of contemporary African art in Amsterdam, if you were asked to be the director of that institute?

Okwui Enwezor: It depends on the parameters. From my own background it is clear that I would be able to support such an institution in principle and in practice. But the issue is not really about mixture. As an editor I try to consider different aspects of 'cannibalisation', of positions of power. As a curator you have to be aware of this when creating an exhibition. I'm afraid that in what you consider to be a mixture the overwhelming history of Dutch painting remains unchallenged. Why not set up Meshac Gaba's museum for contemporary art and then invite individual artists and de-nationalise the presentation of artists. Many museums in Holland are dedicated to Dutch art; perhaps we have to dismantle those before we can achieve a genuine mixture.

Din Pieters: Maarten, would a museum like that give you the opportunity to become better acquainted with African art?

Maarten Bertheux: In many ways we lack information about art produced outside the Western metropolises. But I don't think museums specialised in a particular kind of art help. Dutch museums that focus on Dutch art are unable to continue on that basis because they tend to stagnate.

Okwui Enwezor: A brief comment on the myth of these so-called Western metropolises. Very little is actually known about what happens in South Africa or Nigeria. We are out of date. It's time to challenge curators and force them to confront the limitations of their own practices, and institutions. Curators from institutions should get off their behinds and begin to set up new forms of engagement. What artists are asking today is not charity. In discussing globalization it's important to recognise that art institutions are often slow to act on questions about complex issues that have been raised in other places. You don't need to have special faculties to understand a painting by an artist from Benin. It's a painting! Curators and art critics are trained to deal with this uncomfortable position, so let's get on with it.

Din Pieters: To what extent does your own history of migration play a role in your perception and vision of art?

Okwui Enwezor: My own migration doesn't always necessarily play a role, it's a combination of things. Many people in Amsterdam may be better informed about the world than I am. But because of my migration I am able to talk about the culture from which I come and at the same time to assimilate into the culture in which I've arrived. These are the opposites in which I exist. It's here that I question the epistemological concepts on which institutions base their practices. There is a gap and to fill it we need people who are willing to question institutional practices.

Din Pieters: Maarten, you have travelled around the world. How did you come to understand art from non-Western countries?

Maarten Bertheux: For me, being educated in a culture in which I learned about Western art, it is important to be confronted by other ways of expressing, with other material in different circumstances. You wonder to what extend the context is important for the work. For example, in South Africa I learned there was a limited art circuit in galleries and commercial opportunities were dubious in practise. I was once asked to help host «Zuiderkruis», an exhibition on South African art, which had originally been shown at the Venice «Biennale». Two months after the opening I went to South Africa and met Noria Mabasa, whose work was included in the «Zuiderkruis» exhibition. She was working in the north of South Africa, an area where a lot of woodcraft artists are active. She was selling sculptures to tourists that were completely different from her work

in the exhibition. We started talking about the environment in which she lives. She told me that the crocodiles in the nearby river gave her spiritual messages. When I heard that I was completely confused; I was presenting sculpture in the Stedelijk Museum Amsterdam that was made by a group of people almost eaten by crocodiles. Before, I had been completely neutral about the context. It's possible to exaggerate this element, however; it is important to find out about the artist. This taught me that it is not enough to see the work. It confuses my Western art perspective as well as the art production.

Din Pieters: On the subject of the assessment of works of art on aesthetic and non-aesthetic criteria. Today, the Western aesthetic, formalist approach is challenged by a broader view on art. This broader view includes identity, migration, belonging, power structures. Okwui, these themes play an important role for you. You describe yourself as a cannibal, what do you mean by that?

Okwui Enwezor: I use the term 'cannibalism' as a metaphor for symbolic consumption. When I say that the West is a good cannibal, I mean that it knows how to ingest and consume. With cannibalism I refer to strategies of empowerment. The actual cannibalism is not the eating of human flesh; it's about the displacement of power: you take someone else's power to gain more power for yourself. What Maarten is describing, is a quintessential form of cannibalism. He finds different ways of saying his Western country allows him to consume certain things and to display others. It's important to think beyond the post-colonial context and the terminology of acculturation. These terms are no longer adequate to describe the type of mechanism that we have for cultural exchange. All cultural exchange is filled with paradoxes and questions. Cannibalism doesn't mean that every day I consume Western things and I'm happy and exited about it. No, cannibalism is a critical project, it is about the way you position yourself, the way you critically examine and re-examine your relationship to other cultural constructs.

To return to Maarten's «Zuiderkruis» exhibition. In the first instance he was unable to understand what Noria Mabasa's work in her culture is about. If you don't know or understand a work of art then find out and ask the artist what her sculpture is about. It's as simple as that. Maarten talked about the question of value. In his opinion, Kendell Geers's video was 'not art' and William Kentridge's work was 'not good enough'. These are values and we have to admit that these values are informed by opinions that are educated.

Maarten Bertheux: My opinions can be rather extreme. I wanted to show that we all have these kinds of perspectives and that we all have our affections and judgements based on a personal attachment to a particular kind of work. We shouldn't deny that. These days the value placed on objects or artifacts that deal with colonial background is exaggerated. Kendell Geers shows images of the Dutch colonial past but the interpretation remains undone. Presenting these images does not necessarily mean that the work qualifies as art.

Okwui Enwezor: We set up hard and fast parameters for the work of so-called contemporary artists. If you came to South Africa today and decided to curate an exhibition, bringing multimedia artists such as Kendell Geers together with the artist from South-Africa you mentioned and claimed that they spoke the same language as artists who listen to crocodiles, then we are missing the entire point. These artists wouldn't be able to interrelate and engage in discourse; those values would stop them from talking about issues with which they are familiar. Even in South Africa black artists don't necessarily understand avant-garde art. They are much closer to Western traditions because many of the works are metaphorically related to the Bible. You in the West are better able to understand that than a Zulu person who visits witch doctors. We have to find ways to create a dialogue between artists, to divide the exhibitions of art by people from non-Western countries into subjects and to look at artists who address this subject directly and find ways to mediate the dialogue rather than to locate contemporary African art. Gathering all the shamans and placing them in «Les Magiciens de la Terre» wouldn't really work. The critics have shown that often enough.

Din Pieters: Turning to the tension between 'localism' and 'worldliness', when you were appointed artistic director of the Johannesburg «Biennale» not all the African artists were satisfied with your approach. Some people felt that there weren't enough African artists. What is this criticism based on and how do you deal with it?

Okwui Enwezor: The issue I wanted to raise at the «Biennale» was about the context to which we view identity and national postures in a global setting. We need an opportunity to discuss that. So, having twenty percent South African artists was already too much.

Din Pieters: But for them it's an important opportunity to present themselves to a larger audience.

Okwui Enwezor: Yes, and they should have their exhibition! But if I think something doesn't fit in my dialogue then there's no point becoming a charity. It's understandable; if you were to have an international exhibition in the Netherlands, Dutch artists would also feel marginalised. We recognised the need to have of a number of South African artists. Six were included in the catalogue, a few are in the film programme and some of the people who spoke at the conference were from South Africa. The broader question of the «Biennale» is globalization, it is by no means only about Africa.

Din Pieters: On the other hand, as a curator you have long been involved in African art. Were you disappointed that only three African artists were included in the «Documenta»?

Okwui Enwezor: No I wasn't, Catherine David created the project in her own way. That is what interests me. A particular view prevailed in the «Documenta» and the curator remained faithful to it, giving us the opportunity to argue about it, which is valuable. I am more interested in how many other artists we have in Johannesburg than in the «Documenta».

Maarten Bertheux: Okwui, you curated this exhibition in Johannesburg and you selected artists on the basis of your concept of looking at identity in global settings. Why did you in most cases chose multimedia productions? Is it because of the special narrative quality of this kind of work? Questions about cities, issues of body, memory and kinship can be activated in a powerful way through painting as well. So why was there no painting?

Okwui Enwezor: To be honest, I probably just visited fewer studios with paintings. I don't discriminate against paintings. The «Biennale» is about values and meanings of what is presented and what presenting means. None of the artists showed paintings, but their works involved questions that are being asked by all contemporary artists today. Questions about cities, issues of body, memory and kinship and all kinds of things. If these questions can be tackled through video I don't see why I should prefer painting to video.

Report on the debate on performing arts

Dragan Klaic: Lamice, you lived in Iraq, in Germany, Algeria, and Spain, and now you live in Berlin. You use the words 'nomadic' and 'nomadism'. To be honest, that sounds a bit romantic, perhaps even too romantic. Is that a sustainable notion in this day and age? Is our dynamic of displacement, of movement, really something that can be described in terms of nomadism? Do you feel nomadic in the sense that you can make a free choice to move anytime you like?

Lamice El-Amari: Rosi Braidotti has written about this notion of being a nomad. I see a nomad as a person who can feel at home anywhere, having no real home. That is how I feel. I move around in the world, I move where my work takes me and I don't give it a second thought.

Dragan Klaic: But isn't that metaphor rather too seductive?

Lamice El-Amari: Well, I kept thinking about this expression. What is this nomadism? In a way it describes something essential to me. I am interested in what Wole Soyinka said about homeland. He became a 'new' European when he was forced to live in exile. He said, and I paraphrase: 'Homeland is in my head. Wherever I go I have a taste of something that reminds me of home. I have a taste, an odour, a flower, some food, and that is home.' And that is exactly what it means to me. We move in a world with many simultaneous cultures. If I maintain my identity, what then is my identity? I have a serious problem with terms like ethnic identity and authenticity, because these belong to a specific area of thinking and of terminology that is beyond our present day and age.

Dragan Klaic: The terminology now is 'new internationalism'. Do we need to talk in terms of nationalism versus internationalism, or can we move away from this dichotomy?

Lamice El-Amari: Today, after the fall of the Berlin Wall, there is a new world structure and a lot has been written about the new world order. Guillermo Gomez Peña, the artist Catherine Ugwu mentioned, has published a book on

'border art', not world art, but on how to break through the conventional way of looking and perceiving. It is a challenge to all artists and thinkers. Where are your roots in this new installation. And it would be good if we could move away from the dichotomy! That's why I find that the solution is, to do that what you want to do in life anywhere. I could do it in Berlin, I could do it on the moon even. I am really excited by the outer space civilisation, if there is such a thing. Soyinka said nomad in a transformed Europe, I say in a multinational Europe, you move among all these nations. I can never forget I am an Iraqi, whether I like it or not. When I hear an Iraqi song, even one I have forgotten, it is there and it is meaningful to me. And yet, I can feel at home as well, with you here or anywhere else, because there are aspects of life that are important for you and me wherever we are.

Dragan Klaic: But you don't feel that internationalism is a word that has been overused?

Lamice El-Amari: Yes I do. But these are the current terms. We use them as currency in our talk, and yet, we have not really defined the new world that we are heading for. We live on shifting ground, and we don't know where we are going.

Dragan Klaic: That is the point that Catherine was also making, about shifts, about impermanence. Catherine, I have not had the chance to see much of the work you presented, but I regularly read the ICA monthly bulletin and am jealous and bewildered by the kind of interesting original rare and unique work you have been funding and presenting. What kind of theatre, what kind of performing arts brought you to this business, when you decided that you wanted to deal with live arts?

Catherine Ugwu: I have worked with a range of companies. I have worked in a community arts organisation, I have worked in a research base, I have worked with a traditionally-based theatre company, and eventually I went to the ICA because I decided I was going to spend my life working with arts and culture. And the place where ideas, work and practise actually cohabited was the ICA.

Dragan Klaic: In your plea for difference and respect and discovery of difference, for the understanding of shifts and transition, you use the term 'cultural broker'. What do you mean by that?

128

Catherine Ugwu: I use the word cultural broker to describe the job that I think I used to do. I use it to imply that responsibility is proactive as well as reactive, in the sense that it is not objective. It involves some kind of mediation, so it seemed a more fitting word. As cultural broker you invest, you have ideas, you have a creative role and you acknowledge the responsibilities of that.

Dragan Klaic: How do you resist tokenism in your own case? When people ask you to join a board, to sit in a panel, to be in their committee, you probably question their motives, their reasons. How do you yourself go beyond being stereotyped as a British, black curator, programmer or expert? What are your personal risks in that game?

Catherine Ugwu: I have not got it right every time in the past six years. The personal risks in the UK are very complex. The reason we are having this discussion is also because I've chosen to straddle two kinds of worlds, the one of the post-modern art world and the other the Black Arts sector. These are not completely distinct, they are interrelated, but they also have a weird relation in terms of power. The mainstream avant-garde was predominantly adopted by white European artists, historically here in the UK particularly male artists. That's the type of world the ICA represented for a long period of time, and it was this type of audience that was supplied with work. My position there has been a difficult position, but the fact that I'm black is indeed a fact, it is not my interest. My interest and my passion is innovative performance work, and I wanted to place myself in a position and context to be able to deal with that in all its manifestations, with all its difficulties, with all its complexities. I did not want to place myself in a situation where I was being asked to deal with cultural specific work. Not that there is not a lot of cultural specific work that I do deal with, but I didn't want to have my career and my ideas restricted in a way that is not expected from people.

Dragan Klaic: But how much space is there for this kind of innovative complex live arts work in Great Britain today? The space that you created with Lois Keidan at the ICA is virtually gone. You are no longer with the ICA which is in a transformation process that is not too promising in terms of what space it would allow for non-commercial work. In what other venues is it possible to present the art that you have been presenting for the last couple of years? How much cultural space is there for that kind of often controversial work?

Catherine Ugwu: In the past five, six years, there has been nationally in the UK a whole range of venues that has supported innovative practise because there has been an audience for it. And it has been responsive to what audiences have wanted. In the past twelve months, the inner spaces which are the Centre for Contemporary Art in Glasgow, the Green Room in Manchester, the Arnolfini in Bristol and the ICA in London made a small national network for properly contextualised, well presented pieces of work to a good audience.

Dragan Klaic: Are you able to have a good debate with the curators, with the programmers of these other venues? Can you really engage with them in a passionate, intensive and deep debate about how to present a particular artist?

Catherine Ugwu: We often disagreed, and we often did things differently. And in hindsight, six years on, the things that I did one year, I wouldn't do in the same way now. I would definitely present them in a different way. I'm gaining experience and that's acknowledging the mistakes you made and the journey you take. It is true that more and more unconventional and experimental bases in the UK are starting to disappear and that's frightening. A lot of artists are not going to be supported. The work that we have been presenting continues to be made, but it is underfunded, underrepresented and it has been for all the time that we have been supporting it. And yet, it has always managed to locate itself and find its space. This is because it's driven by people who have to say what they are saying. They do not say it because it has been funded. I think that they will find more provocative terrains to locate themselves in.

Dragan Klaic: In your lecture you talked about William Yang as an artist presented in three different ways in three different venues or contexts. Isn't it better as an artist to be shown in three different ways than to have a single label that pursues you like some kind of a curse?

Catherine Ugwu: It is not a case of better or worse. The point that I was trying to make was how institutions and curators create meanings. And how they mediate a whole body of information down to a narrow statement or a few lines that labels the artist in such a way that leads the audience into a particular kind of direction. 'Here we have a gay artist, here we have a Chinese Australian artist, here we have a theatre maker', in the case of Yang.

Now, what that kind of practice does, it fixes the work of an artist and it limits the possibilities of the people seeing his work. When you do that you need to be very aware of what you are doing.

Lamice El-Amari: A long time ago someone said that the educators must be educated. We are getting to a situation in which we have to reassess the knowledge, the ability, the vision of the curators who really hold all the strings. Most curators come with perceived ideas of what is and what is not and since the money is in their hands, they judge who is and who is not.

Dragan Klaic: What do you see in your experience in Berlin? If there is a city with plenty of theatre and funding for theatre it is Berlin. There are four operas, although that is a mainstream, predictable, standard kind of work. Do you in your present nomadic phase, in Berlin, see curators presenting, programming non-traditional, non-Western art anywhere in Berlin?

Lamice El-Amari: In the mainstream world, for those artists working against the mainstream in Berlin, in Europe, it can be heartbreaking. At festivals big names are brought just because they have big names. And sometimes they present petty work and it is accepted. And sometimes I leave the hall and I just want to cry. That is the system we are in, you have to face the fact.

Dragan Klaic: Let us not go into the pathology of festivals. What about a place like «Haus der Kulturen der Welt» in Berlin, which has been set up as a kind of cultural ghetto.

Lamice El-Amari: I wouldn't call it a ghetto. They had their own problems with the established art world which felt that the «Haus der Kulturen der Welt» was getting too much money for presenting work that was not even art. They were doing all kinds of multicultural things and when they were threatened with closure, artists and 'non-artists' in Germany stood up in public and declared that the «Haus der Kulturen der Welt» should continue to exist. In the end a compromise was found through the intervention of parliament.

Dragan Klaic: But it was the only place in Berlin where you could see this kind of work?

Lamice El-Amari: On a large scale. On the scale of micro groups, small clubs, there are various communities exhibiting and presenting work.

Dragan Klaic: But that's a reinvention of a ghetto within a ghetto, the Moroccans away from the Turks, the Turks on their own, the Greeks.

Lamice El-Amari: You're partly right, but partly not. Some sections of Kreuzberg are like a melting pot, but it is a small proportion. The mainstream is still traditional: every community is on its own.

Dragan Klaic: But is there any challenging, radical, innovative work in Kreuzberg? Let us move from Kreuzberg to the Arabic world. Where today in the Arabic world is interesting, innovative, challenging work in the performing arts? Work that is not perpetuating the traditional forms of the region and that is not imitating the Western canon?

Lamice El-Amari: As I have said, ninety per cent of what is presented is in the traditional Western style. That is what is accepted and legitimate. That is why I call for a new approach to theatre history in the Arab world, as well as in the Western world. I made an interesting discovery here in Amsterdam; a production by «Het Onafhankelijk Toneel», Rotterdam. The director is Dutch and the actors are Moroccan. I watched the play and I wondered if I could have been able to see it anywhere in the Arab world, without this marriage of East and West, and the answer is clearly: no, impossible. There have been many attempts in the world by a foreign producer going to another country and creating something with people from another culture. But like this, with the harmony in the actual production, I have never seen such a wonderful example. For the Dutch director the interesting thing was that the Moroccans do not distinguish between art and vaudeville, in the Arab world the two go together. And for the Moroccans it was interesting and challenging to experience that the Dutch have a tradition of separating art theatre and vaudeville. The curiosity on both sides lead to a lively theatre production. Gerrit Timmers, the director, used video as an additional character. So you had an artistic synthesis of Arabic acting, Arabic atmosphere and highly sophisticated video technology and developed images from the West.

Dragan Klaic: Catherine, you were speaking about instances in Britain where the public challenged the cultural institutions, their programming and their

framing of particular artists. Could you elaborate on how these challenges to the programming of the cultural institutions were structured and articulated in the British context?

Catherine Ugwu: With the «Sensation» show, which featured young British artists at the Royal Academy, with artists such as Jake and Dinos Chapman and others from this younger generation whose work is quite provocative. It is work that may not have been seen in such a mainstream institution before, but which has been appropriated by the mainstream institutions, because all the institutions in the UK at the moment are aware of the shifts you have to make in terms of audiences. The Royal Academy got on this exhibition because it was the work that everybody was talking about. But they had never taken into account that they might have to deal with the issues that some of the work threw out in the public domain, issues that they were not particularly interested in, because they were interested in market forces and selling. A lot of the work is terribly provocative – pictures of a mass murderer who is still in prison today, penises in the mouth, vaginas and so on – which is interesting because it forces you to locate yourself and it is not always comfortable. You can only deal with this kind of work if you are prepared to have a public debate, if you want to identify the reasons why this art is so important. The problem with the Royal Academy is that they don't know how to defend the work, because they don't really understand it. That was one instance. And there have been others like the Royal Opera House crisis in London. There has just been an independent assessment that has recommended that the chief and the whole board of the Opera House resign, because it has been so mismanaged. In the UK, if that can happen to the Royal Opera House, than it can happen to anyone. And it is probably the same in any major European city. So the power of the public to influence the agendas of cultural institutions has become enormous, which forces us in the UK to be responsible: the best thing that has happened in a long time.

Dragan Klaic: You mention the Royal Opera House crisis and public criticism, but how much is public intervention and how much is politics, a question of power?

Catherine Ugwu: The whole crisis started when the Arts Council gave out the first amount of lottery money. The Royal Opera House received seventy million pounds. Ninety per cent of lottery tickets in the UK are bought by

working class people with no money, and no possibility of ever buying a ticket for opera, who see the Royal Opera House as an organisation that has nothing to do with their lives and nothing to do with their reality. All of a sudden they see the money they've been spending on the lottery going there. The Arts Council is the major funding body in the UK and they did not question their responsibilities and the way their actions were perceived. Because they think that they are above such a confrontation, they did something stupid. It was badly managed PR. Of course the Royal Opera was under scrutiny from that moment on. A couple of weeks ago we were told that seventy million pounds was not enough, they needed another thirty million, otherwise the Royal Opera would have to close down. Well, there was just no way that this would be tolerated by anyone. And then the new chief executive, a former member of the Arts Council, was appointed without regard to the equal job opportunity policy. The job was never advertised, she never went for an interview. So people felt that it was not on for the Arts Council to give this money to an organisation whose executive is a former employee of your own organisation. This is a prime example their remoteness from the real world, both the Opera and the Arts Council. In this case it is clear that the public did intervene and that the conventional power structure was under scrutiny.

Dragan Klaic: You worked at ICA, and there is only a small circle of similar places. Is it a stigmatising factor or does it help to break open, to set a precedent for the regular mainstream places to open up for less conventional productions?

Catherine Ugwu: A lot of practises started at the ICA are now found in other places. The ICA was the place where people put things on first, the place that took risks. That's why it was great to work for the ICA, to try out new ideas. I recognise that it was a privilege. You have to realise that in London the ICA is clearly positioned because of the number of cultural and artistic institutions, and in terms of the landscape of cultural institutions in London. The ICA had its own niche, it presented a programme that nobody else was presenting. And a lot of the other work was facilitated by other institutions. We could be specialised about what we did. Wherever you go in the world, everybody knows the ICA, even if they don't really know how we work and they have never actually seen the works we present. It has that power of influence and legitimisation of certain kinds of work, which is also why it was incredibly interesting to work in an institution like that. At the same time I was part of

134

the avant-garde and part of the establishment. That is not the same everywhere. In Manchester, for example, one of the other venues, they would present a much broader range of work that probably would be presented at four or five venues here in London. So their kind of image and the way they represent themselves to the world is completely different from the way the ICA is represented.

Dragan Klaic: Lamice, what kind of strategies do you have in mind for educating curators? In our experience it is hard to think about strategies. They generally don't want to be educated.

Lamice El-Amari: That's the whole point. The main focus for the curator should be the artist he or she wants to present. Bertolt Brecht says: 'Compromises are okay. Artists must make compromises all the time, but [...]' and he cites the following example. He went to visit a friend who did not have enough wine. He brought half a bottle and wanted to fill it with water and drink together. Brecht said: 'I accept we only have a little wine, but please give it to me separately; the wine in one glass, the water in the other, then I know what I am drinking.' We should follow this example in curating, to keep the integrity to the artistic work, that would be the best strategy. Okay, you have to play the game in a certain way, you need money. But when we need money, we must not become so involved in making or getting the money, that we sacrifice the actual artistic product. After all we are representing artists. In terms of an intercultural project the Moroccan Dutch co-operation shows how to do this. The problem is usually that money goes through administrators who are not really connected to the real process of creativity and art. Let me give an example that shows how much work we still have to do in the world of art. Some time ago an interesting discussion between four religions, Islam, Judaism, Christianity and Buddhism, took place in the «Haus der Kulturen der Welt», and was broadcast on Radio Berlin. A priest from the Christian church said: 'My community is a multicultural community, not only Christians who come to the church. The other day a Turkish woman entered the church to light a candle for a sick person. She came to me, and of course I was happy to welcome her.' This example shows that it is possible to welcome the so-called other in your midst, but you have to want it. If the Church can do that how much more multicultural education do we need in the world of art!

Dragan Klaic: Lamice, how well do you think that the production of «Het Onafhankelijke Toneel» would do in Casablanca in Morocco?

Lamice El-Amari: In Casablanca it would be a raging success, for the simple reason that it is a play that has been shown in Amsterdam. In the second place, it is not in a foreign language, it is in Arabic and in their own culture. Everything about it is really Moroccan. It is local, they understand it and above all it uses new technology and they are mad about this technology.

Dragan Klaic: But would it be seen as a type of theatre that is different from the sort you usually see in Casablanca?

Lamice El-Amari: Thematically, yes. It is written by an Algerian writer and it deals with bureaucracy and corruption within the army. It is anti-establishment. I asked the director how much trouble he would expect, after all Morocco is not a haven of democracy. He said – his actors have to live – that they would shift the setting to Latin America. With this strategy of displacement they will still make the point, they would still have their audiences, but politically they would get away with it.

Dragan Klaic: The actual question is: would these kinds of productions really come to Casablanca? Often this does not happen. Mostly it is traditional artists who are asked to perform: people don't get the chance to see provocative productions. How can you avoid being caught in the authenticity game, the fetishism of the difference? Catherine Ugwu, what do you think?

Catherine Ugwu: I was recently in Ghana at a festival that happens every two years. A lot of the work is from all over Africa and is traditional, but there is more and more work from the diaspora too; from the States, from the UK, from France. It is incredibly difficult for artists from the West to go to Ghana to perform. Problems of transport, lack of space, lack of money, it is difficult for these artists to do these reversed journeys. And also because all the money for those artists has to be raised in their country of origin, so it has to be artists or curators who actively want to open that dialogue to get themselves there to participate in that event. But the work that I've seen from the UK and the US that has been presented there, has been received with tremendous amazement just because of the languages these artists use. And in fact, a lot of innovative work from those places goes out there because of the dialogues that those

artists are involved in. They are aware of the festival and the massive happening there at Cape Coast, with work from all the regions of Africa. So it does happen. The same goes for Hong Kong as well and Taiwan and Singapore. I have seen it, where there is work from the diaspora that goes back, and performances in that context. It can be problematic; for the right reasons. People have to negotiate notions of self, place and belonging, that you don't have to if you are a UK Chinese or African artist living in London. But you go home and start owning a place that is not actually practically part of your existence. That can be problematic, that is an interesting conversation.

Dragan Klaic: How do you interpret the motives, for example of African-American artists from New York, going to Ghana to perform?

Catherine Ugwu: They want to have a connection with what they see as home. They want to participate in a colloquium which is five days long. The colloquium is not just about culture, it is about every aspect of African life as it is at a particular moment in time. It is an amazing event, because it brings together everyone from planners, housing people, to economists, to cultural brokers. The idea is to bring all these people from the African diaspora together to talk about strategies for African independence and Africa developing in African terms. Basically admitting that there is resources, skills and knowledge around the diaspora that can be brought to bare on the situation in Ghana.

Dragan Klaic: An analogy to that in the Arab World?

Lamice El-Amari: There are very few. Attempts have been made by Algerians, and for Tunisia by those in exile. The actual great event as Catherine mentioning for Africa, is really a state event.

Dragan Klaic: Fewer venues are prepared to take risks and show innovative work. How do you see the position of curators like yourself, who don't work in an institution like the ICA, but independently? You still need venues to present the artists you want to bring to the audiences?

Catherine Ugwu: It all boils down to the relationship that you have with artists. It is about the integrity that you have about the work, it is about the trust that is built into that relationship. I have been away from the ICA for two months

and the people I used to speak with, who used to come into our office and used all our facilities, still try to do that in my office. In terms of the daily environment, the contact with the artist has not changed. The test will be whether you can still weald power, influence, and money located outside an institution like the ICA. That is going to be the test, not the relationship with artists, I never had any doubts that that was going to be problematic. Those relationships have been built up over a long period of time and have to do as much with the respect that I have for their work as they do for the way Lois and I work. But, what we have to see is how much support we will get from institutions, and institutions that don't have to listen to us anymore, because we are not located within them.

Report on the debate on literature

Xandra Schutte: Valentin Mudimbe, you have discussed identity, a complex matter. I am aware that a person's personal history is not the same as their identity, but to make it less abstract, could you tell us something about your own personal story?

Valentin Yves Mudimbe: The point I was trying to make is simple: there is no such a thing as pure identity. All of us are historically, culturally and even biologically mixed entities. I could take my personal story which in itself is not particularly interesting. I was born in Africa, to a Christian family, I became a Benedictine monk, then a missionary in Rwanda. I chose to go to university for political reasons, dissociating myself from my Church, took degrees in France and Belgium and today I am professor teaching at various American universities. This is an individual story, but the point I am making is that this story is simply an illustration of what is going on in our cultures today. All of us have stories like this. Even if we define ourselves as being male or female, we are playing a game of reducing ourselves to physiology. In fact we are more than that. When we look at the identity of a person, culture or literature, we temporalize that identity and reduce it to a thing. To imagine a literature – Dutch, Senegalese, American – to be a literature in the way that this table is a table is a fallacy. Literature is something that moves. An individual, and a literary work of art can never be reduced to a thing, the way mathematics can state that A equals B.

A writer is someone who stands outside of the self, the culture, outside the conventional literary production and who reflects on literary creativity. A writer also creates and reflects on a personal level, being both subject and object and with the same individuality. This is why it is impossible to claim a single identity.

Literature is always literature for others. Even when it is specific, when it is national, it is a literature speaking to others. It is in the reading, the interpretation that we find ourselves. That is the point that I have tried to make by showing that any identity is a project. We are living in an exceptional moment in the history of humanity in that we see ourselves as belonging to a mixed background.

Xandra Schutte: Michaël Zeeman, on the subject of mixed backgrounds, there is this cliché that people who emigrate from one land or continent to another have a more mixed background than we Dutch people who live all our lives in Holland. Can you say something about your background in terms of the mixed identity that Valentin Mudimbe talked about?

Michaël Zeeman: I agree with Valentin Mudimbe about the hybrid character we all carry around with us. Of course this is not just the result of moving from one country or even continent to another and then to a third, but of the opportunity to find out directly at whatever trivial level about other systems of thought and systems of viewing the world. I was amazed to hear that Valentin Mudimbe had once taken holy orders, because that means he shares more of an idiom, a system of images, a system of references with me than many other people. Of course we tend to consider an obviously mixed background to be an advantage, whether it be mixing clearly defined cultures, nationalities, languages or continents.

We have a romantic idea of what a mixed background entails. It pleases us. And we tend to exaggerate the practical, historical side of our own mixed backgrounds. My students say things like 'Well, when I lived in Paris...'. They are twenty-one and they have been an *au pair* in Paris for three months, feeling desperately unhappy, longing for their parents, and they say 'When I lived in Paris', because they feel it as an advantage to have that mixed background. However, they misunderstand the relative weight of the historical difference of actually living in another place. They have twenty-five channels in six languages on their television, when they were children, their parents took them on holidays across most of the continent. The market presents a range of products incorporating all kinds of levels of cultural appreciation – eating at an Italian restaurant before going to a concert of African music. So, by selecting and collecting impressions about what is perhaps a crossroad of cultural streams, they require a culture that is hybrid. Not as hybrid as travelling from Zaire, via Louvain, to Stanford or somewhere else in America. That involves a physical effort which is much more impressive. But you cannot hide from your own hybrid character.

Xandra Schutte: We live in a multicultural society and since we talk, listen and read in various dialogues and languages we live in several cultures at the same time. But is there a difference between living in Holland in a multicultural society and actually moving between one continent and another. Or am I being romantic in thinking that the difference is greater than it is?

140

Valentin Yves Mudimbe: There is a big difference. A point has been raised about differences in ways of reading in a multicultural context; that is the kind of difference we can measure: synchronic reading. But let me complicate the matter by introducing the idea of historical reading. Take for example the Dutch or the French experience in terms of knowledge. Michaël Zeeman used the expression epistemology, which refers to the production of knowledge. If you compare the Dutch or French tradition of how knowledge and literature was produced during the Renaissance, after the Baroque period, during the classical age in France, in the nineteenth century and in our time, you find three types of intellectual configurations based on the hypothesis of Michel Foucault. During the Renaissance, knowledge was dominated by the transcendental; to know is to bring together, to link, to be able to read the book of nature, to find relations of similitude, of resemblances through conveniences, analogies, emulations and sympathies. After the Baroque period, especially after 1620, to know is to separate, to discriminate, to distinguish, to compare properties and classify them. This is a new type of knowledge. It seems more relevant, more economical, but it is different. In the West, knowledge is different from what it was during the Renaissance, and it is possible to make the distinction I made between hermeneutics and semiology. Semiology being the capacity to distinguish, and social science and hermeneutics the capacity to read meanings in social formations, in literature, in behaviour and so on. And since the eighteenth century we have historicised systematically. As you did by asking me to tell my personal story, to historicise myself. To know about languages, about bodies, about social formations, is to describe a beginning, an evolution and an end.

The point I am trying to make is that even within what we perceive to be the identity of the Western experience, we find configurations which are completely different. Which are as different as the spatial opposition between French culture and Dogon culture. But your experience as a Western woman today in the twentieth century is completely different from the experience of a woman – in terms of knowledge – of comprehending what it was to be a woman here in the Baroque period in this country. So my position is that identity, spatially or temporally, historically, is always a project in the making, contradicting itself, becoming increasingly complex. It is a mistake to reduce and essentialise.

Michaël Zeeman: Indeed, there is a beautiful example of one of the first people to become aware of projecting systems: it is in Louis Carrol's *Alice in*

Wonderland. It is the moment when Alice arrives at the palace of the King and she wants to relate what she has experienced. She is confused and wonders: 'Where shall I begin.' 'Well,' the king says, 'begin at the beginning, go right through until the end, if you arrive at the end, then stop.' This is as far as I know, the first time that the preset hermeneutics of understanding, and the definition have ever been made clear – in the dialogue with Alice.

Cornée Jacobs: There is a political dimension to the concept of the 'other', of difference, but is there an ethical dimension? And, if there is, what is it? What about communication in this regard?

Valentin Yves Mudimbe: To identity, yes, there is an ethical dimension and it can be reduced to something very simple, the title of the book published by Simone de Beauvoir, *An Ethics of Ambiguity*. Because the self is divided, the 'we' is divided, it is a predicament everyone faces. The ethics we face may be, and may indeed necessarily be, an ethics of ambiguity. So the only rule is that my freedom stops where yours begins. And then negotiate.

Xandra Schutte: Michaël Zeeman has discussed literary criticism. Besides being a scholar, you are also a literary writer. What are your experiences with critics in the Western and in the non-Western world? Is what Michaël is saying familiar to you?

Valentin Yves Mudimbe: His position is very relevant. I always cite the paradox stated by Jean-Paul Sartre in reference to Proust. Sartre said: 'Proust is infinite.' Obviously Proust's oeuvre is not infinite, we can calculate the number of words, variations, and so on. That is not infinite. Yet, I can read Proust and, the way I read Proust twenty years ago is completely different from the way I read Proust ten years ago and it will be completely different from what I sense if I read Proust today. Proust is infinite in the sense that any work of art is infinite. It is there that the tension between writer and critic exists. Literary critics have a certain subjectivity based on their own background. The battle between writer and literary critic seems ridiculous. Critics are completely free to read my writing the way they want. Just as I am a being for others, so too is my text.

Michaël Zeeman: But have you noticed differences in the responses to your work from French or American critics and from African critics?

Valentin Yves Mudimbe: Yes, the response is different; it is based on an ideological nature one can identify quite easily. The dichotomy of the African and the non-African way of reading is irrelevant. Some people in France or in Africa interpret creative or scientific works in terms of confrontational mythologies, foundation sagas. Others, in Africa as well as in France, focus on the literary dimension or the philosophical dimension. In fact, this is highly ideological. The best example is Sheik Anta Diop. A number of African savants and students see him as a prophet rather than a scientist. In France it's the same.

Today, we are living in such a complex intellectual configuration, that a distinction in terms of space - African space, European space - no longer seems relevant. The best example is Afrocentrism, a movement in the United States which is an intellectual catastrophe. A critical rereading of the history of humanity based on African prepositions, which are more ideological than scientific. Afrocentricity is not about African identity, it is a rereading and a rewriting of the history of humanity based on three prepositions:
1 The human race began in Africa;
2 The most important civilisation in history was that of Egypt, of the pharaohs, and the pharaohs were not only Africans, but black;
3 The Greeks, the founding fathers of so-called Western civilisation, were in fact in contact with Egyptians (which they were), but they stole the knowledge of the Egyptians and claimed it to be Greek.
From these three prepositions you can rewrite the history of humanity, but they are no more than prepositions. If you trace the politics of race back to the foundation of Egyptian civilisation, you are taking a dangerous route. The danger is that you show history under the burden of contemporary contradictions, and that you read history, not from the material base of facts and events and elements that can be seen, but based on today's political confrontations.

My colleague and friend Martin Bernal, a British professor of government and a professor of Near and Middle East cultures, wrote a monumental work on black Athena, showing that in order to understand the foundation of Greek civilisation, we have to understand the contribution of Egypt and the Middle East. He is correct, but he exaggerates the African influence. That's why he is celebrated by Afrocentrists: he makes their point. I asked Martin Bernal why he plays this game and he replied that he enjoys contributing to the humiliation of an arrogant civilisation. That is not a scientific argument, that is political. An African scholar like Kwame Anthony Appiah responds by saying that it is

nonsense to approach history in that way. Again the distinction between African space and European space is no longer relevant.

I realise that all history is culturally driven. But history also claims to be a discipline, a science, so we should distinguish history as a discipline from the writing of history, which is subject to ideology. What is true for history, is true for all disciplines. It is true for biology, economics and philology. History is always history for someone. But despite this, we can try to face our subjectivity in order to reduce the margins of subjectivity itself. Just look at the history of France, or of Holland, look at textbooks used in primary schools presenting the history of Holland or of France at the beginning of the nineteenth century, and compare them to textbooks published in the mid-nineteenth century and to textbooks published in the beginning of this century and then to those published in 1950 and to those published and used in this country and in France in primary schools last year. Look at the position of women in those histories. You will see an evolution. Yet ever since the nineteenth century, history has been a rigorous discipline. Even so, perspectives have changed, exactly the way perspectives in sociology have changed. I'm not saying anything about the past, I say that I have to negotiate my interpretations according to the rules of the game. That doesn't mean that tomorrow the interpretation may be different. If I decide to use the Afrocentric perspective in order to reread the history of humanity, that is my right. Yet, to remain credible, I have to negotiate that right by using the rigorous method of the period, according to the paradigms of the discipline. Otherwise I might as well stand in the marketplace and preach.

Michaël Zeeman: Returning to the issue of literature, there are two examples I would like to give. I have worked with poets and prose writers from Arabic-speaking countries on a few occasions. In the framework of a project we were confronted with the issue of language. There was a poem entitled *Het Wad*, about the mudflats of North Holland. How do you translate the term mudflat into Moroccan Berber? It takes whole lines to explain what it means. It is interesting to find empty domains of language, to find the 'untranslatable'.

The second example relates to conceptualisation. When we read or write poetry, we have an obvious expectation of what poetry is. Sometimes it is hard, however well-educated we are, to get in touch with work from other cultures.

There are many writers from Northern African countries (Malika Mokeddem, Tahar Ben Jelloun, Mimouni, Rachid O) in prominent positions in French literature these days. It is far easier to read their books than to listen in

on a mutual poetry reading of Arabic poets and Dutch poets, since these writers share the same language, namely French. Nevertheless, interpreting concepts in these books proves highly complex. The comments I have heard at readings in the Institut du Monde Arabe in Paris from North African, French-speaking readers, and Parisian-based French people reveals completely different levels of conceptualisation.

The third level is also interesting. I was recently in The Hague at a reading in the public library with seven exiled Arabic poets. Most of the people in the audience were of Arabic origin. Something spectacular happened: some of my poetry had been translated into Arabic and an Iraqi poet stood up and said: 'You are deeply influenced by Arabic literature. It is a sort of poetry I have never heard in Holland. What you write is ironic, sceptical, anecdotal, but you are writing also about sadness and love, typical Arabic themes, deeply Arabic themes.'

This was very interesting because, I have no Arabic influence that I am aware of. I have read a lot of poetry, but the activity in the back of my mind of old Arab verse, is on a level with old Chinese or Japanese verse, or Spanish verse. It is highly unlikely that I have been influenced by Arabic culture.

Valentin Yves Mudimbe: How do you know that? Are you sure?

Michaël Zeeman: Well that's the interesting question: how can one know, how can one be sure? How can I say: this Iraqi poet is wrong? For her she is right.

Xandra Schutte: In Western criticism of non-Western literature, you find notions about the mixture of influences, the influence of Western modernism and post-modernism on the one hand, the local literary or oral traditions on the other hand. Valentin Mudimbe, Michaël Zeeman talked about a new kind of hybrid literature emerging, and with tremendous success. Do you have the same idea about this literature?

Valentin Yves Mudimbe: Absolutely, we live in a period which is amazing in terms of the literary landscape. Our sources are increasingly shared. We travel more easily, today we may be in Amsterdam and tomorrow in New York or Cairo. In terms of reading also, the politics of literary translation is incredible compared to that of the nineteenth century for example. There is a globalization of epistemological space in terms of creativity and in terms of scientific productivity. Let me give you a concrete example to illustrate the point.

Some time ago a number of colleagues met in Houston, Texas. At a given moment they were discussing my rather theoretical and academic book *The Invention of Africa*. An American colleague said in public, while I was there: 'This book of Mudimbe is uninteresting, and it is not useful, we can read it, but it is not African, because an African peasant cannot read it.' Well, why should I write for an African peasant. No American peasants are going to read it, if he was implying that I was writing for the American audience. This concrete example shows the new space in which we function today. Pierre Bourdieu, the French sociologist who rejected Karl Marx, suggested that we forget about social class and we refer to 'classes on paper'. The paper classes created by education, assimilation, conversion and dialogues, include many who would have been set apart on the basis of race or sex in the nineteenth century. We are creating new areas of dialogue and creativity.

Xandra Schutte: I don't know if there are many African elements in your novels, but I imagine that some 'primitive' readers, if they do not find African elements, would be disappointed. What is your experience?

Valentin Yves Mudimbe: That may be what the media suggests, who tend to impose these identities on us. When I say I am an African, teaching philosophy at Stanford or Duke University, some people are shocked. I am supposed to be exotic and if I teach at the university, it should at least be exotic things, like anthropology for example. The same applies to Michaël: he writes poetry and it has an Arabic dimension or sensitivity and people don't understand what's going on. I think that we have to oppose these essentialist policies of identity that reduce us to a set of characteristics. Because you are a Dutch woman, people expect you to behave like a Dutch woman. What is a Dutch woman anyway?

Xandra Schutte: Michaël Zeeman, you're not just a poet, you are also a critic. Are you at times an essentialist reader? Perhaps not by choice, but nevertheless...

Michaël Zeeman: Yes, but on a slightly complex level. Taking exoticism as a state of mind of the Western world and with it's long history... Certainly it is seductive, but it has had its heyday. We are much more aware of it than fifty years ago, or even twenty five years ago. The most beautiful example in twentieth-century literature is Pearl S. Buck. No one reads her work anymore,

but if you read the critics of the 1920s and the '30s, you discover she received a Nobel Prize for her chinoiserie. The developments of the last fifteen years have made us aware of our expectations, and that the important literature from outside the Western world is literature that no longer tries to fill our folkloristic expectations, nor do we hesitate as soon as we see folkloristic elements in that literature. To compare this with the visual arts, there was a time when we referred to *primitive art*. In this century we used the term *ethnographic art*, which was useful to the modernist developments in the visual arts of Europe [Picasso, for example, was heavily influenced by African iconography, Ria Lavrijsen]. Later, the dichotomy returned. It was no longer an incorporated element. But you would not expect an Aboriginal artist in Australia to produce stones and painted carpets and other tourist attractions. So it has doubled, and now the denial has to double again.

Today, there is a growth in political and governmental structures, increasing globalization and internationalisation, while at the same time the concept of identity has given birth to a Babylonian confusion. Private and individual identity is mixed with cultural identity, national identity, local identity, gender identity or whatever. It is a beautiful melting pot bubbling over the fire. But what you see is the concept of local or regional cultures – cultures that are not participating on a larger scale – which we saw during the 1960s and '70s through the communication industry, the common sets of cultural values; these are still very much alive. Like the Scottish renaissance in Britain, the recognition of the Frisian language in the Netherlands as a second official language and the efforts in southeast Limburg to get the local patois recognised as an official language. Within my own lifetime we will need courses to understand each other's languages.

Ria Lavrijsen: In today's multicultural society there is a tendency to romanticise There are people who say: if we discuss literature and migrant communities and we want to communicate with these migrant communities, we have to recognise their oral traditions. Supporters of this view are found in and outside the migrant communities. And in South Africa, Njabulo Ndebele has pleaded against this whole process of retraditionalisation, of romanticising old traditions. How do we deal with this phenomenon, which is part of the cultural debate?

Michaël Zeeman: It is a concept we both know in history and anthropology: the invention of tradition. Today you find folklore about the invention of tradition

everywhere. Just before I came here I was reading a book on the most folkloristic place we have in this country: the island of Marken. A so-called typical wedding party was being discussed. This kind of party is now put on for tourists, and they claim it is an age-old tradition. But the first wedding of this type took place in 1927.

It is romantic to talk about traditions and to purify them of strange influences. That is my point. I consider them to be romantic myths, with all the dangers that accompany the genre. I am far more interested in the common ground, in the result of the process of negotiation that Valentin Mudimbe is talking about, then withdrawing into idiosyncrasies.

Valentin Yves Mudimbe: I would go even further. We seem to be inventing traditions, because we need foundation sagas, a history of particular experience. And we live at a time in which it is fashionable to claim that anything, any culture, any social class constitutes its own system with its own rules and its own norms. This is true of South Africa, it is true of England and Scotland, Ireland and the United States and people are unfortunately even ready to kill in the name of that promotion of difference.

Some people say: 'I want to create a difference, an epistemology, a department at university to promote the epistemology of people who, like me, have flat feet. Why not? It's a difference. We have been discriminated against throughout the history of the West because of our flat feet. We have been barred from the army, for example.' We can begin with flat feet, and then fat people, and then left-handed people ... At least there we could imagine the possibility of universality. These differences – flat feet, fat people, left-handed people – are real, they are objective. They are as objective as the existence of Flemish people as opposed to Walloons.

Ria Lavrijsen: Given the history of racism, colonialism, women and sexism, I know many people from the migrant community here, who would object strongly to what you are saying.

Valentin Yves Mudimbe: Absolutely. I work at universities where there are traditional departments of German studies, of French studies, but there are also Chicano studies, gay studies, and we promote all these differences in order to understand the variety of human experience. I was being provocative, because we have to ask ourselves: how far can we go in that promotion of differences. Who is going to pay for it. Stanford University can afford to have

these programmes. How many universities in the States can do that, how many universities in the world can do that, even in Africa? And we know that by promoting these differences, we are promoting new traditions. We are separating ourselves in order to meet.

As for the understanding, my position is traditional. I would say in social sciences, humanities and economics, we can examine the dialectics between the processes of production and the social relations of production. We can also look at variations in terms of gender, classes, races. We can use a rational and objectivist method by reflecting on the organisation of power. Who exercises power? How? Since when? We can link these questions to the political discourse. And we can then start to understand what is going on in the city, not only in terms of gender or races, but also in terms of the production of literature. Who is producing literature? What kind of literature? What kind of ideologies are being produced? That is a different way of entering dialogue, rather then creating ghettos in which we enclose ourselves because we have flat feet, because we are women or because we are Chicano.

Report on the debate on film

Gerdin Linthorst: The Western world has set a universal standard against which all cinemas are now measured, including Indian cinema. Does that affect you?

Kumar Shahani: Yes it affects me. But I think the problem is the lens itself, not so much the so-called universal standard. The way a film is made, the different layers of colour, the way it is produced chemically, the way it registers, is already a certain kind of language which has its roots in the Renaissance. It is not just me that is colonised by that linguistic system, it is inherited in the technology. The people who invented the technology, they are colonised by the fixity.

An important aspect of the lens is the vanishing point: the presence of God in the so-called scientific perspective. This is the problem that we have to overcome not only *vis-à-vis* visual presentation, but for the musical presentation, as well as the narrative, because it really conditions ways of thinking for a lot of people who just accept these things. Black, Indian, Western it doesn't matter, everyone is as colonised as I am.

Gerdin Linthorst: The danger here is perhaps that the idea of a Third World culture is revived. An underdeveloped culture, which is supposed one day to become a First World culture, our world culture. What's your opinion about that, Paul Willemen?

Paul Willemen: Third World culture is a nonsense term, it was invented during the Cold War. It's redundant now. It doesn't mean anything anymore. Once you accept that there is no such thing as one world that can be unified and described as a Third World, it is no longer a concept worth using.

Gerdin Linthorst: Isn't there also a danger that non-Western filmmakers will accept these notions about an underdeveloped culture and about the Western universal standard, and will adapt to them in a sort of self censorship?

Paul Willemen: Let me ask you about the term non-Western. Is there such a

thing in the West as a non-Eastern filmmaker? What does a Ghanaian cultural form have in common with medieval China? What justifies the lumping all these aspects in one concept? In the end, it says nothing about any culture at all.

Gerdin Linthorst: Indeed, but we always talk from the perspective of our own culture. I cannot talk from the basis of any culture other than my own.

Paul Willemen: I agree that it's difficult. Everyone has habits of speech and thought. I sympathize with your difficulty, but I think we have to try.

Gerdin Linthorst: But what's the problem exactly?

Paul Willemen: The problem is placing yourself in the centre as the standard by which everything is measured.

Gerdin Linthorst: But all filmmakers do that.

Kumar Shahani: Well I don't! I can't think in terms of Western or Eastern. Many filmmakers, poets and critics have rejected the notion of separate identities. It's painful not having a bed to go to at night, but it keeps you alert and keeps you alive and it probably makes you enjoy some things more than people who have a bed at night and always go to the same bed.

Gerdin Linthorst: I have a problem with that! Many European films of the last fifty years have presented strong national identities. Filmmakers such as Ingmar Bergman of Sweden or Fellini of Italy had strong national identities, and that is why they are successful and popular. Today, Europe is trying to be united and a sort of Euro co-production cinema has been born. This kind of cinema seems to fail because of a lack of identity. What's the matter with going to the same bed every night?

Kumar Shahani: It can all go wrong, not only between West and East but also next door. You have people who behave humanely and suddenly become monsters with strong nationalistic feelings, because they decide that they speak Marati, Gujarati or Urdu and the other person doesn't speak that language. Or that they have a single God and the others have multiple Gods. It's not just a question of race or nation. And of course there are signs of that in

the gender question which is worrying. I recognise the need for the feminist movement, that women be able to assert their rights: but mental barricades have started to appear between men and men, men and women and so on, purely on the grounds of identity. First the gender topic, later sexual preference. It is increasingly fragmented and I think that this fragmentation leads to intolerance. This serves the purpose of those who creates the actual situation, which has been the story of India for hundreds of years.

Paul Willemen: I would just like to make the point that Fellini was never popular in Italy and Bergman was never very popular in Sweden.

Gerdin Linthorst: To what extent are Indian filmmakers popular in India, Kumar Shahani? These days, for example, Chinese and African filmmakers are popular in Europe but they are not always loved by their own governments or local audiences. How is that in your case?

Kumar Shahani: My films aren't popular anywhere in the world! This has nothing to do with my films, it is a structural problem, a problem of distribution.

Gerdin Linthorst: Identity is a complex matter. Paul Willemen, if you tell me not to approach it from the perspective of Western cinema, how do you suggest I approach it?

Paul Willemen: That's a good question. There are two brief points. On the subject of national identity I argue that national identity is not a matter of origin at all, it is something that is painfully and painstakingly enforced, it is something we are educated and trained into. All the social rituals that are designed to solicit our affections and emotions and attach them to certain national symbols, combine to make you a national subject. I don't think it's a matter of origin. Given that this is what creates the notion of the national, you might think I was implacably opposed to any notion of identity and implacably in favour of any notion of subjectivity. I wouldn't want to polarise it like that, because I think the two are joined, like two sides of a coin. What is important is the tension between the two, how you steer the tension and in which direction you steer it. You can manage it in the direction of identity or in the direction of subjectivity. But you need concepts of identity, partly because you cannot escape them, partly because they are useful points of

references, they can act as a shorthand. The problem arises when you identify completely with these points of reference, in other words, when you assume all the characteristic attributes that go with what is simply a point of reference which nobody really inhabits.

Gerdin Linthorst: I meet young African filmmakers who are offended when I talk to them as African filmmakers and about African cinema. They are offended because they do not want to be seen as African filmmakers. How do you deal with that?

Paul Willemen: When you interview African filmmakers you should take their position into account. They are trying to survive as filmmakers by raising funds and by pleasing certain people. They usually try to finance or sell their project in different countries. So it doesn't make sense to say, I am a Senegalese filmmaker and I need lot's of money from Germany. You define yourself in different ways in this market. Naturally they object. Secondly, making films as such is very difficult for African filmmakers. It's hard trying to organise your next film. So it's perfectly understandable that they should position themselves in a sort of no-man's land were they can receive money from everywhere.

Kumar Shahani: I remember I once refused a retrospective of my films. The organisers of a festival in Europe had asked me to present a retrospective of Altman and Susamani of Japan and two Indian filmmakers. I wrote back: 'If you can't remember my name than forget about the retrospective.' That was an insult! Moreover we are working in a global market now and either you accept it or you reject it as a commodity. The commodity is not the film; you are the commodity. The important thing is not to be taken for some sort of exotic African or Indian fruit.

Gerdin Linthorst: True, a lot of people in Europe want to see films from other continents, a sort of exoticism or folklore which the makers of those films themselves reject. But when we watch an African film, for example, we want to see the beauty of the baobab tree; because that's something we don't have. What's your opinion? What's the harm in it?

Kumar Shahani: You are the poorer for it if you only look for the baobab tree and you don't look for other things Africa has to tell you.

Gerdin Linthorst: And if I do look for other things. To what extent can we really understand those things?

Kumar Shahani: Why shouldn't you? I know that it is difficult; our perceptive organs are conditioned by ways of listening or ways of looking at things through the cultures imposed on us. By proposing one particular system you suppress the other potentialities that might be there. I know people in India who can't stand Chinese or Western music, and I know people in the West who can't stand either Indian or Chinese music. It's their loss and it is my loss if I cannot appreciate it.

Paul Willemen: That raises the question of how well we understand our own cinema.

Gerdin Linthorst: On the subject of modernity, to what extent are we able to understand new languages? Isn't there a danger that filmmakers will try to adapt to what audiences want to see? Will they feed us with the baobab tree and the exotic stuff we like so much and apply a form of self censorship?

Kumar Shahani: Ninety-nine percent of the filmmakers do that.

Paul Willemen: Fortunately, it doesn't always succeed. If people knew what audiences really wanted, then there would be no box office flops. It's difficult to predict. There is no formula, however much a filmmaker tries to look to certain formulas that made money in the past, there is no guarantee that it will work again. Sometimes it does, sometimes it doesn't. The reasons for this are elsewhere, not necessarily in film.

Kumar Shahani: Usually it's the distribution system. Spielberg can earn 85 million dollars in a week.

Paul Willemen: But even a Spielberg film doesn't always make money. Some of his films have been massive flops. There's another issue. I teach film to filmmakers, I have to remind them constantly that the way they read a film is a restrictive way of relating to films. And I'm sure that it's the same for teachers of literature, painting and so on. There are certain automatic reading habits that you develop and are trained to use. If you think back to the way we are taught to read at school, the way to judge what constitutes good literature,

it's a whole aesthetic training which you are supposed to absorb and to reproduce. That's an institutional training, not a training in skill; it is a training that is not supposed to make you proficient, it's to keep the rest out. It is not to control what's inside the boundaries, it's to avoid other ways of relating to films and culture. As I see it, my task is not to say this is a better way of understanding a film, but to give people better tools to think with, to be able to see more complexities at work and derive pleasure from that. Pleasure is a big issue. You can derive pleasure from working with the variety of tools, rather than expecting films to provide you with a confirmation of a pleasure which you know is your particular pleasure regime, simply because you have been told that it is.

Gerdin Linthorst: Is it possible to get these tools when America and Hollywood dominate the world?

Kumar Shahani: It is mainly the notion of individuality, the way the individual filmmaker cuts, shoots, or organises action or colour. How faithful you can be to the vision that you as a filmmaker have, is the determining factor for the audience and for yourself as a maker. To be anguished enough about it in the first place.

Paul Willemen: We should not forget that a lot of the effort and the energy behind questions about how we relate to films historically, come from an intense involvement with Hollywood since the 1950s. Hollywood is not a monolith. David Lynch's film *Lost Highway* was not made in Hollywood but it's a Hollywood film and an anti-Hollywood film at the same time. It's a Hollywood film without a central character, that is a major narrative innovation. Hollywood elaborates certain formula, like Frank Tashlin in comedy and Douglas Sirk in melodrama. They worked with Hollywood conventions but did different things with them. I don't believe in creating demons, not even Hollywood.

Gerdin Linthorst: You mention Douglas Sirk's melodrama, and refer to the similarity between Indian and early European melodrama dealing with the conflict between the rising bourgeoisie with it's moral and cultural values, and the declining aristocracy. Today, in Chinese, Taiwanese and African cinema you see the same kind of tension between collapsing old traditions and rising new sets of values. Do you consider this to be a time in which new

values are replacing old ones, especially in the non-European non-American cinema?

Paul Willemen: There are three types of melodrama. The first is the theatrical melodrama starting at the time of the French revolution, with the amazing discovery that nobles and aristocrats could be really nasty. This became a stock figure of melodramatic theatre, which went hand in hand with the kind of endings with which we are now familiar. Later, in England, the figure of the honest mechanic emerged, which was basically a worker in a factory who in the end falls in love with the boss's daughter, or eventually it turns out that he is a long-lost son and the old status values are restored.

These belong to the first type of melodrama which depends on the notion that a particular generation understands and can attribute preset values to certain social groups. Then there is the Douglas Sirk kind of melodrama, in which the tragedy revolves around the tension between parents and their children, parents making judgements the sons and daughters who do not necessarily agree. The status identity remains in place but there's a tragic dimension to it and a desire to get out. The third is the *When Harry Met Sally* type: two individuals who know nothing about each other bumping into each other. It develops into a crazy comedy. The narrative is based on the absence of knowledge, on the fact that people don't know anything about each other and the next thing the heroine discovers is that she's sleeping with an axe-murderer. It is this kind of analysis that can be useful in trying to understand films produced by various cultures.

Gerdin Linthorst: Europe needed the Renaissance or Enlightenment in order to create new values and modern notions. Is modernity possible without Enlightenment?

Paul Willemen: As Ghandi said about English civilisation. It's not a bad idea to have had it.

Kumar Shahani: I suppose I would agree.

Gerdin Linthorst: A bit of modernity wouldn't hurt then?

Paul Willemen: I look forward to it.

Gerdin Linthorst: Kumar Shahani your latest film *Char Adhyay* was inspired by a Rabindranath Tagore story. Tagore expresses the idea of the Bengali Renaissance, that's an intellectual and spiritual movement which attempted to reconcile Indian and Western values. Can you tell us about it?

Kumar Shahani: At the start of the twentieth century the notion of the Bengali Renaissance was something that many people from that part of India believed would reform society, which had been confused by internal contradictions and colonialism. The Bengali Renaissance tried to reverse this degradation. When Tagore wrote this novel at the beginning of the century, he was questioning the idea of Bengali nationalism or the need for it. That kind of identity crisis had not been invented yet. Tagore had travelled. He had an Argentinian girlfriend and was quite old when he wrote this novel. Hitler was already in place in Europe and Tagore was aware of this. He had begun to develop an international vision. He started questioning anything to do with nationalism; after friends of his joined the militant movement which degenerated into violence against people in Bengal. *Char Adhyay* is a film which opposes in a sense *self realisation* that is supposed to be a long-standing cultural goal of that part of the world and *self determination*. Tagore places these two in a sort of tension in this novel.

Gerdin Linthorst: I hope it will show in Rotterdam but they are still negotiating.

Kumar Shahani: It's India's fault, they are censoring it out of existence.

Gerdin Linthorst: What do you think about this reconciliation of Eastern and Western standards, is it possible? And if so what's the best way to create a new standard?

Paul Willemen: To me, reconciliation presupposes a form of hostility and enmity which have been created and constructed. I have never seen a reliable outline of these differences. We are still trying to work out the problems. Reconciliation is not on the agenda as far as I'm concerned. There are major problems, not in trying to understand other cultures, but in de-touring: back into your own culture.

If Western aesthetic and film theories devised in Europe and the United States cannot deal adequately with the strategies of narration and narrative constructions in melodrama, music etc. in other cultures, how much trust can

we place in the theories dealing with Euro-American cultures? If there are whole areas of cultural function that these theories cannot explain, are they really suitable for their own cultures? Is the historical condition of their own cultures taken into sufficient account in their aesthetic strategies? I have concluded that the answer is no. One of the main things I have learned from talking and working with Ashish Rajadhyaksha is that I began to understand the limitations of the theoretical cultural formation from which I have emerged. I am now, I hope, touching it's limits and trying to find out their contours, looking to other people to help me out of this.

Gerdin Linthorst: I am afraid it will keep getting more complicated. Because these days we live in a multicultural world which will probably effect the appreciation of world cinema and change everything we have just discussed. How does it effect the multicultural world and the way geographical borders are disappearing and changing?

Kumar Shahani: Borders are created by multiculturalism.

Gerdin Linthorst: In Europe that is certainly true! The moment Europe was united, we started building walls to keep the rest out.

Kumar Shahani: In North America the philosopher Charles Taylor has argued that not only is multiculturalism being practised in society, but within individuals as well, as people try to find themselves. He seems to be celebrating it, and failing to understand the fractures that it produces within the body and the mind. Here we are trying to create freedom for the individual and at the same time the individual is being fitted into multiculturalism and broken apart.

Paul Willemen: I agree with Kumar that multiculturalism is a problem. I used to earn my living as a cultural bureaucrat for multiculturalism in Britain. Multiculturalism was presented as a liberal progressive policy for tolerance, but there are problematic aspects. The notion of multiculturalism presupposes or implies that you define the other cultures and that you therefore lock them up in neat little boxes. You define Indian, West-Indian culture, Turkish, Kurdish and so on. Multiculturalism becomes just an accumulation of boxes. If you give these communities funding according to their proportion of the population, you automatically end up with the most conservative

representatives of these cultures becoming their spokesperson. So in effect what you do with multiculturalism is you create a set of identities. You can always find people to embrace this kind of identity and promote themselves as representatives. People who feel uneasy about these cultural ethnic definitions never get to talk or they are not represented in negotiations, they are marginalised, hybrids and mongrels. The people that make the definitions determine the kind of people who can occupy the position of spokesperson. You define the kind of person to speak for these cultures. Multiculturalism always selects the most conservative backward looking members of any particular community to speak in their name and those who cross over the border never get a look in. Cultural funding in that system always goes to the most conservative backwards looking areas of the cultural map. For me, multiculturalism is more part of the problem than part of the solution.

Ria Lavrijsen: What's the solution then?

Paul Willemen: You tell me.

Kumar Shahani: It is the same for every oppressed minority, as it is for women, and in their case they are not even a minority. The idea is that artists, regardless of their background should be given the opportunity as individuals to be able to ensure that a work of art is individuated. That is the only way to function; not merely because the artist happens to be a Black, Arab or Indian woman. We must view art as individuated; as something which moves things in unanticipated directions.

But the exact opposite is happening; there is complete control. There was a person in the Netherlands who was interested in buying a film of mine to broadcast on Dutch television. After he had seen one reel he said: 'I cannot possibly show this film. The idiom is not what the market wants.' If eventually even those who want to protest, bow to the market, then I'm not sure if an Arab women in the Netherlands will ever get the chance to make a film with the content and form she wants to present.

I remember a student of mine, who was working on a women's project with a non-governmental organisation (NGO) in India supported by the Dutch government. Women in India come from a very specific background: oppression by men is not exercised in the same way as here. Her advisers, however, insisted that oppression was the same the world over. This shouldn't be allowed, not *vis-à-vis* the artistic form either.

160

Usually cross-cultural people look at what's going on in the film instead of what's actually being said and shown. A film with a particular emotional, philosophical or ideological base, only begins to make sense if it is completely individuated. Only then can it say something free, new and with the authenticity of experience. The problem is that there are marketing experts who tell you how to make a film and what to put in it.

Paul Willemen: Returning to the question of multiculturalism: there are two aspects. One is the inescapable fact that identity includes an ethnic and social element. This kind of notion of identity is an administrative category that relates to disadvantages which must be recognised. The problem, however, comes at the second level: the assessment of proposals, applications for film projects.

As a former cultural bureaucrat I know the problem: differentiation. Differentiating between projects requires historical aesthetic judgements about the extent a project confirms, historicises, examines and complexifies a particular set of problems, that the filmmaker and the culture inhabits. It is about the critical exploration of the tensions of a particular situation without regard to which ethnic identity is involved. To make the two decisions, the administrative and the artistic simultaneously is the difficult part for a bureaucratic organisation. It's easy to have numbers and to say: we have a certain quota of Turks and Asians, a proportion of the money goes to these people and to some other group. But the second aspect is the most essential; to assess the way a particular manner of inhabiting your culture is dealt with by a filmmaker. This is less easy for bureaucrats and there are no prescriptions for it. Bureaucrats are bound to make wrong decisions. So there are always more interesting films which get marginalised. Kumar Shahani's film is not Indian, although it comes from India, and it is not European. Kumar's films examine with material that derives from an experience of living in India, a way of inhabiting a culture which itself is crossed with all kinds of currents and hybrids. And the film is about living in India, because that's the material he works with. I prefer his way of questioning and working with it, to that of other Indian filmmakers. This is a problem. The more interesting a film the less easy it is for people to understand it and for it to be fitted as a commodity into the existing circus.

Gerdin Linthorst: As far as I know in India, films have to be accessible to a large audience, for example in the Bombay industry. Is there any internal pressure to represent a kind of essentialised India in India itself?

Kumar Shahani: Yes, it's a big problem, just as it is in the West. It's the old business of fitting everything in now and it seems that film producers and even festival managers are increasingly deciding on this basis. For instance, festivals now operate with video cassettes. They say it's because they cannot afford film. I remember good old Huub Bals who used to watch thousands of films personally, he saw them on film. To select films on video is impossible. A video is no way of looking at a film.

Gerdin Linthorst: I am afraid it is one of those irreversible aspects of modernity.

Paul Willemen: I differ from Kumar here. You can judge on the basis of a video if a particular film is interesting, if you know how it translates to film and the large screen.

Kumar Shahani: I find that difficult. These days we do colour correction on a video monitor. I insist my camera man goes to the laboratory because I cannot really make out exactly how the film will look in density and colour on video. I find it disorientating.

Gerdin Linthorst: It seems that maybe in this *fin de siècle* everybody is looking for new identities because the old ones no longer suffice. Traditions are being reconsidered. As a result, the notion of modernisation applies just as much to Hollywood and to European films as to Indian or other cultural practices.

Authors and contributors

Okwui Enwezor is a Nigerian-born, New York-based curator, writer and editor. He was artistic director of the 1997 Johannesburg «Biennale» in South Africa. He is publisher and founding editor of *Nka, Journal of Contemporary African Art*. As a critic he has written extensively on contemporary African and American art and as a curator he worked for the Guggenheim Museum, the Aljira Center for Contemporary Art, the Newark Museum and others.

Maarten Bertheux is currently assistant director at the Stedelijk Museum Amsterdam. He has taught art history and has worked education and communication. He curated a large number of exhibitions for the Stedelijk Museum in Amsterdam and several exhibitions of Stedelijk Museum material which toured abroad.

Lamice El-Amari is an Iraqi-born, Berlin-based theatre critic and university lecturer. She has worked as a journalist in Iraq, Egypt and Europe, and lectured at universities in Germany and Algeria. She is specialised in Brecht and modern English drama and has worked as a translator in English and Arabic.

Catherine Ugwu has worked as the Deputy Director of Live Arts at the Institute of Contemporary Arts, London, and is now an independent curator and consultant. She has contributed to numerous national and international conferences, seminars and debates. She compiled and edited *Let's Get It On: The Politics of Black Performance*.

Valentin Yves Mudimbe is a Zairean-born, us-based professor of literature and African studies at Stanford University in California. He studied economics, linguistics, and sociology in Kinshasa, Louvain, and Paris. Among his numerous publications are *The Invention of Africa* (1988), *The Idea of Africa* (1994), *Le Bel Immonde* (1976, a novel in French), and *Tales of Faith: Religion as Political Performance in Central Africa* (1997).

Michaël Zeeman is a Dutch writer, poet, journalist, and television presenter. He was the former head of the arts section of one of the main daily newspapers

in the Netherlands, *de Volkskrant*, for which he still writes regularly. He presents a literature programme for VPRO on Dutch television.

Kumar Shahani is an Indian art film maker and writer based in Mumbai (Bombay). He studied film in Mumbai and Paris. In the 1960s he worked in France with Robert Bresson. His feature films were shown in India and in the international film festival circuit in Europe and the United States and have received numerous awards. His most recent feature film *Char Adhyay* was shown at the Rotterdam Film Festival 1998.

Paul Willemen is a Belgian-born, UK-based professor at Napier University, Edinburgh. He was a member of *Screen*'s editorial board in the 1970s and edited *Framework* in the 1980s. He has contributed to many film journals and is the author of *Looks and Frictions* (1994), *The Encyclopaedia of Indian Cinema* (with A. Rajadhyaksha, 1994), *Questions of Third Cinema* (with J. Pines, 1989).

Curator of the programme and publication

Ria Lavrijsen is a Dutch writer who has written on 'interculturality' and art policy and coordinated a number of international seminars and conferences on this subject. She edited a publication entitled *Intercultural Arts Education and Municipal Policy – New Connections in European Cities* (1997). She is informative programming curator at the Royal Tropical Institute Theatre in Amsterdam.

Chairpersons

Dragan Klaic is director of the Theater Instituut Nederland.

Gerdin Linthorst is a film journalist and critic for *de Volkskrant*.

Din Pieters is an art critic and chairs a committee of the Netherlands Foundation for Fine Arts, Design and Architecture.

Xandra Schutte is a literary critic and journalist for *De Groene Amsterdammer*.

Literature

Al-Isfahani, Abul-Faraj, *El Aghani*, vol. 11. (Arabic)

Altbach, Philip G. and Salah M. Hassan (eds.), *The muse of modernity: essays on culture as development in Africa*. Asmara (Eritrea), Africa World Press, 1996.

Appiah, Kwame Anthony, 'Is the "post" in postcolonial the "post" in postmodern?' In: Anne McClintock, Aaamir Mufti & Ella Shohat, *Dangerous liaisons: gender, nation, & postcolonial perspectives*. Mineapolis/London, University of Minnesota Press, 1997.

Appiah, Kwame Anthony, *In my father's house*. Oxford, Oxford University Press, 1992.

Aqla Irssan, Ali, *Theatre phenomena and the Arabs*. Damascus, 1981. (Arabic)

Araeen, Rasheed, 'Europa 1992 en de plaats van de "Buitenlandse kunstenaar" in de nieuwe orde'. In: *Het klimaat: buitenlandse beeldend kunstenaars in Nederland*. Den Haag, Culturele Raad Zuid-Holland, 1991.

Aziza, Mohamed, *Le théâtre et l'Islam*. Cairo, 1971.

Balandier, Georges, *Sociologie des Brazzavilles noires*. Paris, Colin, 1955.

Bearden, Romare and Harry Henderson, *A history of African-American artists: from 1792 to the present*. New York, Pantheon Books, 1993.

Beauvoir, Simone de, *Ethics of ambiguity*. Secaucus, NJ, Citadel Press, 1994.

Beauvoir, Simone de, *The second sex*. New York, Vintage, 1974.

Belzoni, Giovanni, *Narrative of the operation and recent discoveries within the pyramids*. Westmead (Hants, England), Gregg International Publishers Ltd, 1971. (Originally published in English, 1820.)

Bhabha, Homi K., *The location of culture*. London, Routledge, 1994.

Bouazza, Hafid, *De voeten van Abdullah*. Amsterdam, Arena, 1996.

Bourdieu, Pierre, *Opstellen over smaak, habitus en het veldbegrip*. Amsterdam, Van Gennep, 1989.

Bourdieu, Pierre, *In other words*. Stanford, Stanford University Press, 1987.

Budney, Jen, 'Who's it for? The 2nd Johannesburg Biennale'. In: *Third Text*, no. 42, Spring 1998.

Cámara, Ery, 'Multiculturalism and ethnicity'. In: Christian Chambert (ed.), *Strategies for survival – Now! A global perspective on ethnicity, body and breakdown of artistic systems*. Lund, Swedish Art Critics Association Press, 1995.

Canguilhem, George, *The normal and the pathological*. New York, Zone Books, 1991.

Certeau, Michel de, *The practice of everyday life*. Berkeley, University of California Press, 1984.

Chambers, E.K., *English literature at the close of the Middle Ages*. London, Oxford University Press, 1961.

Chamoiseau, Patrick, Jean Bernabé and Raphaël Confiant, *Eloge de la Créolité / In praise of Creoleness*. Paris, Gallimard, 1989.

Clifford, James, *Routes, travel and translation in the late twentieth century*. Cambridge (Massachusetts)/London, Harvard University Press, 1997.

David, Catherine, 'A reawakened interest in other cultures: urgency or alibi?' In: *MED URBS VIE, the authentic contemporary art from countries such as Egypt, Morocco and Turkey and its presentation in Europe*. Rotterdam, Rotterdamse Kunststichting, 1993.

Dédale, nr. 5-6 (1997), special number on post-colonialism. Paris, Maisonneuve, 1997.

Derrida, Jacques, *Writing and difference*. Chicago, University of Chicago Press, 1978.

Elliott, David, *A story of the eye. About vision: new British painting in the 1990s*. Oxford, Museum of Modern Art, 1996. (exhibition catalogue)

Enwezor, Okwui, 'Travel notes: living, working, and travelling a restless world'. *Catalogue Biennale Africus 1997*. Johannesburg, 1997.

Faraj, Alfred, 'An interview'. In: *Theatre and social realism, an ITI-GDR international colloquy for theatre people from countries of the Third World*. Berlin-Schildow, 1976.

Foucault, Michel, *The archaeology of knowledge*. New York, Pantheon, 1972.

Greenberg, Reesa, Bruce W. Ferguson and Sandy Nairne (eds.), *Thinking about exhibitions*. London, Routledge, 1996.

Hall, Stuart, 'The local and the global: globalization and ethnicity'. In: Anne McClintock, Aaamir Mufti & Ella Shohat, *Dangerous liaisons: gender, nation & postcolonial perspectives*. Mineaopolis/London, University of Minnesota Press, 1997.

Hall Stuart, 'The question of cultural identity'. In: Stuart Hall, David Held and Tony McGrew (ed.), *Modernity and its futures*. Oxford, Polity Press in association with Blackwell Publishers and the Open University, 1992.

Hanru, Hou, 'A certain necessary perversion'. In: *Heart of darkness*. Otterloo (the Netherlands), Kröller-Müller Museum, 1994.

Heusch, Luc de, *Le roi ivre ou l'origine de l'état*. Paris, Gallimard, 1972.

Hountondji, Paulin, *African philosophy: myth and reality*. Bloomington, Indiana University Press, 1983.

Landau, Jacob M., *Studies in the Arab theatre and cinema*. Philadelphia, 1958.

Lavrijsen, Ria, *Beyond exoticism, ethnic chauvinism and faceless universalism*. Wonderstories nr. 2. Maastricht, Jan van Eyck Academie, 1996.

Lavrijsen, Ria (ed.), *Cultural diversity in the arts: art, art policies and the facelift of Europe*. Amsterdam, Royal Tropical Institute, 1993.

Lavrijsen, Ria, 'The body: a house of emotions'. Interview with Clifford Charles 1993 in Amsterdam. Unpublished.

Lavrijsen, Ria, Video-interview with Homi Bhabha in the ICA in London for the MED URBS VIE Conference. Rotterdam, the Rotterdam Arts Council and the City Council, December 1992.

Lévy-Bruhl, Lucien, *The notebooks on primitive mentality*. Oxford, Blackwell, 1975. (Original title: *Les carnets*. Paris, 1949.)

Lucie-Smith, Edward, *Movements in art since 1945*. London, Thames and Hudson, 1995.

Maharaj, Sarat, 'Perfidious fidelity: the untranslatability of the other'. In: Jean Fisher (ed.), *Global visions: towards a new internationalism in the visual arts*. London, Kala Press/Institute of International Visual Arts, 1994.

Marx, Karl, *A contribution to the critique of political economy*. London, Lawrence and Wishart, 1971. (Original title: *Zur Kritik der Politischen Oeconomie*, 1859.)

Masolo, D.A., *African philosophy in search of identity*. Bloomington, Indiana University Press, 1994.

Mazrui, Ali A., 'Perspective: the muse of modernity and the quest for development'. In: Philip G. Altbach and Salah M. Hassan (eds.), *The muse of modernity: essays on culture as development in Africa*. Asmara (Eritrea), Africa World Press, 1996.

McEvilley, Thomas, 'The tomb of the zombie'. In: Christian Chambert (ed.), *Strategies for survival – Now! A global perspective on ethnicity, body and breakdown of artistic systems*. Lund, the Swedish Art Critics Association Press, 1995.

McKeon, Michael, *The origins of the English novel: 1600-1740*. Baltimore/London, John Hopkins University Press, 1987.

McLean, Ian, 'Documenta X and Australians in Oxford: thinking globally from Europe'. In: *Third Text*, Spring 1998.

Meijers, Deborah J., 'The museum and the "ahistorical" exhibition: the latest gimmick by arbiters of taste, or an important cultural phenomenon?' In: Reesa Greenberg, Bruce W. Ferguson and Sandy Nairne (eds.), *Thinking about exhibitions*. London, Routledge, 1996.

Meillassoux, Claude, *Anthropologie économique des Gouro de Côte d'Ivoire: de l'économie de subsistance à l'agriculture commerciale*. Paris, Mouton, 1964.

Mercer, Kobena, 'Interculturality is ordinary'. In: Ria Lavrijsen (ed.), *Intercultural arts education and municipal policy: new connections in European cities*. Amsterdam, KIT Press in cooperation with the Foundation Facelift of Europe, 1997.

Moreh, Shmuel, *Live theatre and dramatic literature in the Medieval Arab world*. Edinburgh, Edinburgh University Press, 1992.

Morley, David, Kuan Hsing Chen and Stuart Hall, *Critical dialogues in cultural studies*. London, Routledge, 1996.

Ndebele, Njabulo S., *Rediscovery of the ordinary: essays on South African literature and culture*. Johannesburg, COSAW, 1991.

Nederveen Pieterse, Jan, 'Multiculturalism and museums: discourse about the other in the age of globalization'. In: *Boekmancahier* nr. 28, June 1996.

Nicodemus, Everlyn, 'The centre of otherness'. In: Jean Fisher (ed.), *Global visions: towards a new internationalism in the visual arts*. London, Kala Press/Institute of International Visual Arts, 1994.

Okri, Ben, *Dangerous love*. London, Phoenix House, 1996.

Papastergiadis, Nikos, 'The South in the North'. In: *Third Text*, no. 14, Spring 1991.

Plas, Els van der, 'Het klimaat', in: *Het klimaat: buitenlandse beeldend kunstenaars in Nederland*. Den Haag, Culturele Raad Zuid-Holland, 1991.

Putinsova, Tamara A., *Thousand and one years of Arabic theatre*. Beirut, El Farabi, 1981. (Arabic)

Rajadhyaksha, Ashish and Paul Willemen, *Encyclopaedia of Indian cinema*. London/New Delhi, BFI Publishing/Oxford University Press, 1994.

Ricoeur, Paul, *The conflict of interpretations*. Evanston, Northwestern University Press, 1974.

Sabri, Mahmoud, *Art and man, a study in a new type of art: quantum realism*. Beirut, 1982/1991. (Arabic)

Said, Edward, 'Reflections on exile'. *Granta*, vol. 13 (1984), p. 159-172.

Sartre, Jean-Paul, *Being and nothingness: a phenomenological essay on ontology*. New York, Washington Square Press, 1988.

Sartre, Jean-Paul, *Black Orpheus*. Paris, Présence Africaine, 1976.

Shahani, Kumar, 'Interrogating internationalism'. *Journal of Arts & Ideas* (New Delhi), nr. 19, May 1990.

Tempel, Placide, *Bantu philosophy*. Paris, Présence Africaine, 1959.

Thiong'o, Ngugi Wa, *The river between*. Oxford, Heinemann International, 1965.

West, Cornel, 'The new cultural politics of difference'. In: Russel Ferguson et al (eds.), *Out there: marginalization and contemporary cultures*. London/Cambridge (Massachuetts), MIT Press, 1990.

Wilson, Fred, 'The silent message of the museum'. In: Jean Fisher (ed.), *Global visions: towards a new internationalism in the visual arts*. London, Kala Press/Institute of International Visual Arts, 1994.